THIS IS LONELY PLANET'S BUCKET LIST. IT'S THE 100 MOST THRILLING, MEMORABLE, DOWNRIGHT INTERESTING PLACES ON THIS PLANET – AND WHAT'S MORE, WE'VE RANKED THEM IN ORDER OF THEIR BRILLIANCE.

HOW?

With a longlist of thousands, which was whittled down to a shortlist, which was then voted on by everybody in the Lonely Planet community. With a little mathematical alchemy, we ended up with a definitive ranking. For the full list of the 500 best sights in the world, check out our Ultimate Travel list (lonelyplanet.com/ultimate-travel).

These are the places that we think you should experience; there are sights that will humble you, amaze you and surprise you. And in these pages, they are yours to re-imagine however you desire.

Let your creativity guide you. Be playful; be inventive. Allow your mind to wander. Allow it to empty itself entirely. Above all else, be inspired by the extraordinary places our planet has to offer.

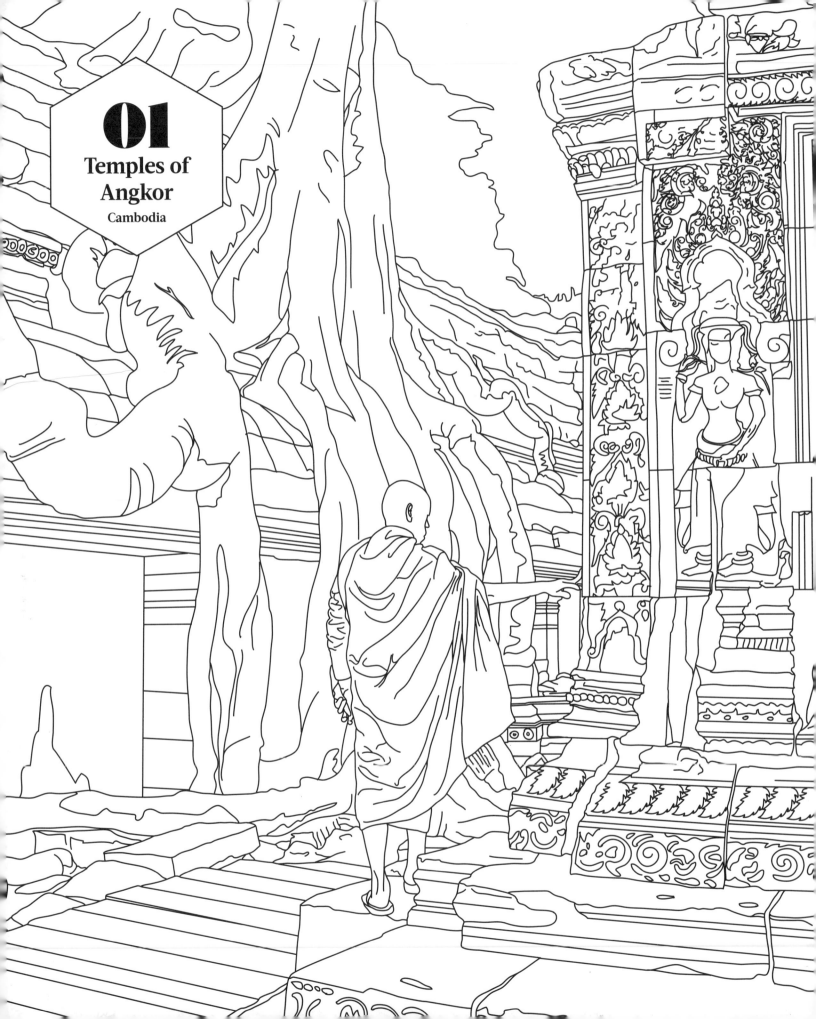

01
Temples of
Angkor
Cambodia

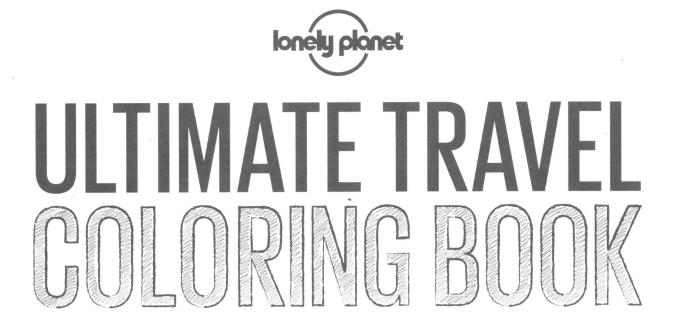

Lonely Planet

ULTIMATE TRAVEL
COLORING BOOK

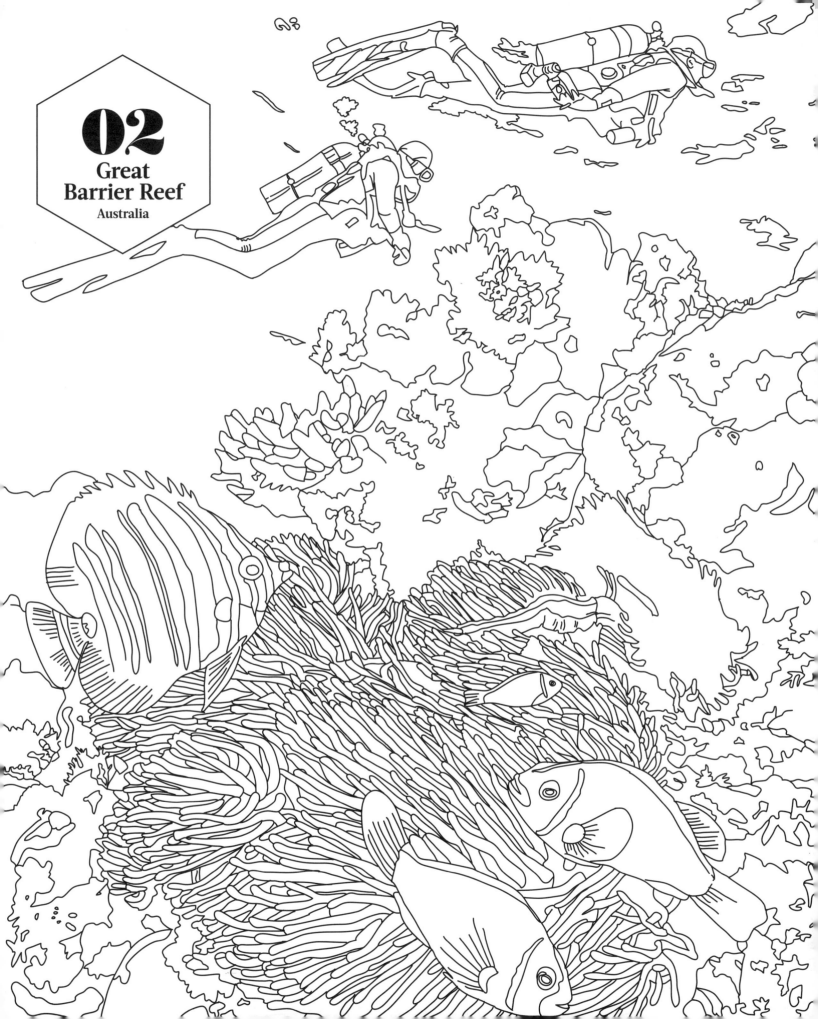

02
**Great
Barrier Reef**
Australia

03

Machu Picchu

Peru

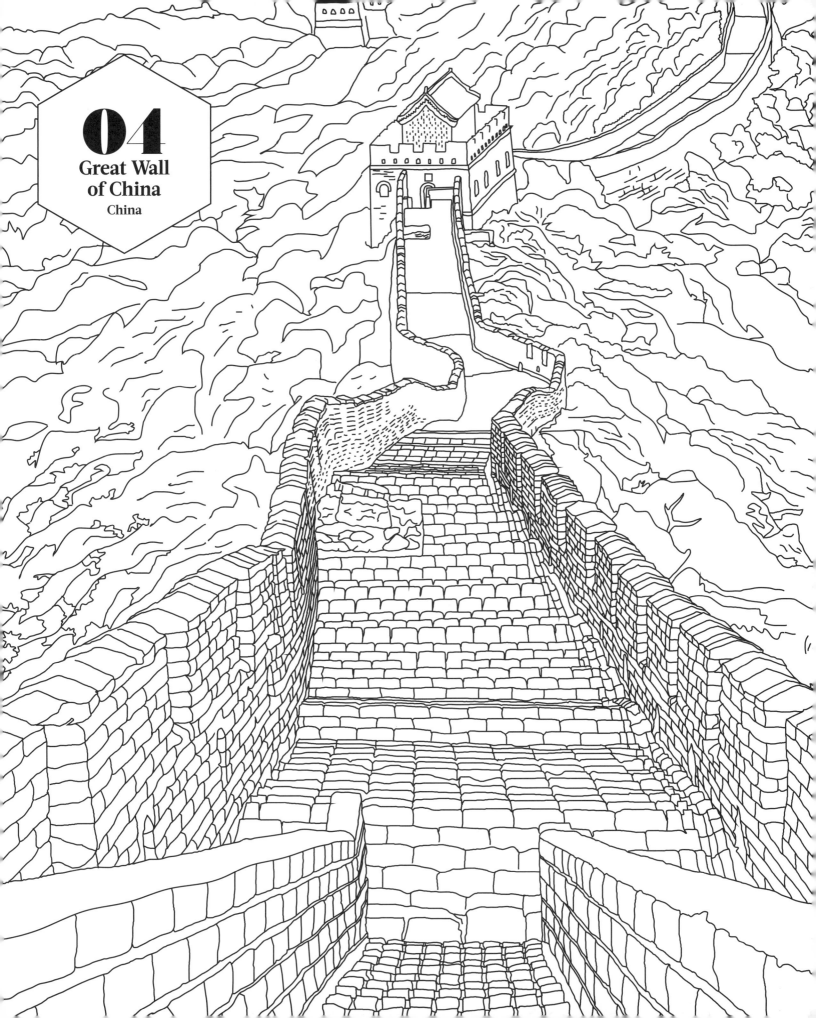

04
Great Wall
of China

China

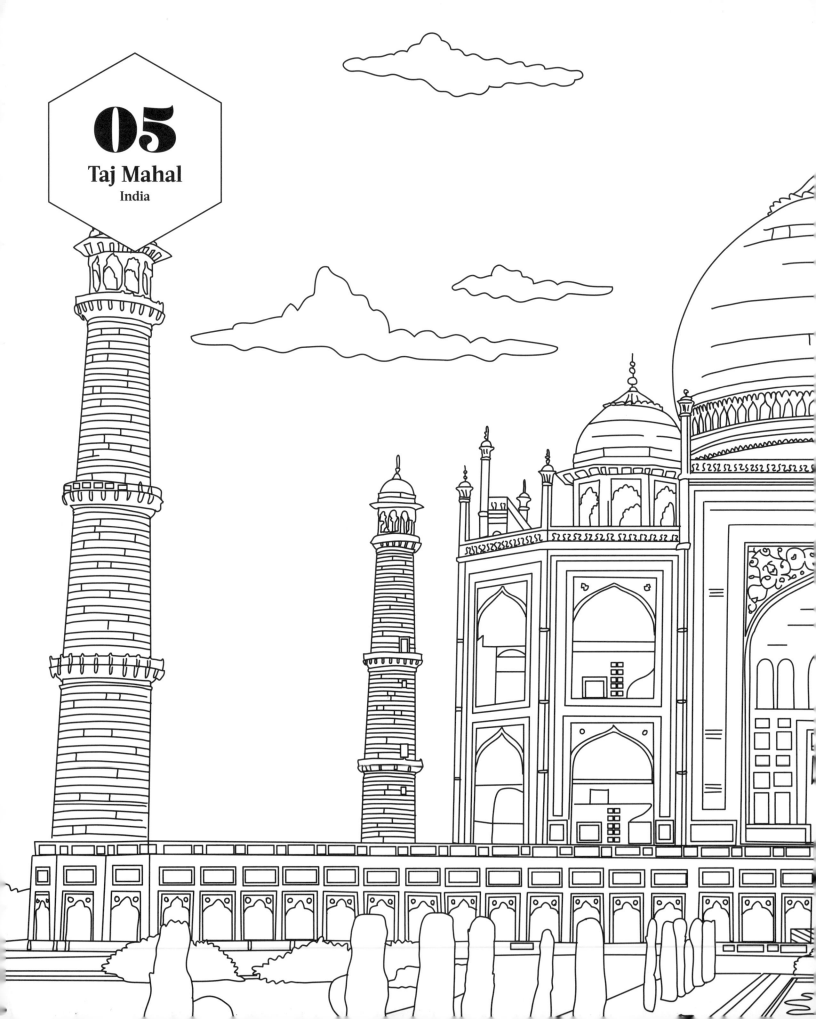

05

Taj Mahal

India

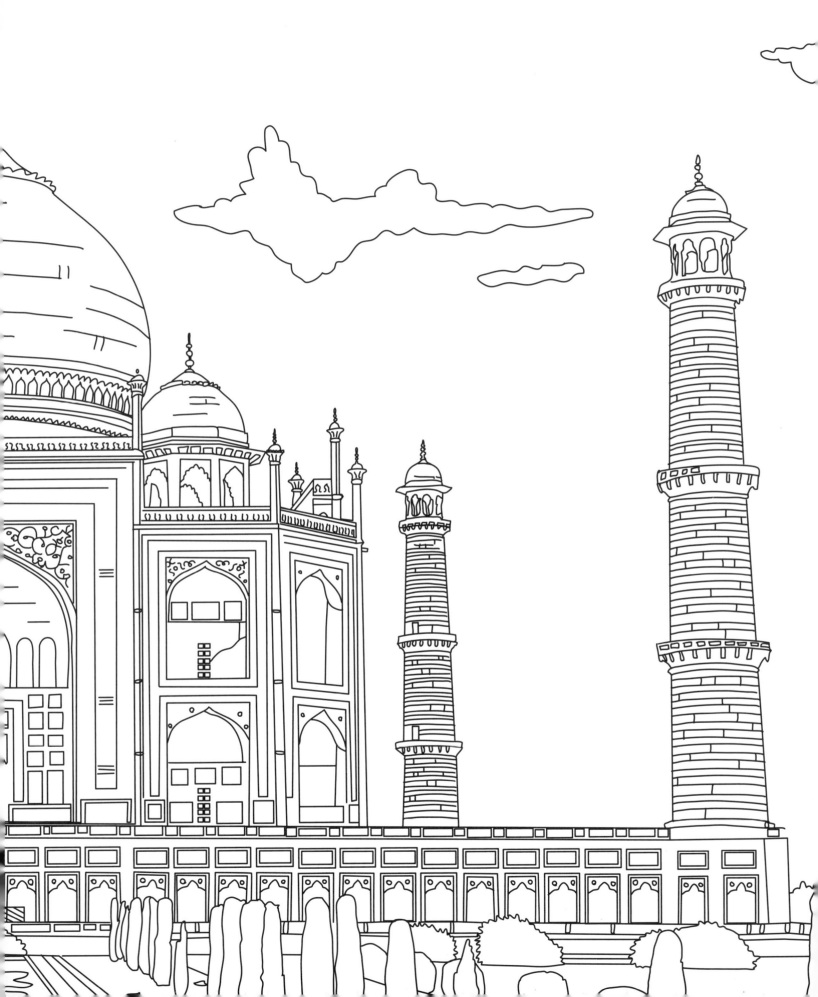

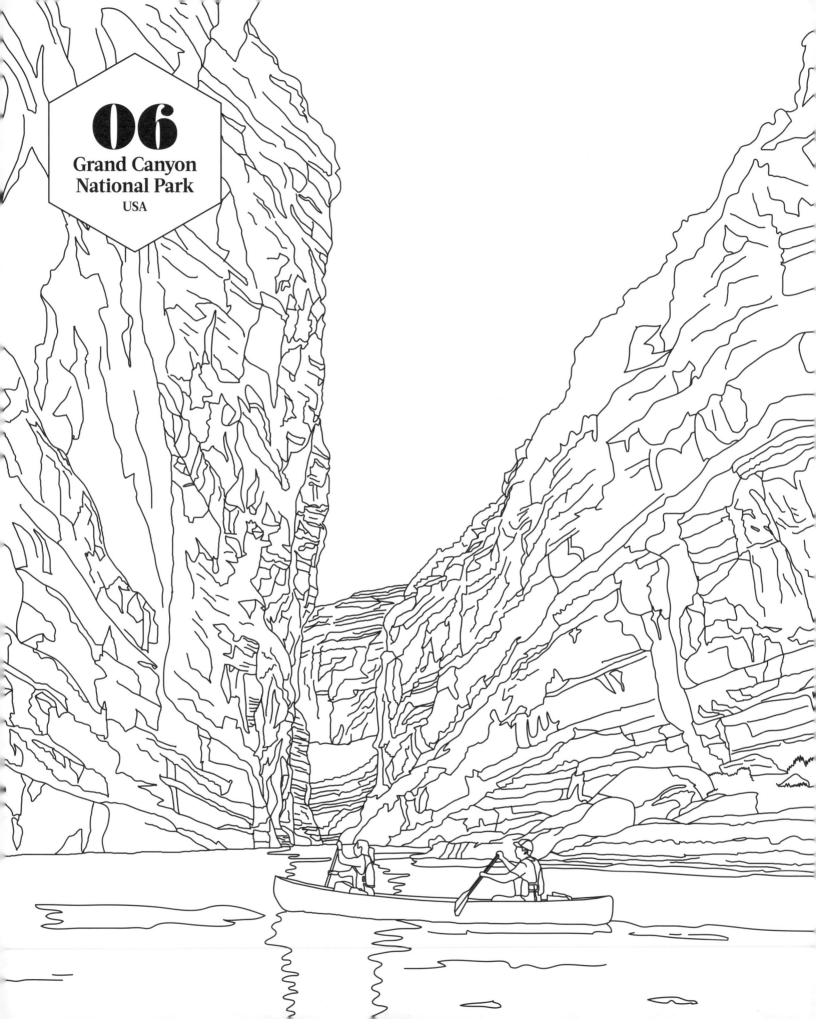

06

Grand Canyon
National Park

USA

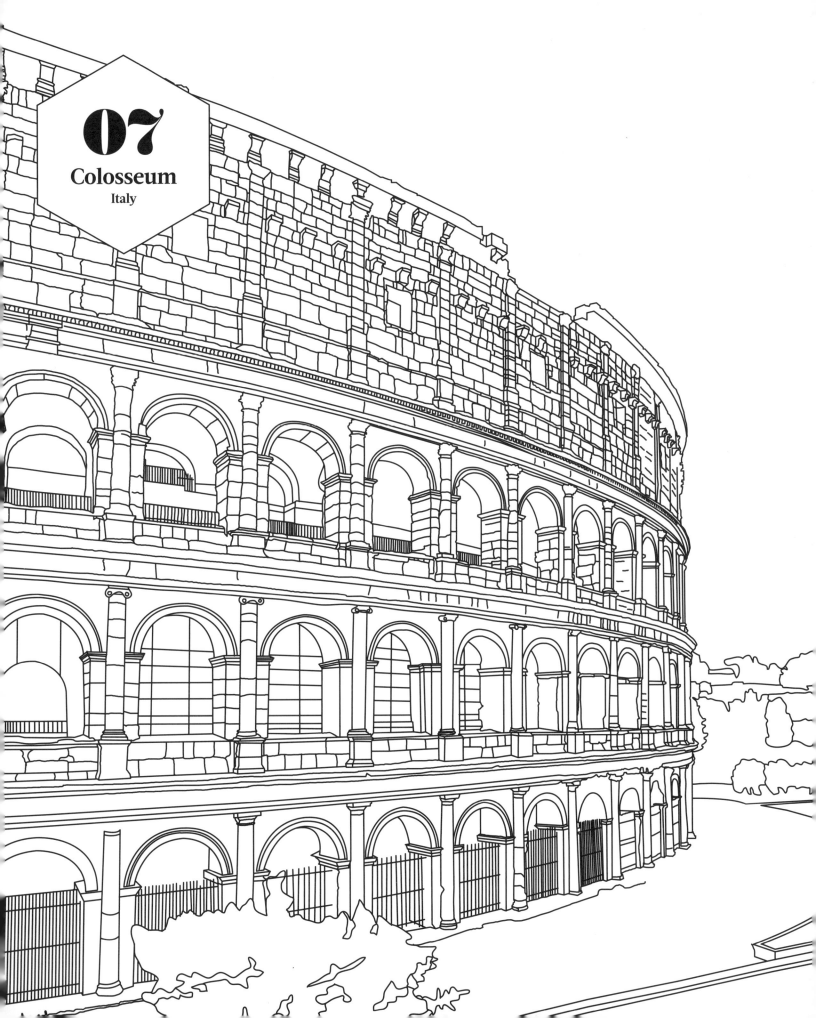

07

Colosseum

Italy

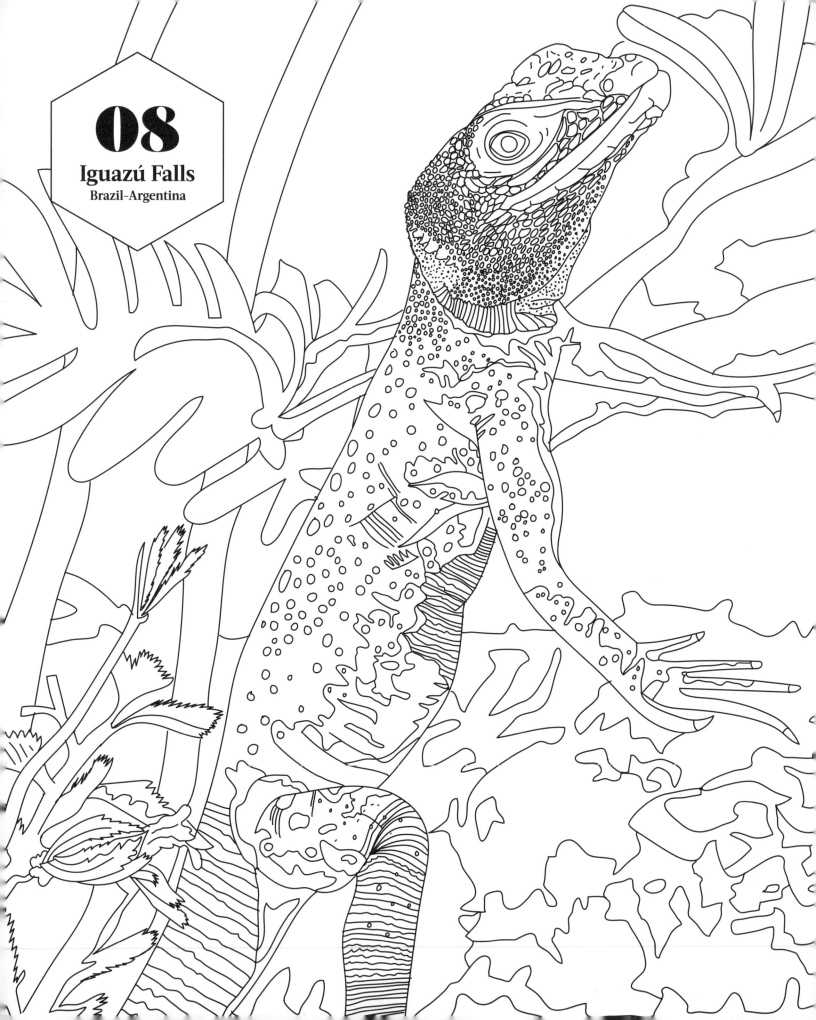

08

Iguazú Falls

Brazil-Argentina

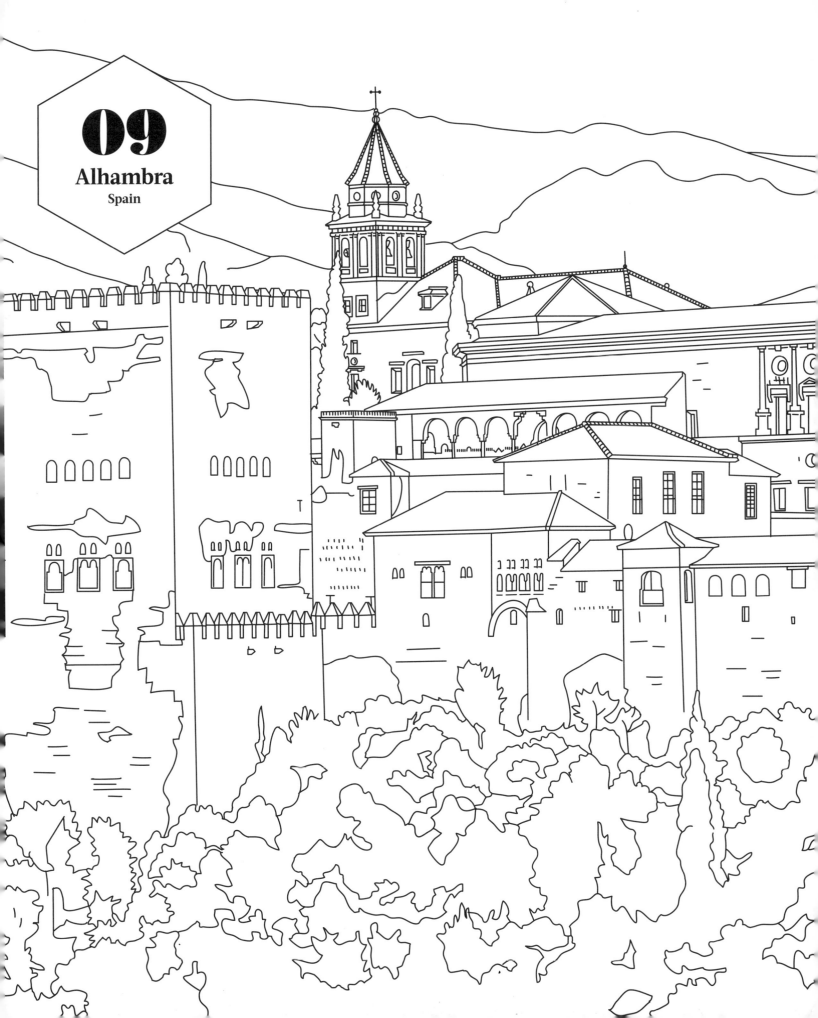

09

Alhambra

Spain

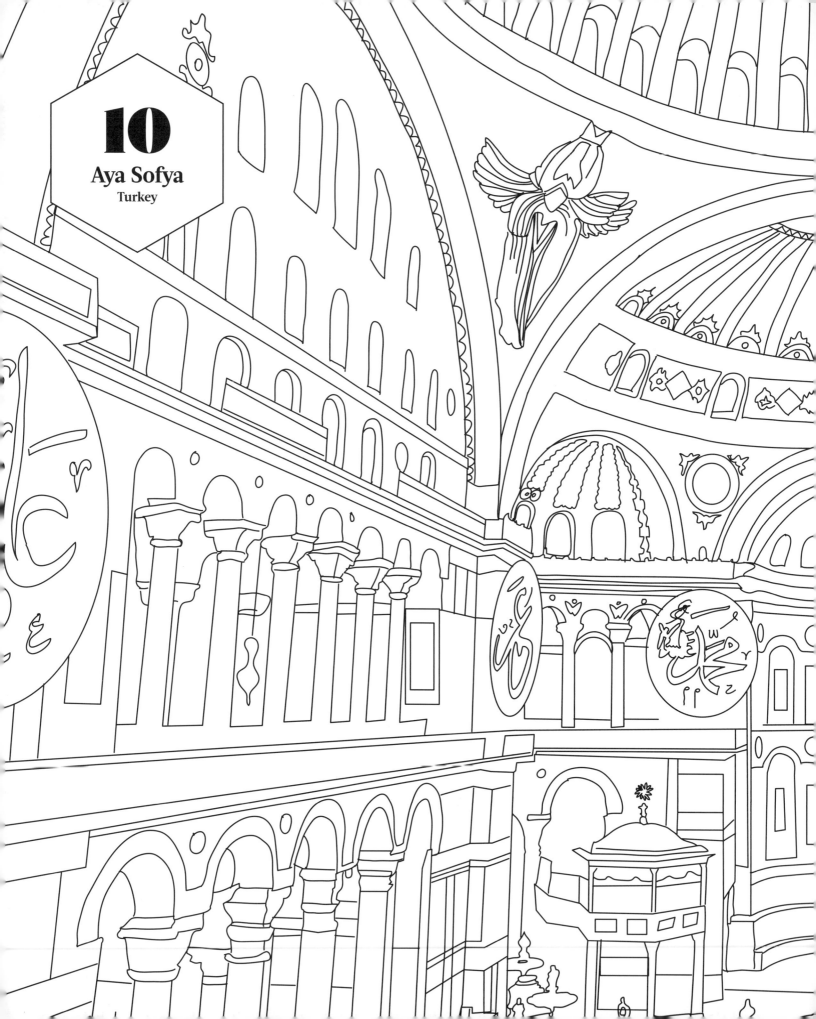

10

Aya Sofya

Turkey

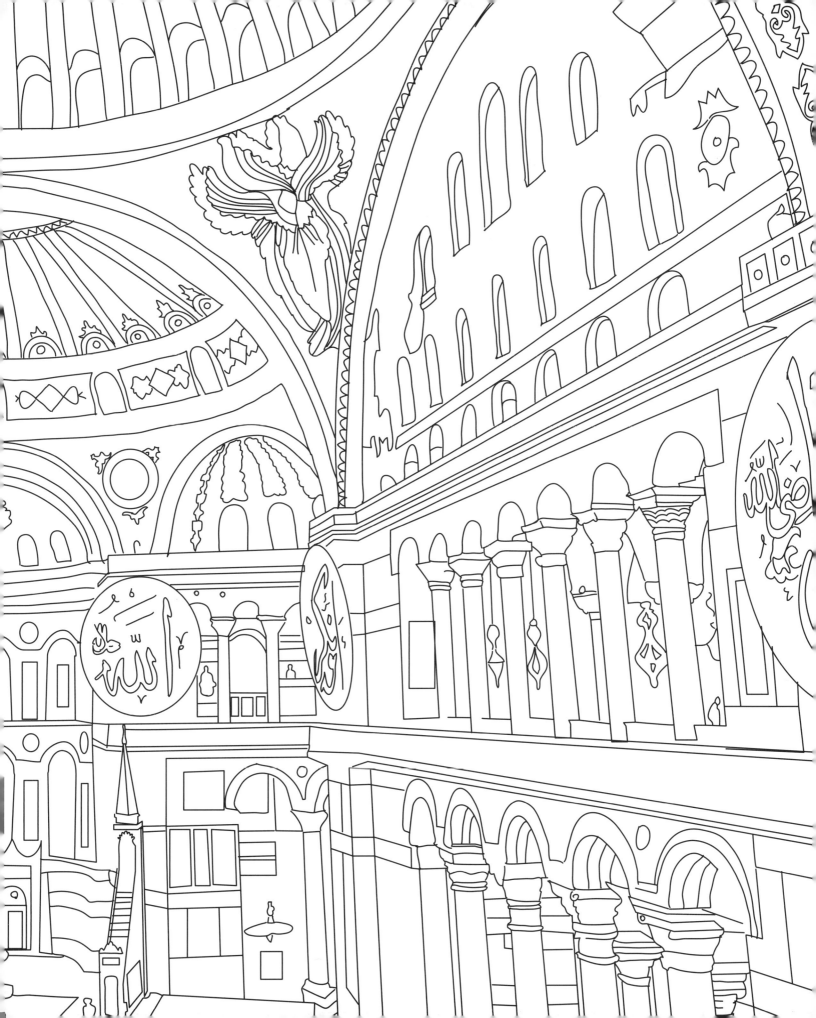

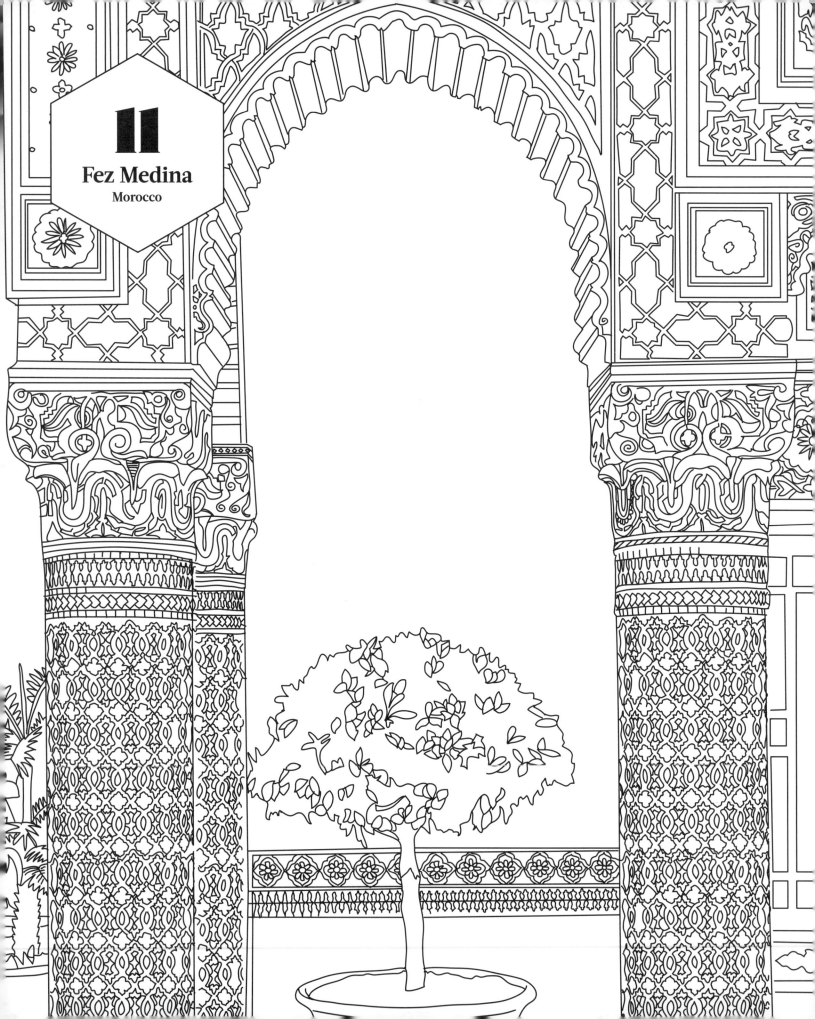

11

Fez Medina

Morocco

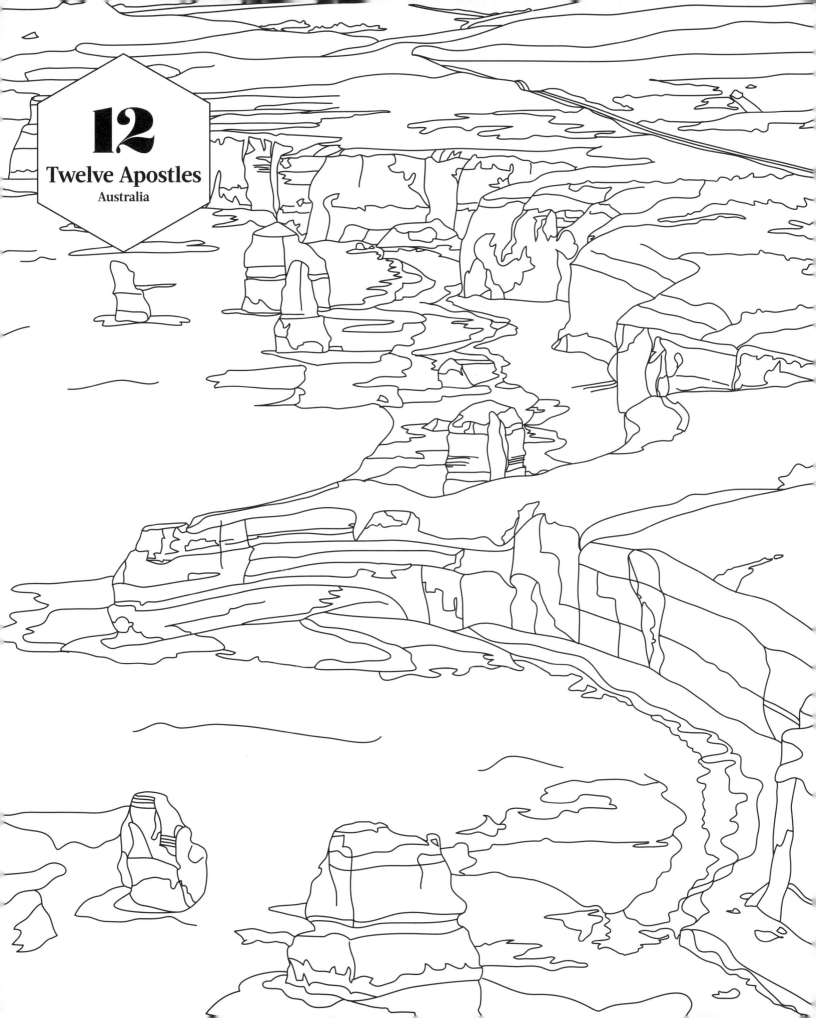

12
Twelve Apostles
Australia

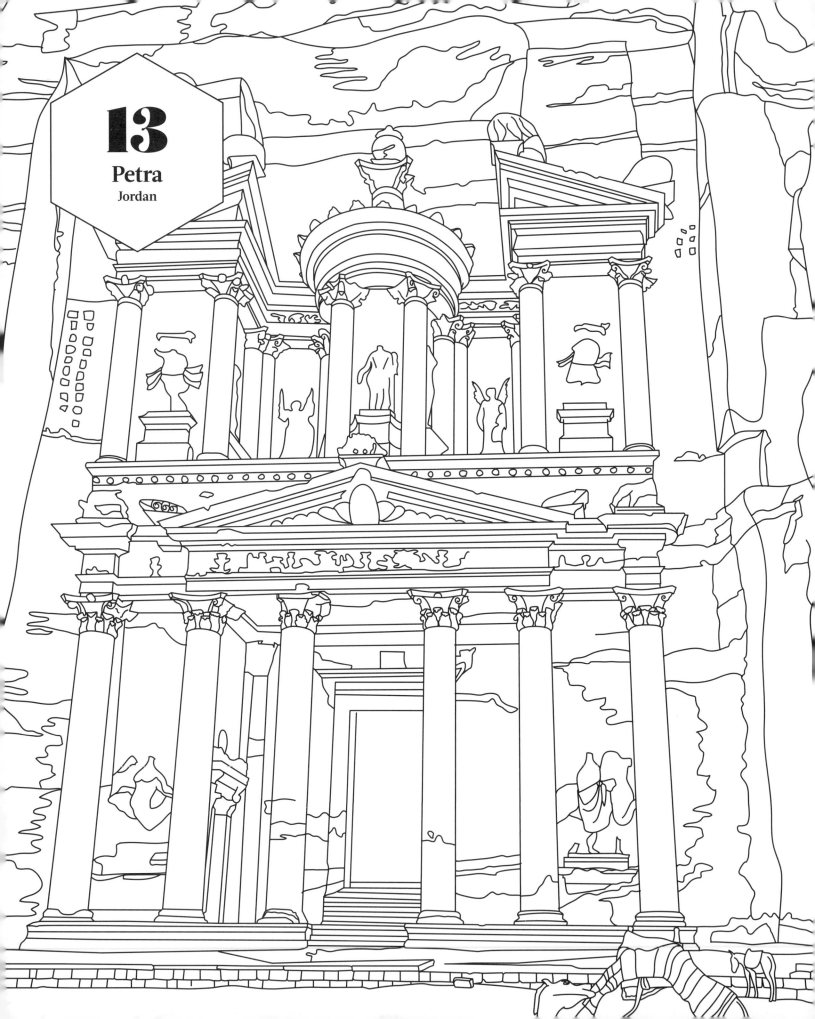

13
Petra
Jordan

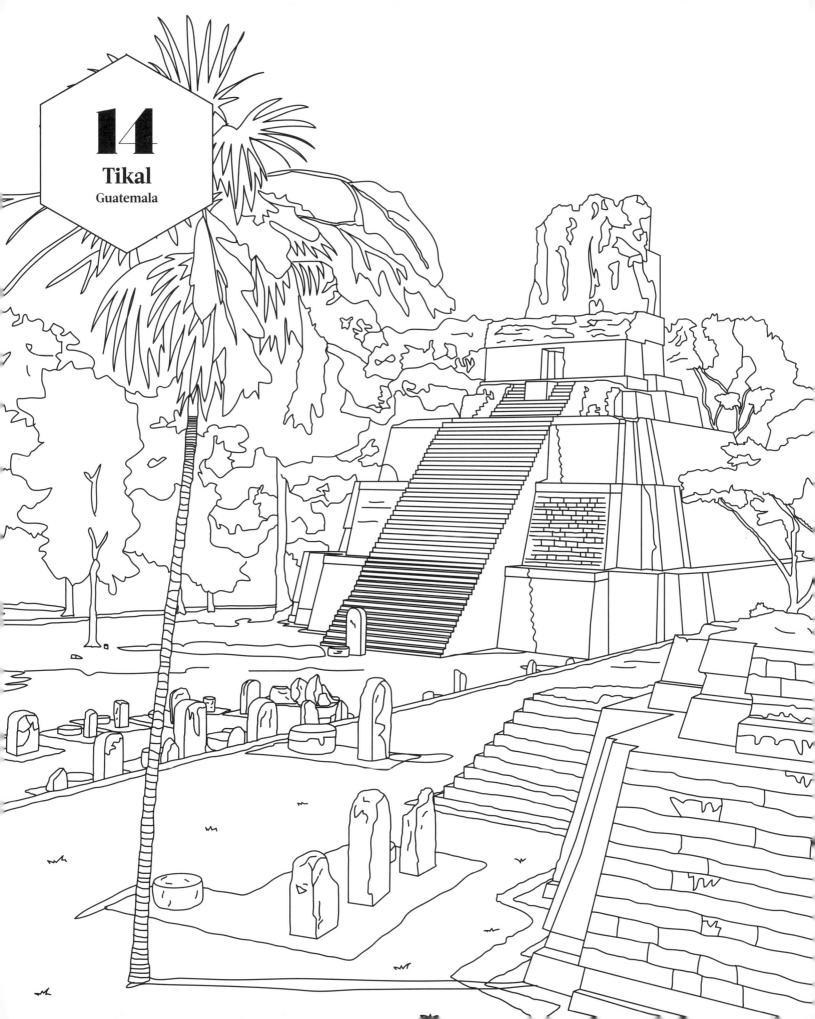

14

Tikal

Guatemala

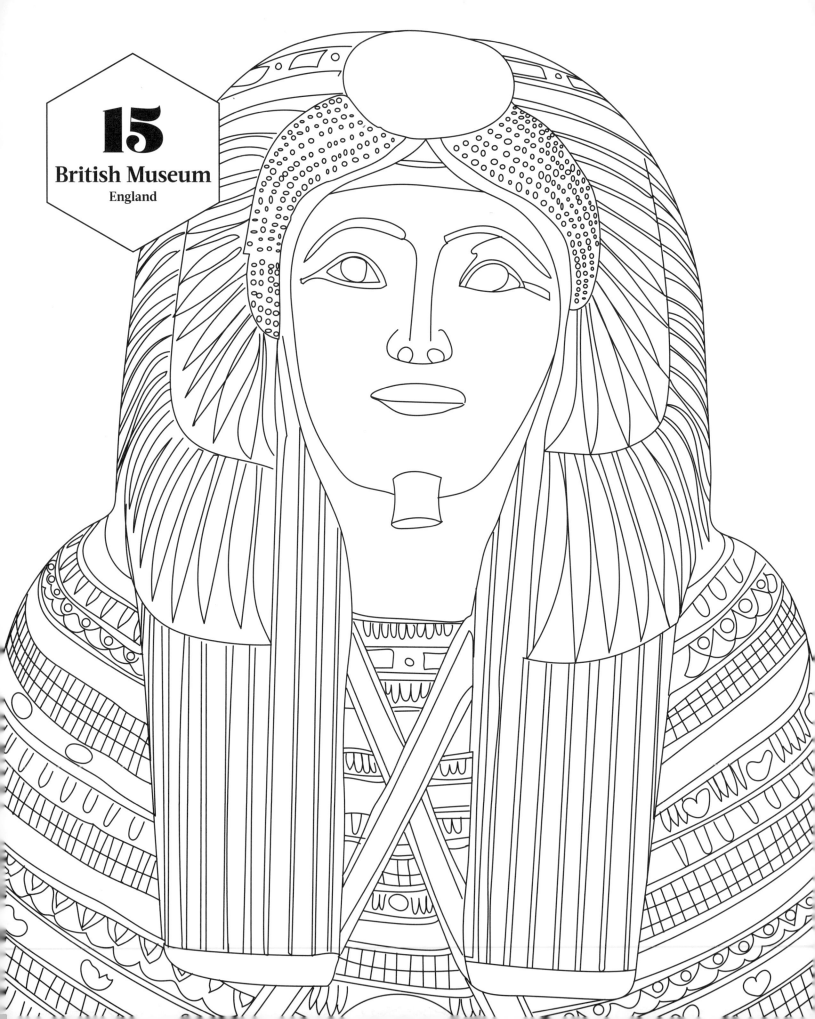

15

British Museum

England

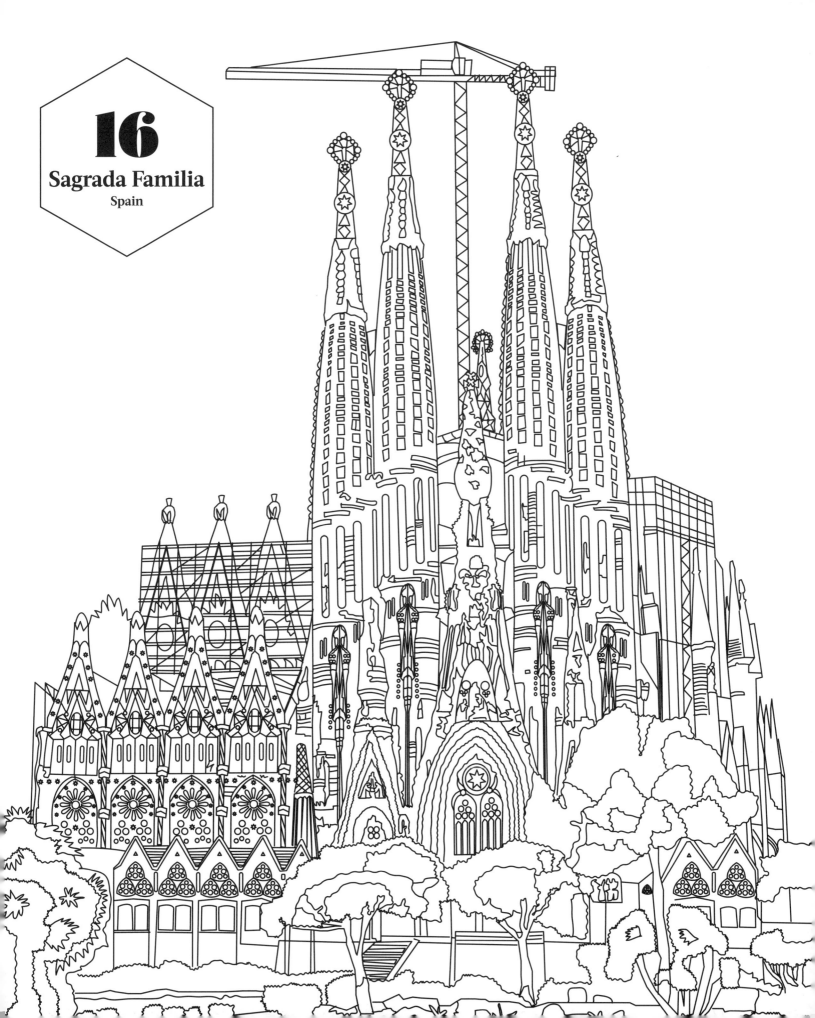

16

Sagrada Familia

Spain

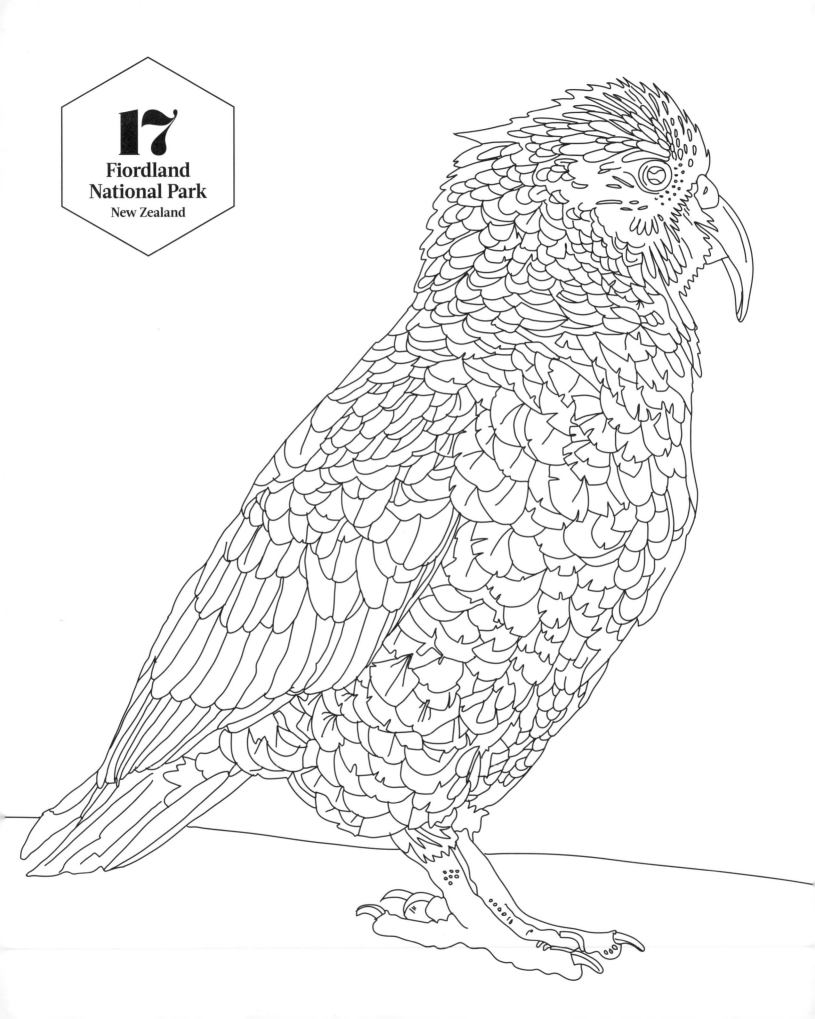

17

Fiordland National Park

New Zealand

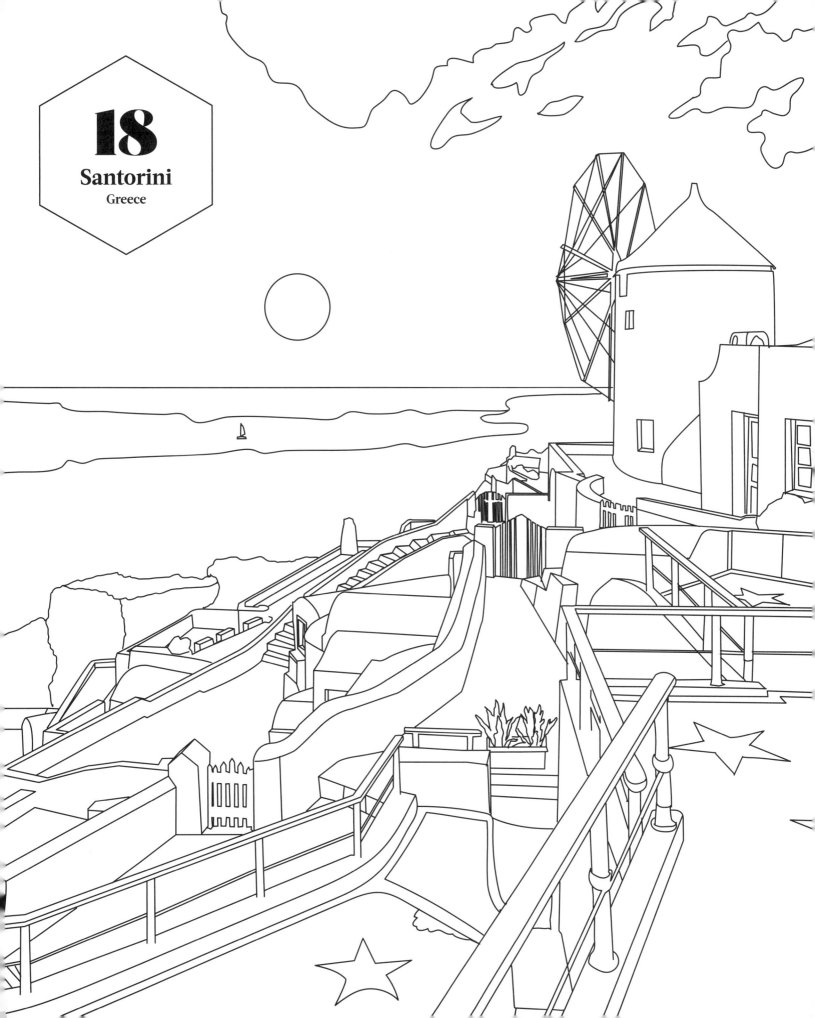

18
Santorini
Greece

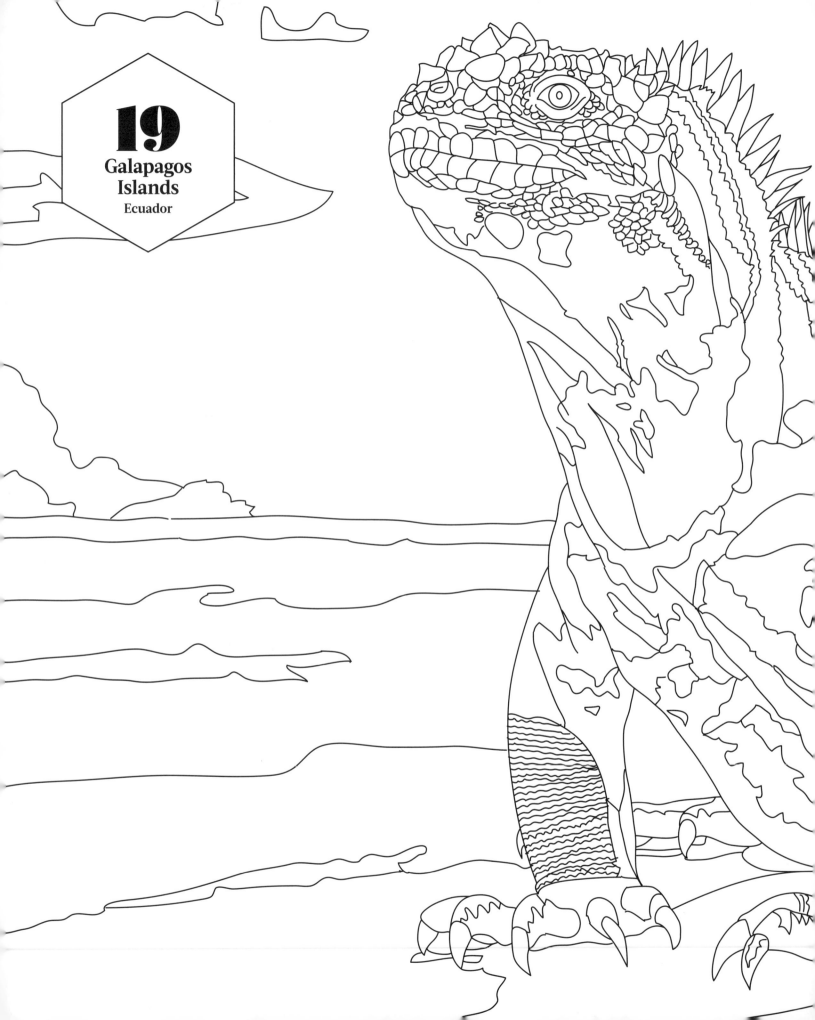

19
Galapagos
Islands
Ecuador

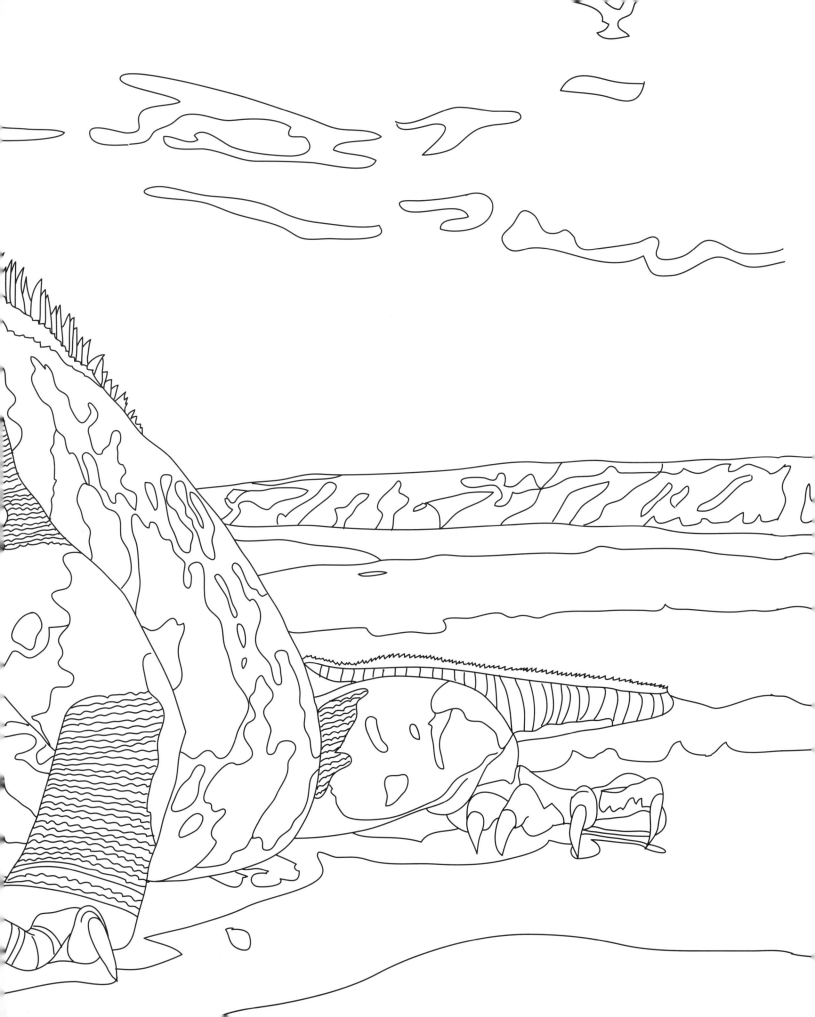

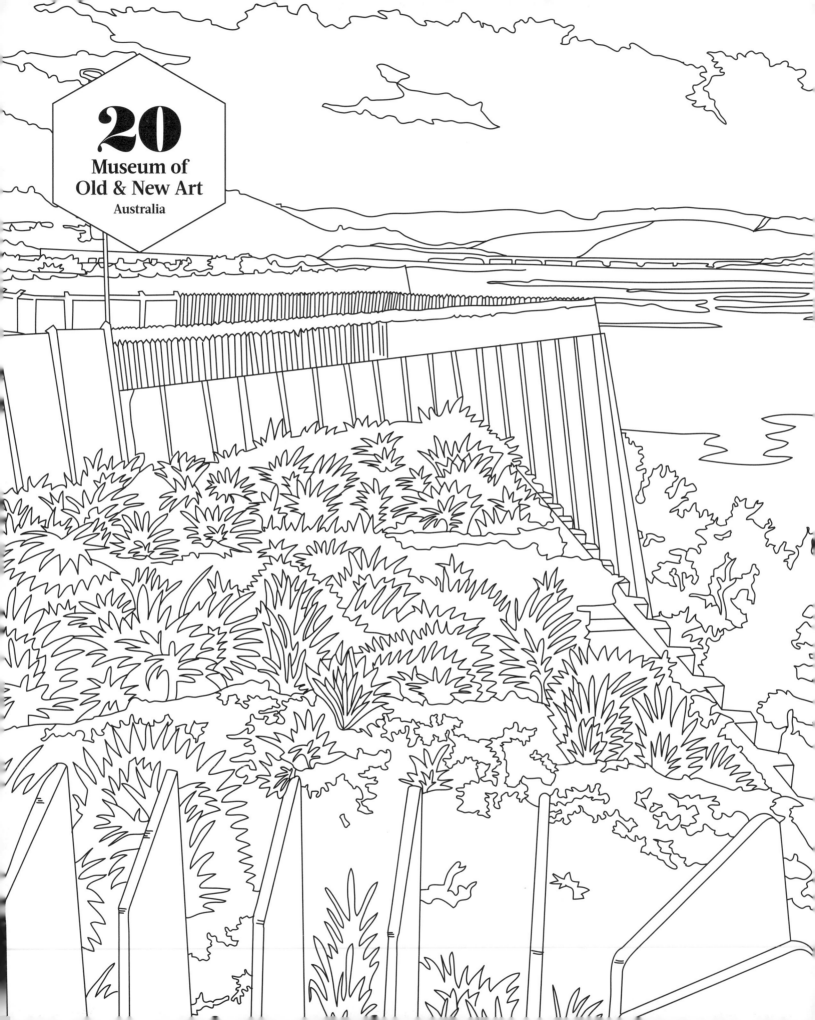

20
Museum of
Old & New Art
Australia

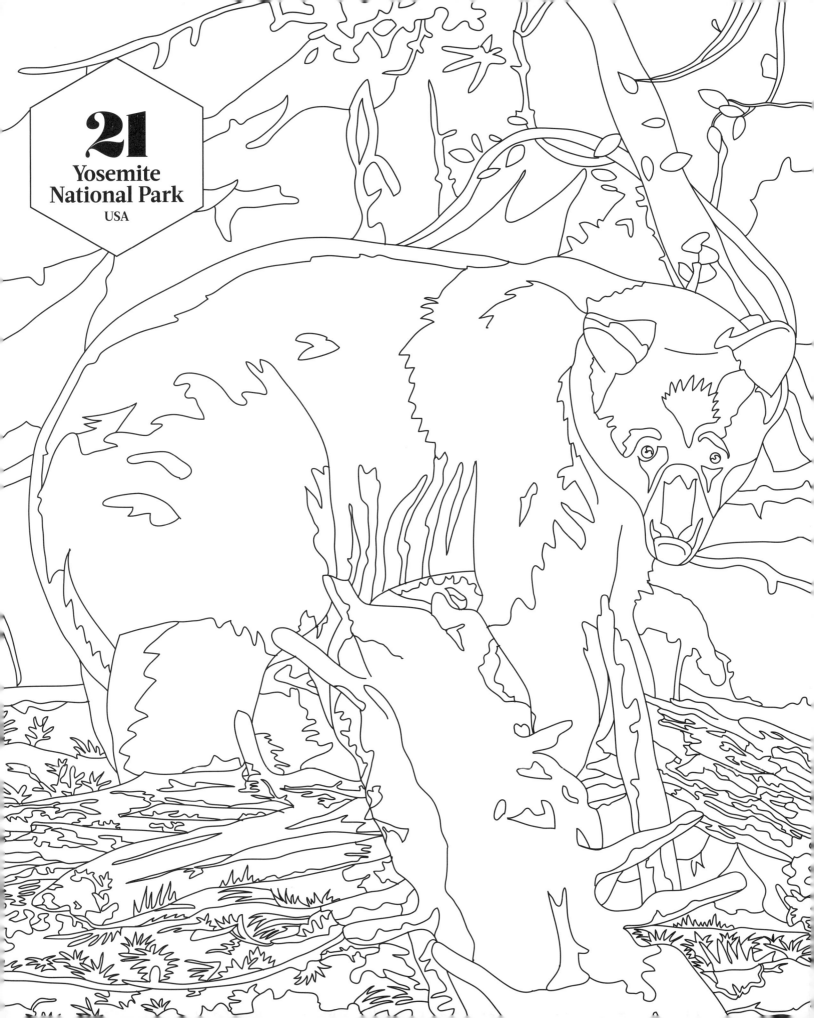

21
Yosemite
National Park
USA

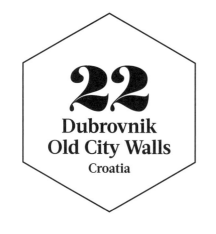

22
Dubrovnik
Old City Walls
Croatia

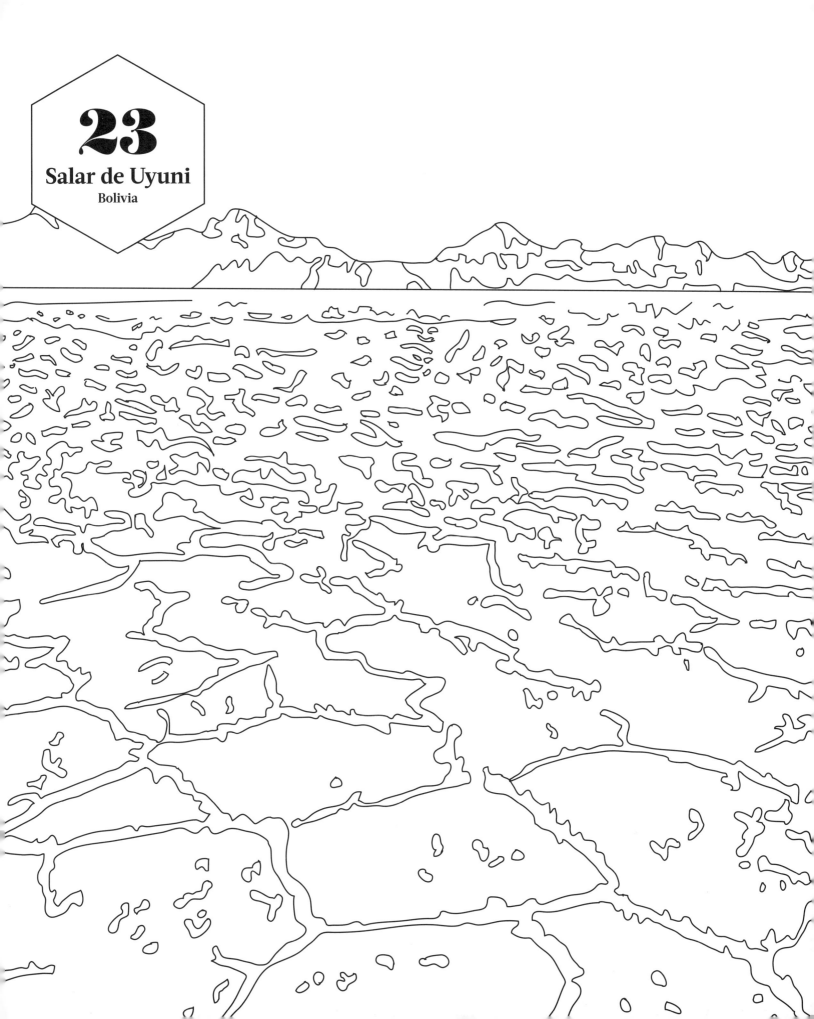

23

Salar de Uyuni

Bolivia

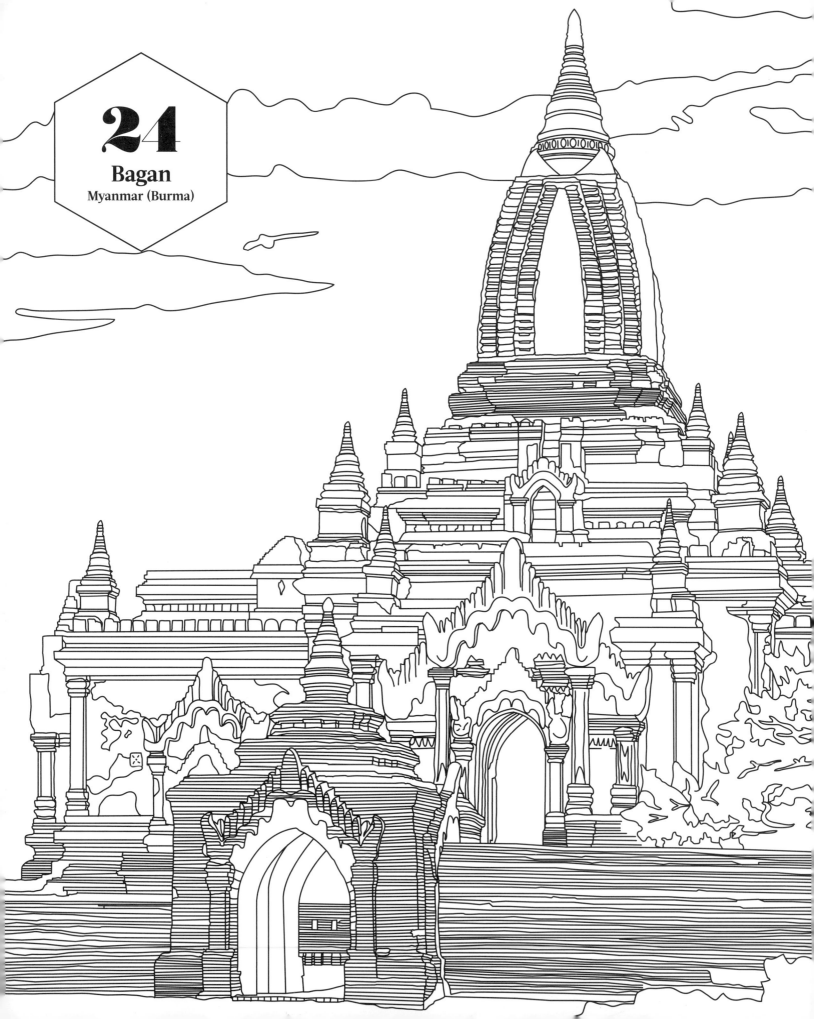

24

Bagan

Myanmar (Burma)

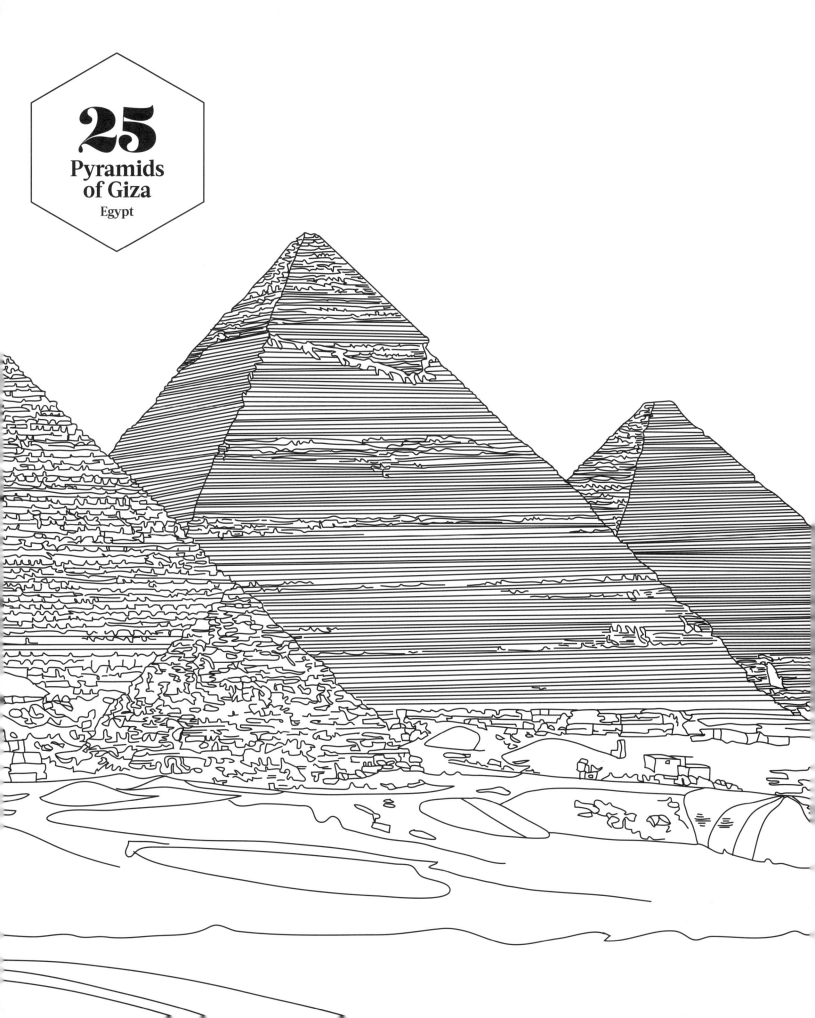

25
Pyramids
of Giza

Egypt

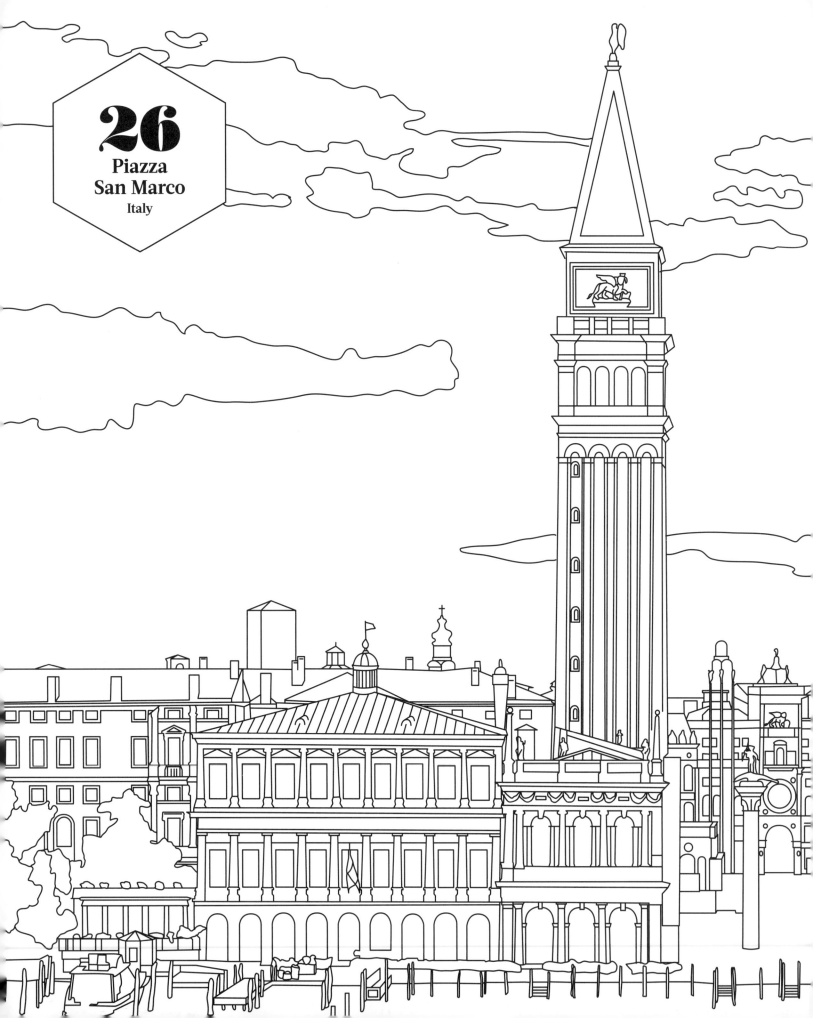

26
**Piazza
San Marco**
Italy

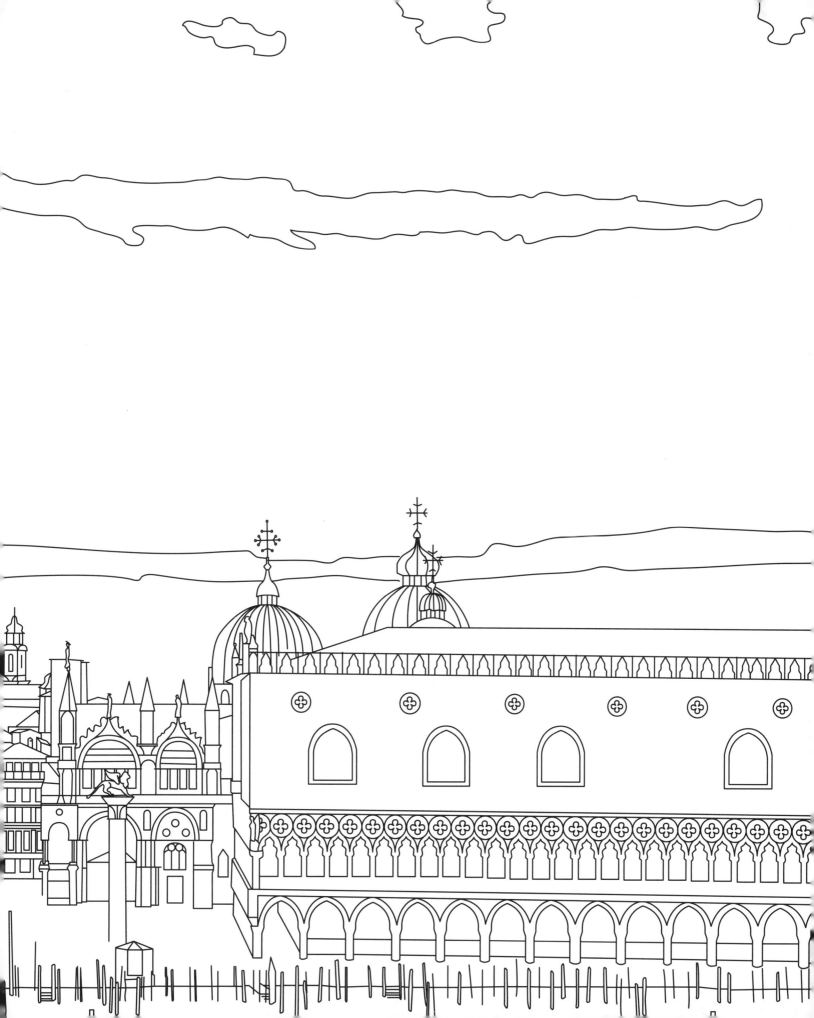

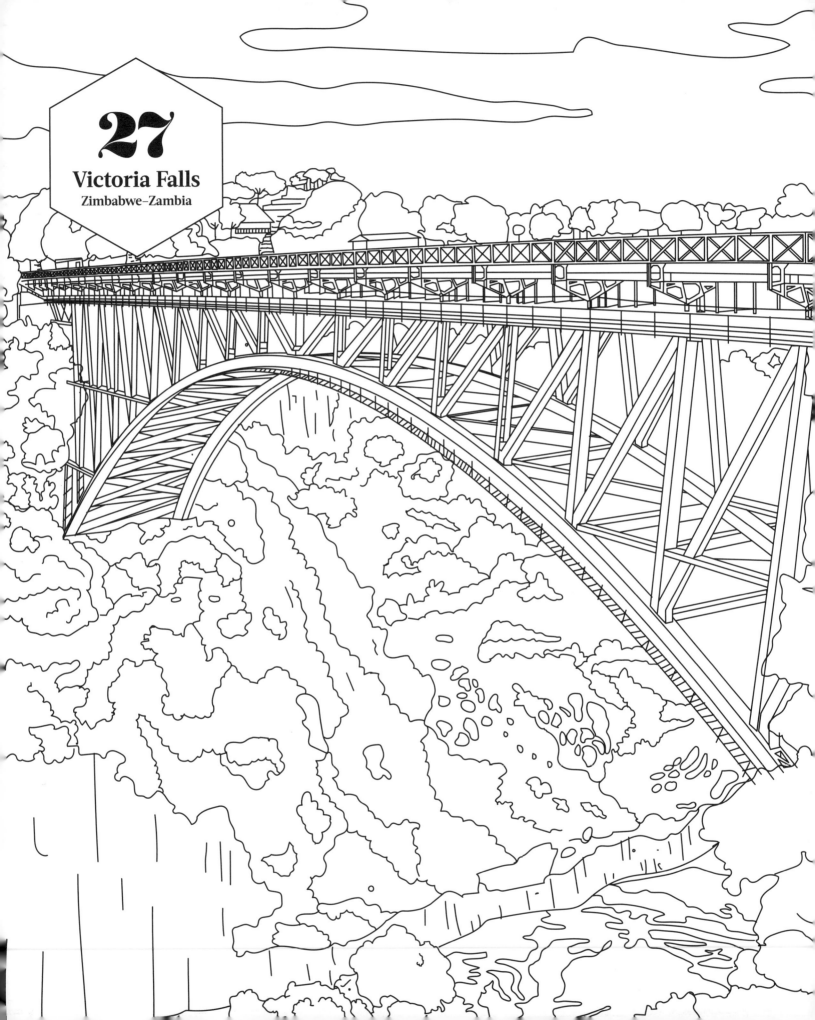

27
Victoria Falls
Zimbabwe–Zambia

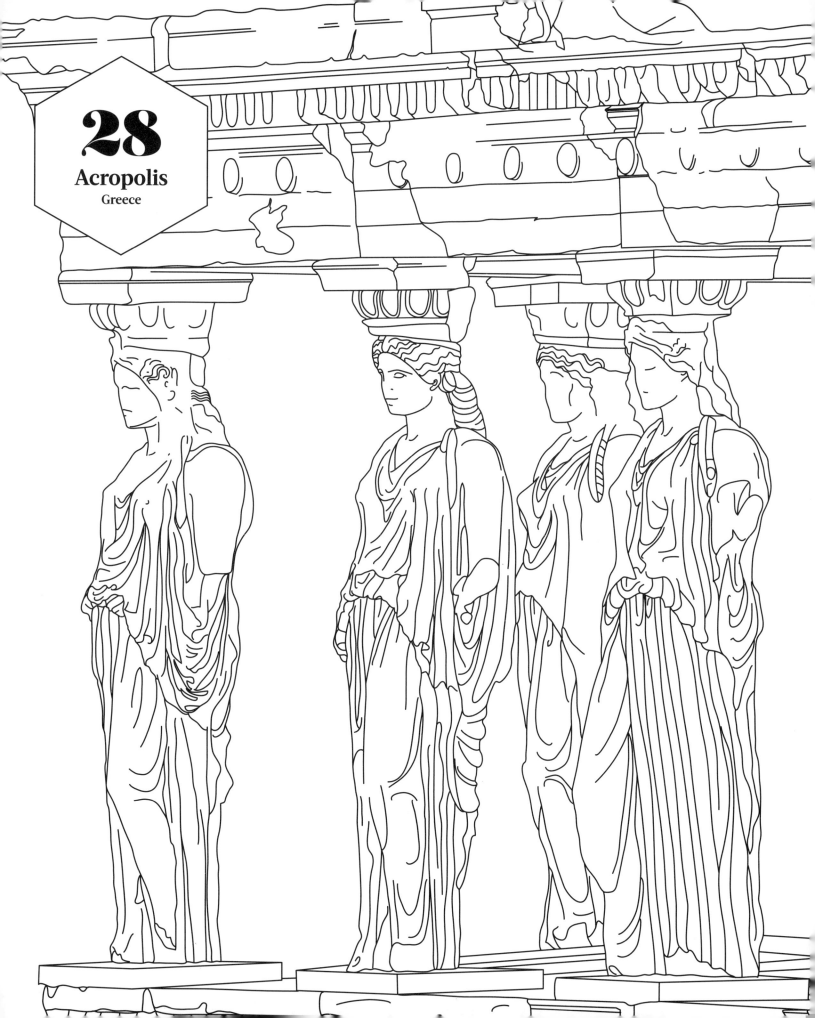

28

Acropolis

Greece

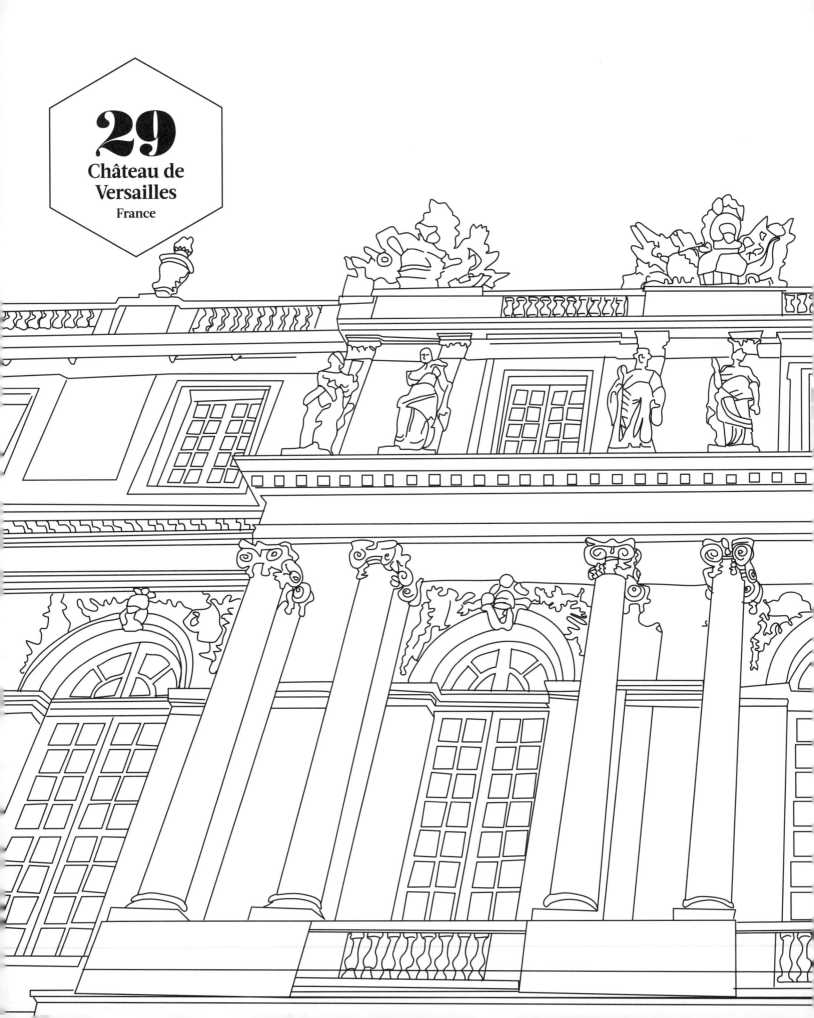

29

Château de
Versailles

France

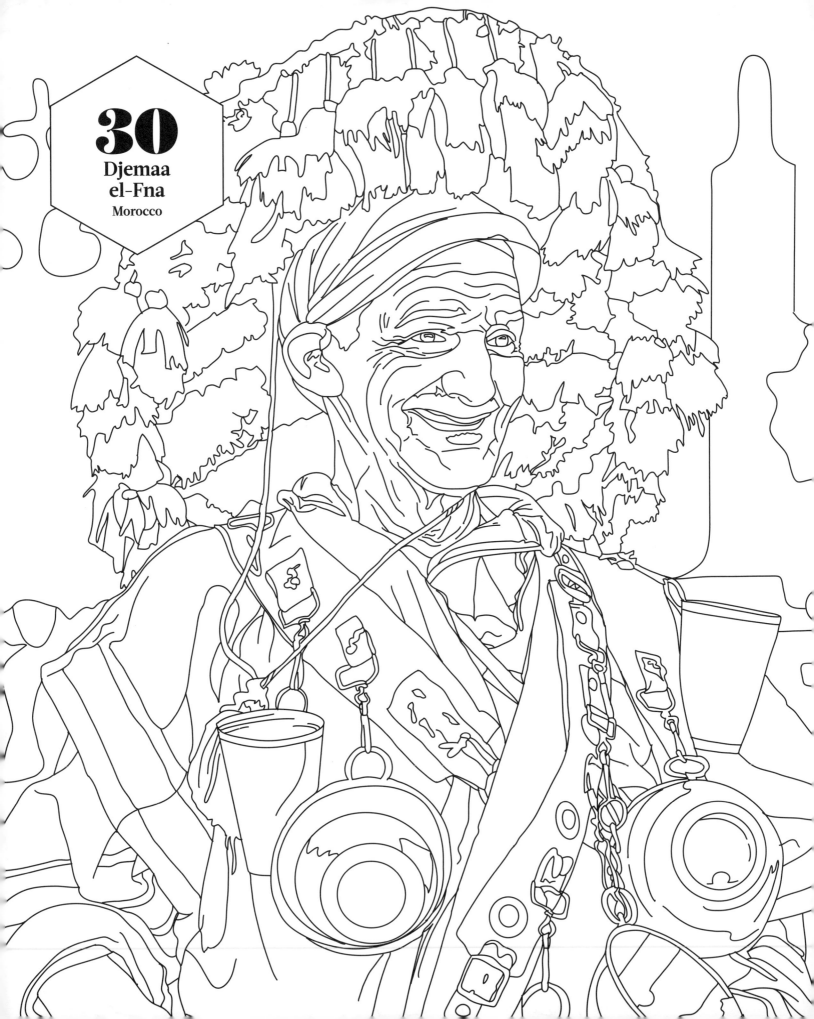

30

Djemaa
el-Fna

Morocco

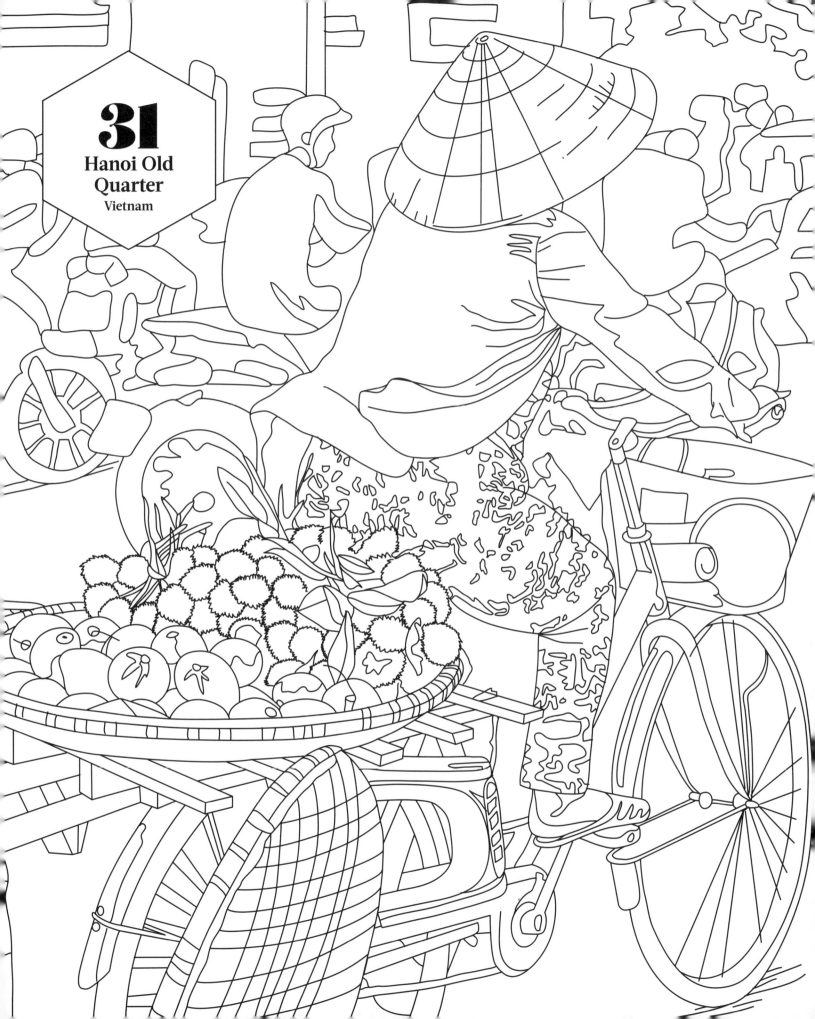

31

Hanoi Old
Quarter

Vietnam

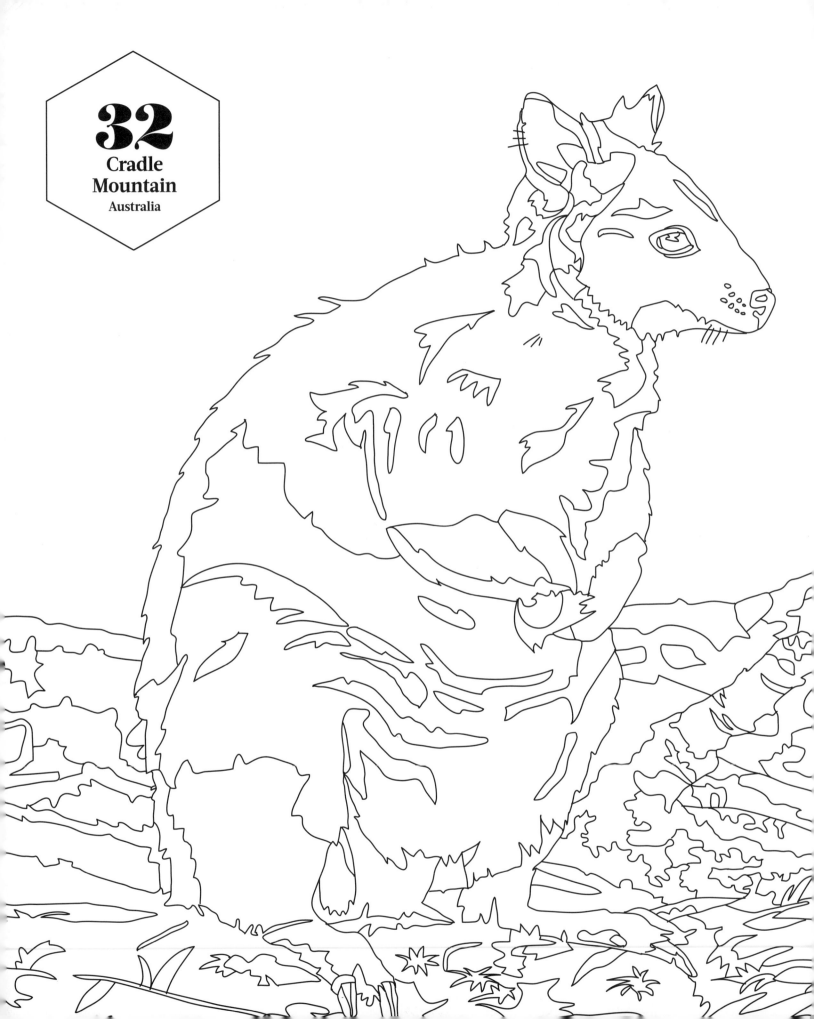

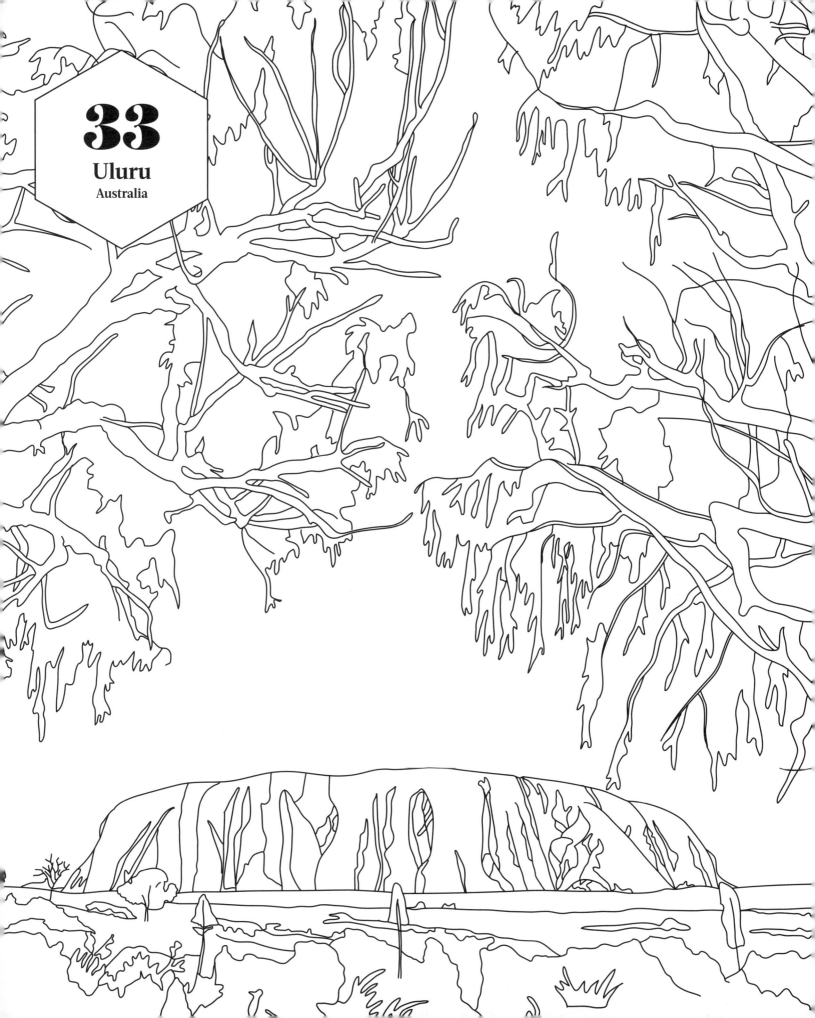

33

Uluru

Australia

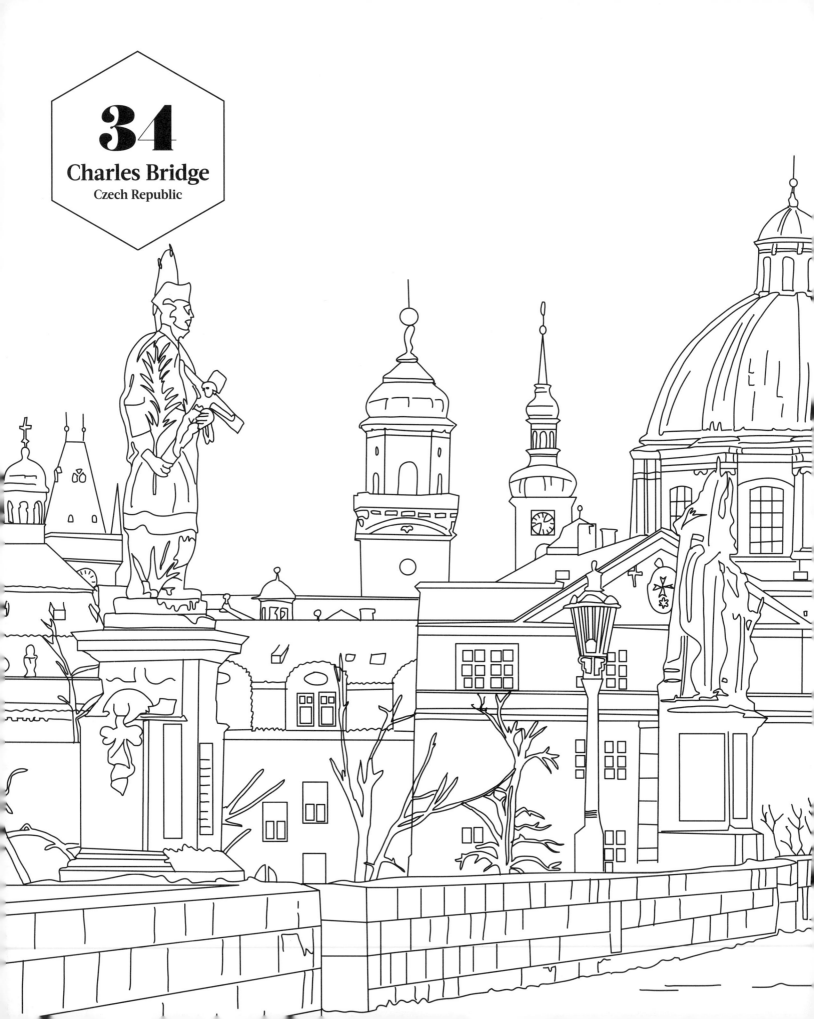

34

Charles Bridge

Czech Republic

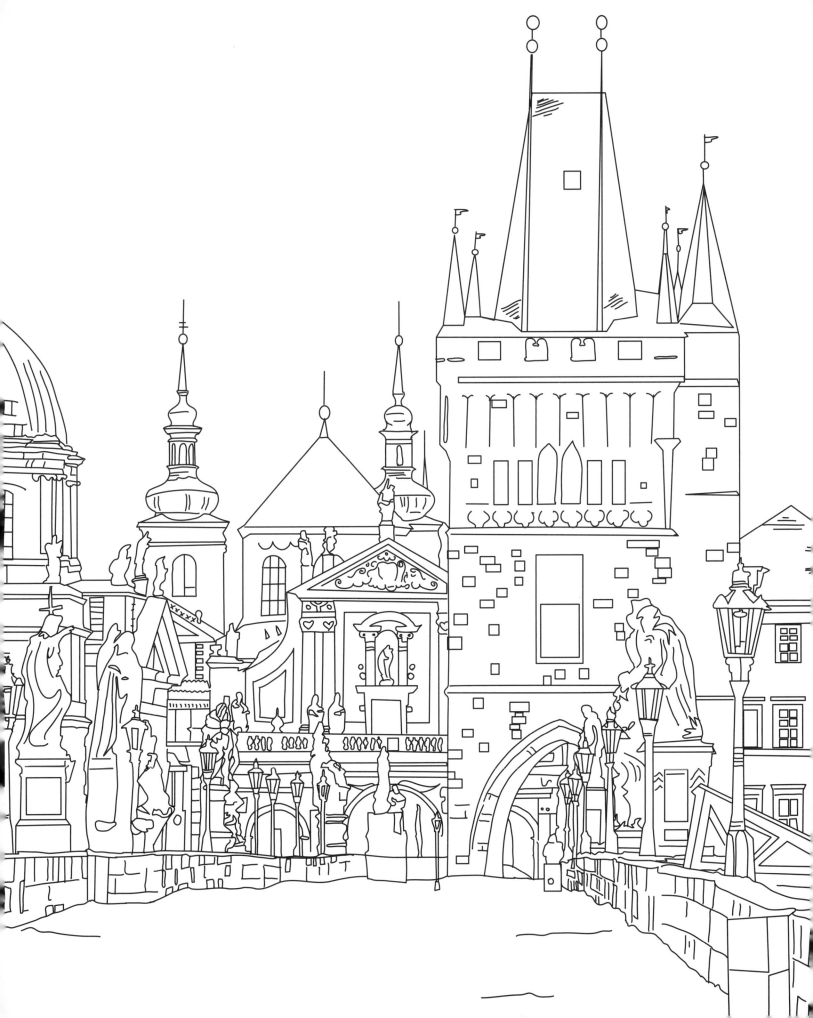

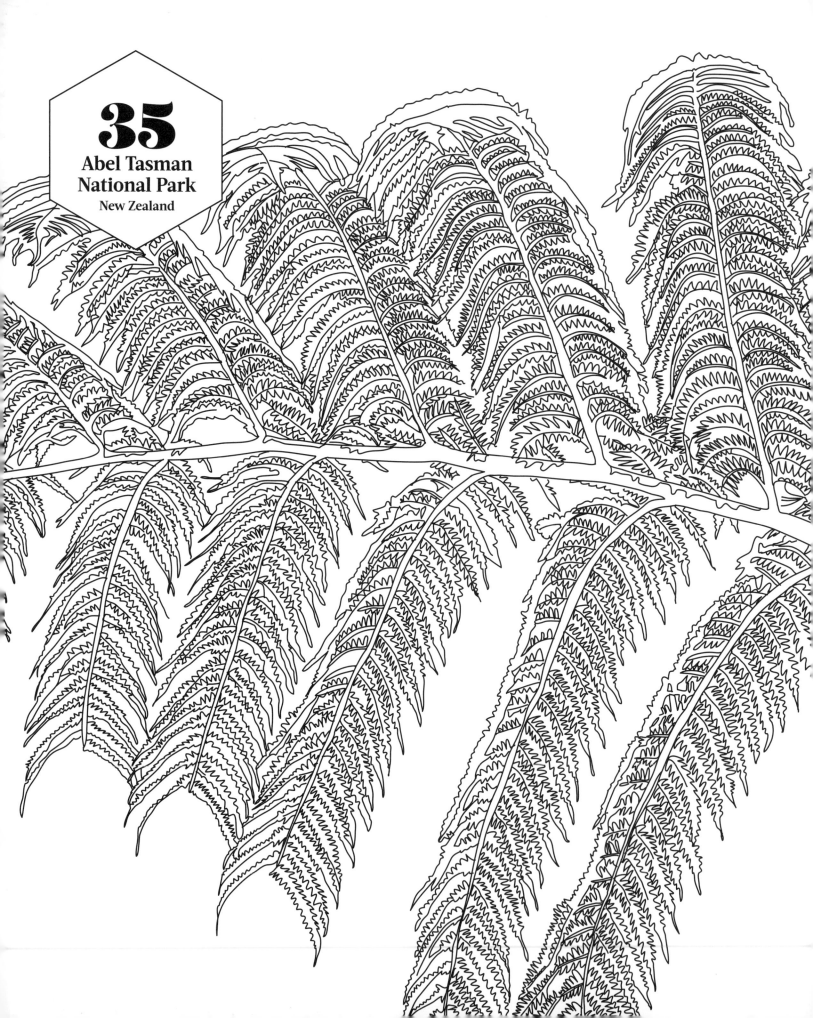

35
Abel Tasman
National Park
New Zealand

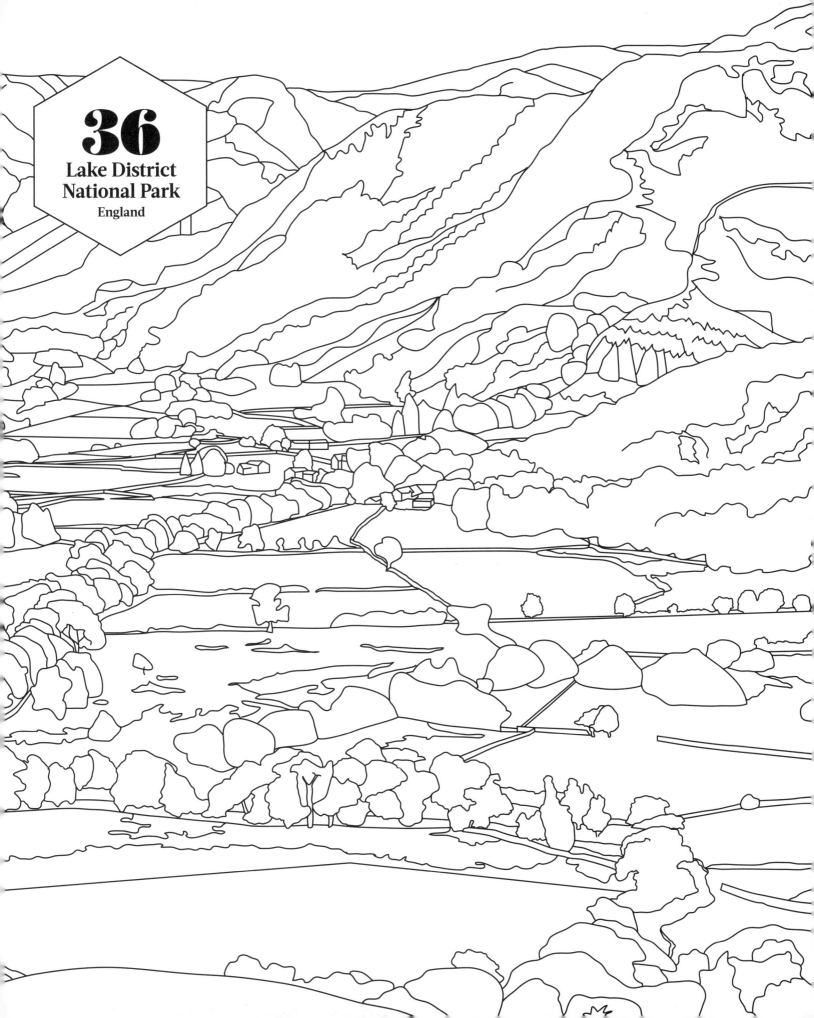

36
Lake District
National Park
England

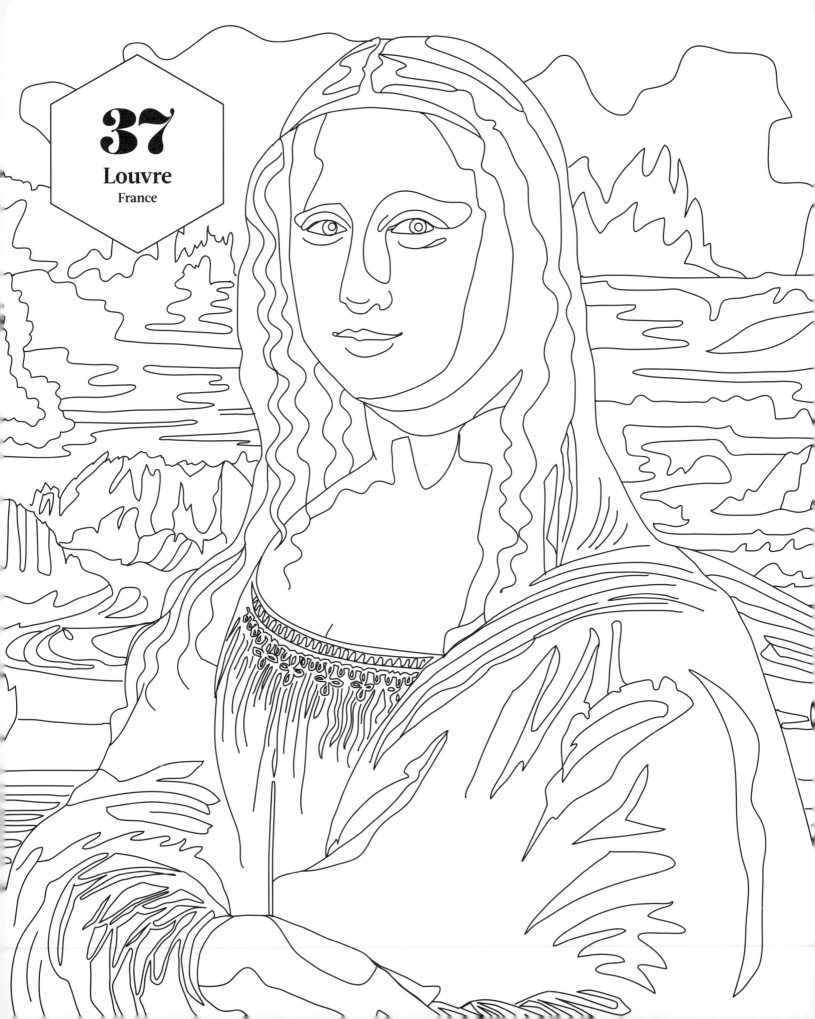

37

Louvre

France

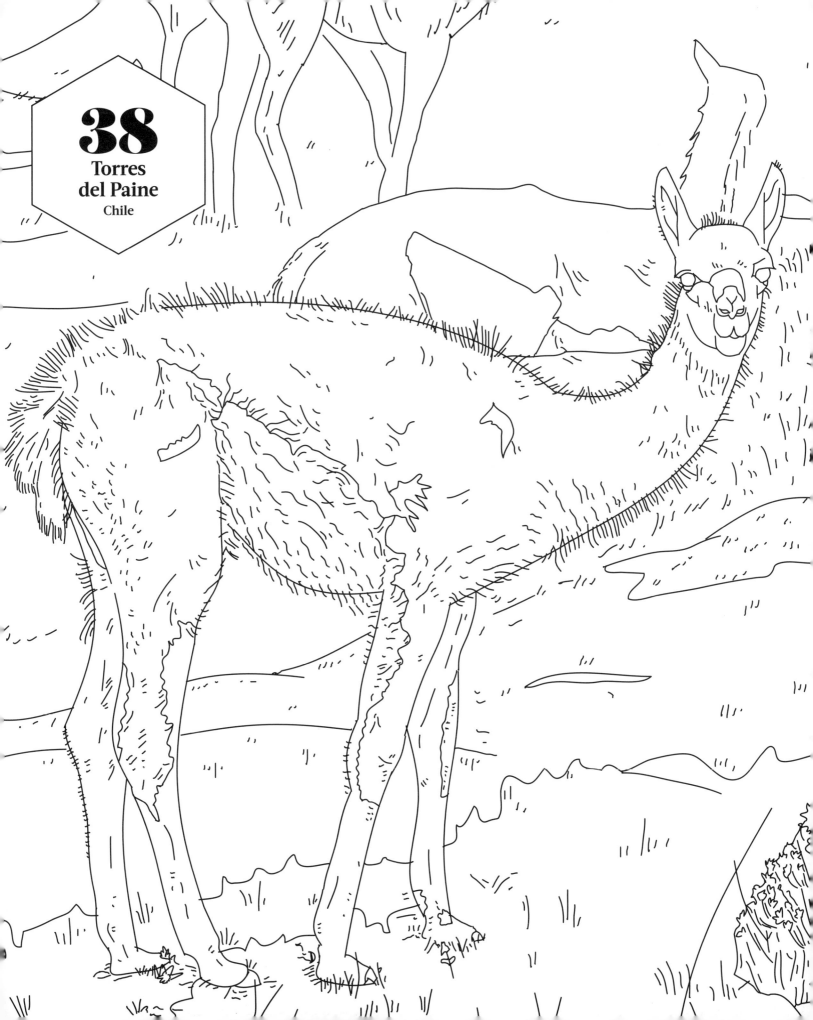

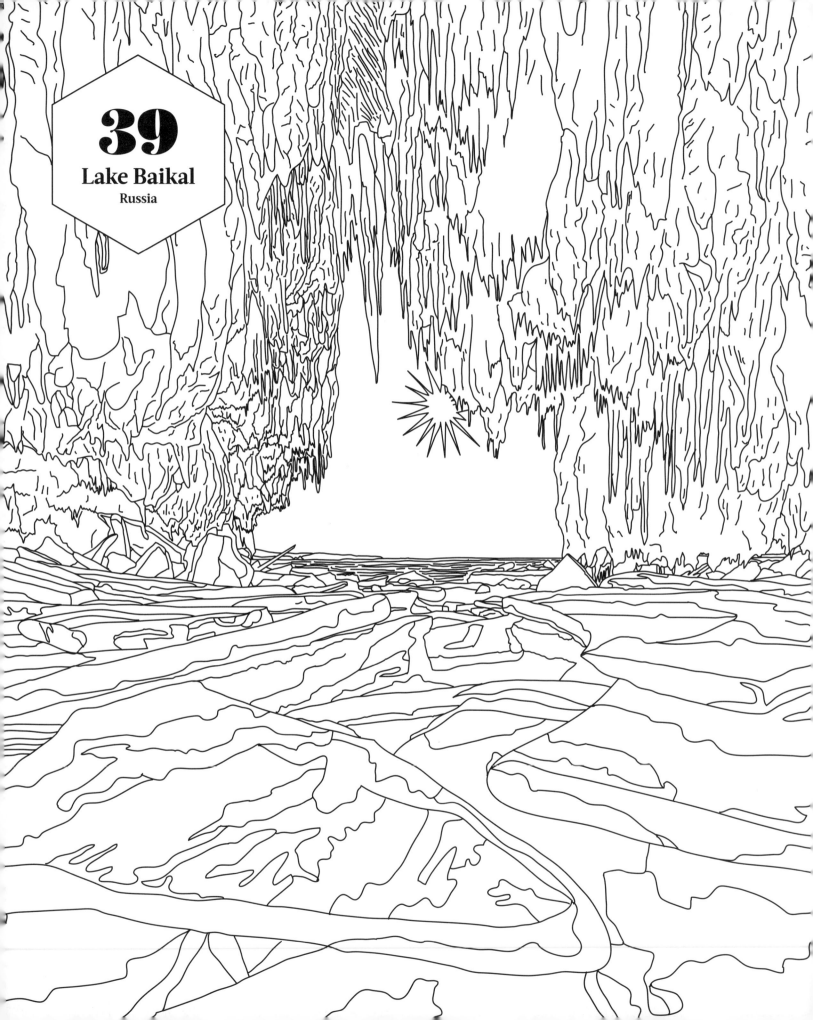

39

Lake Baikal

Russia

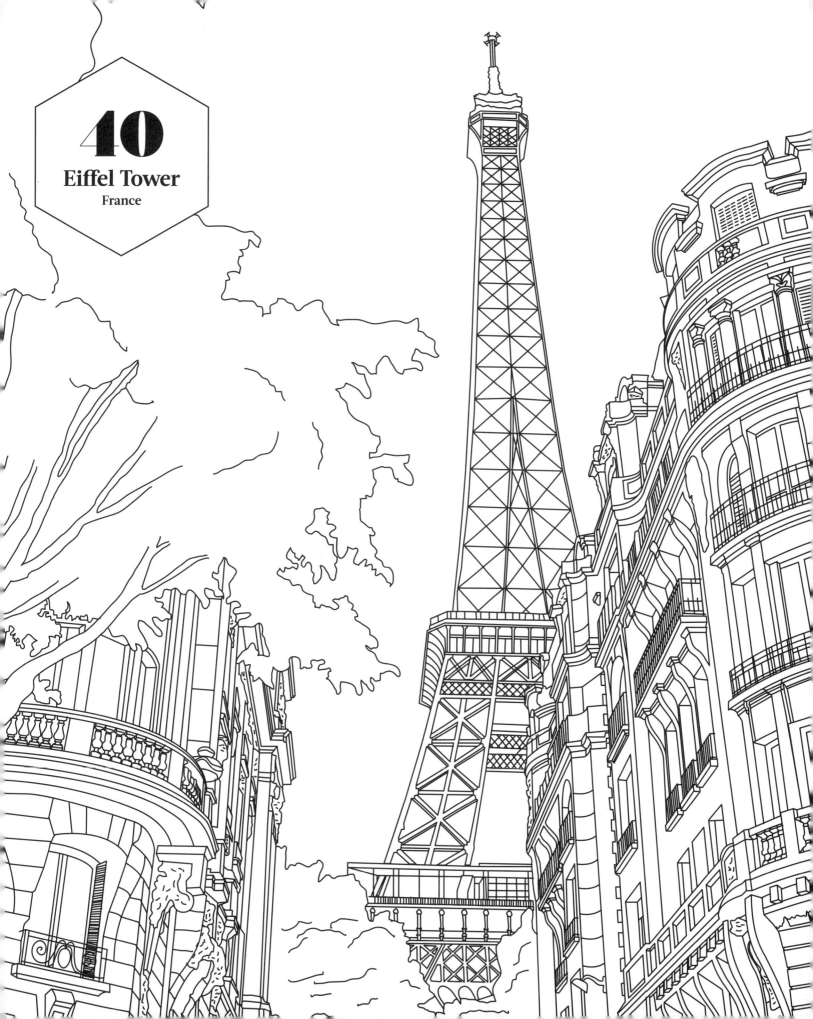

40

Eiffel Tower

France

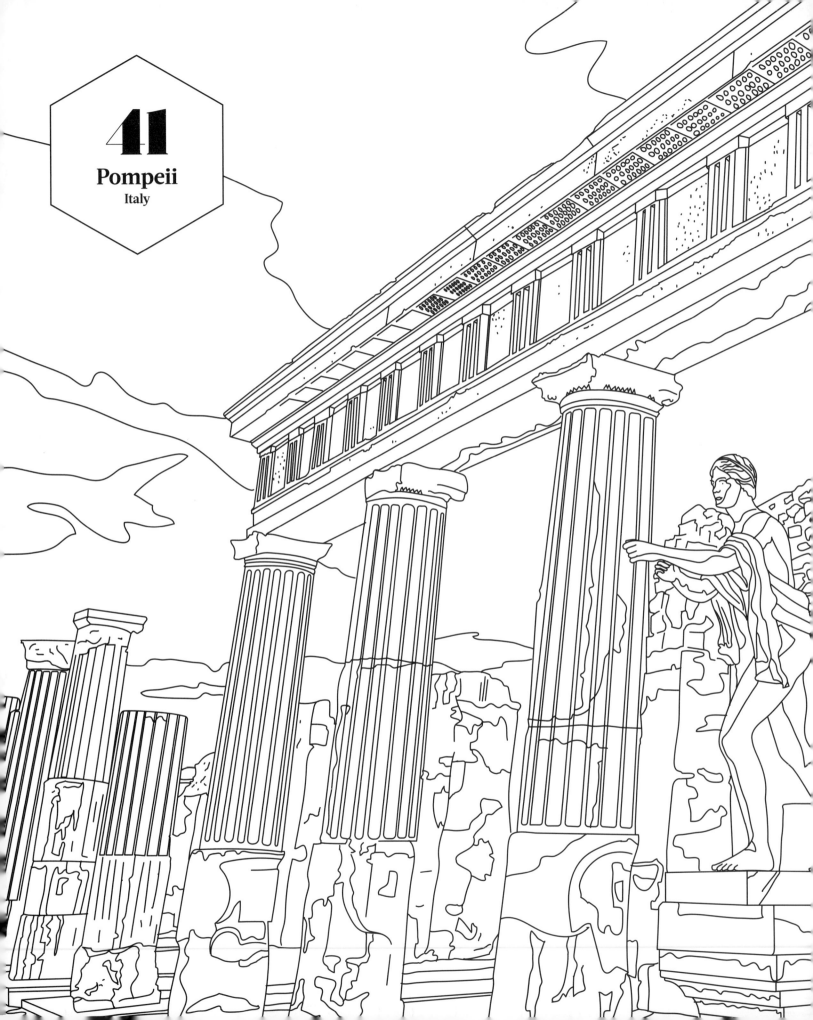

41
Pompeii
Italy

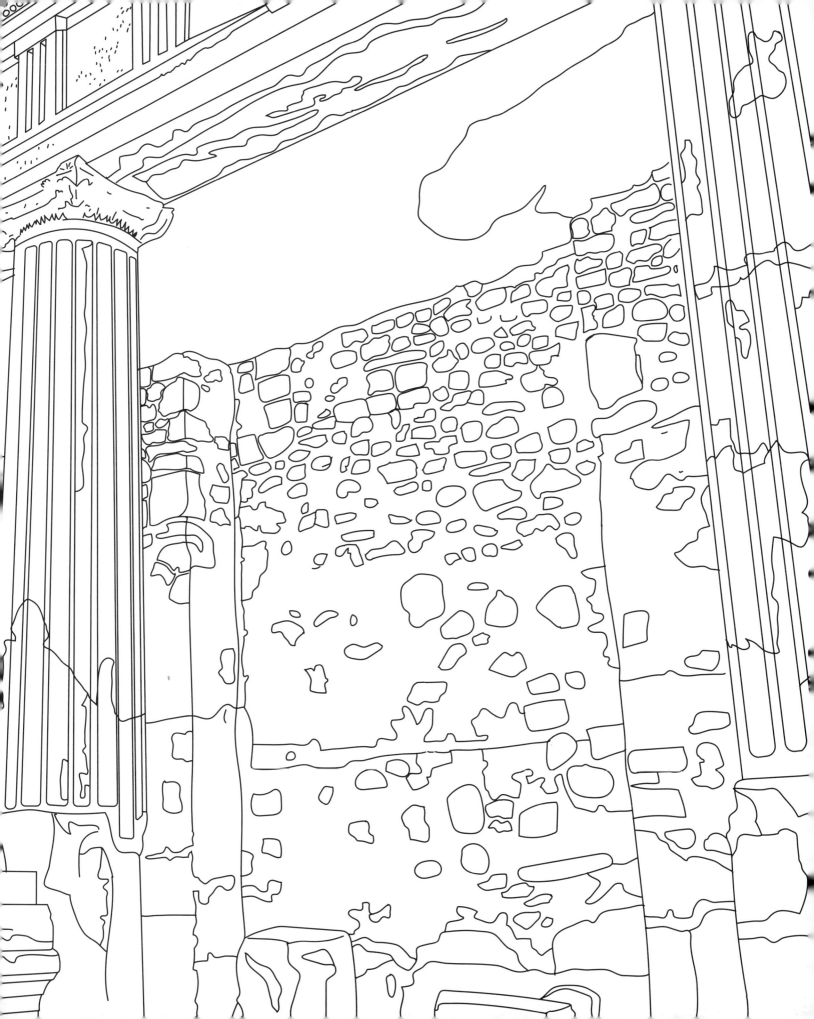

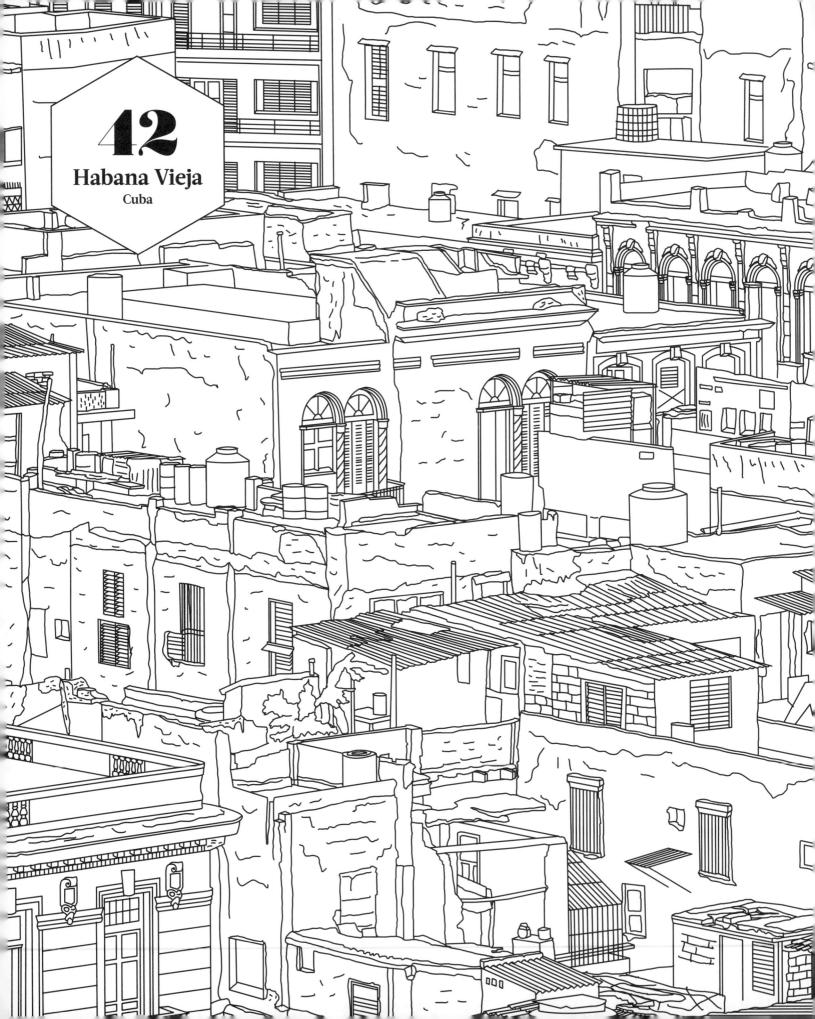

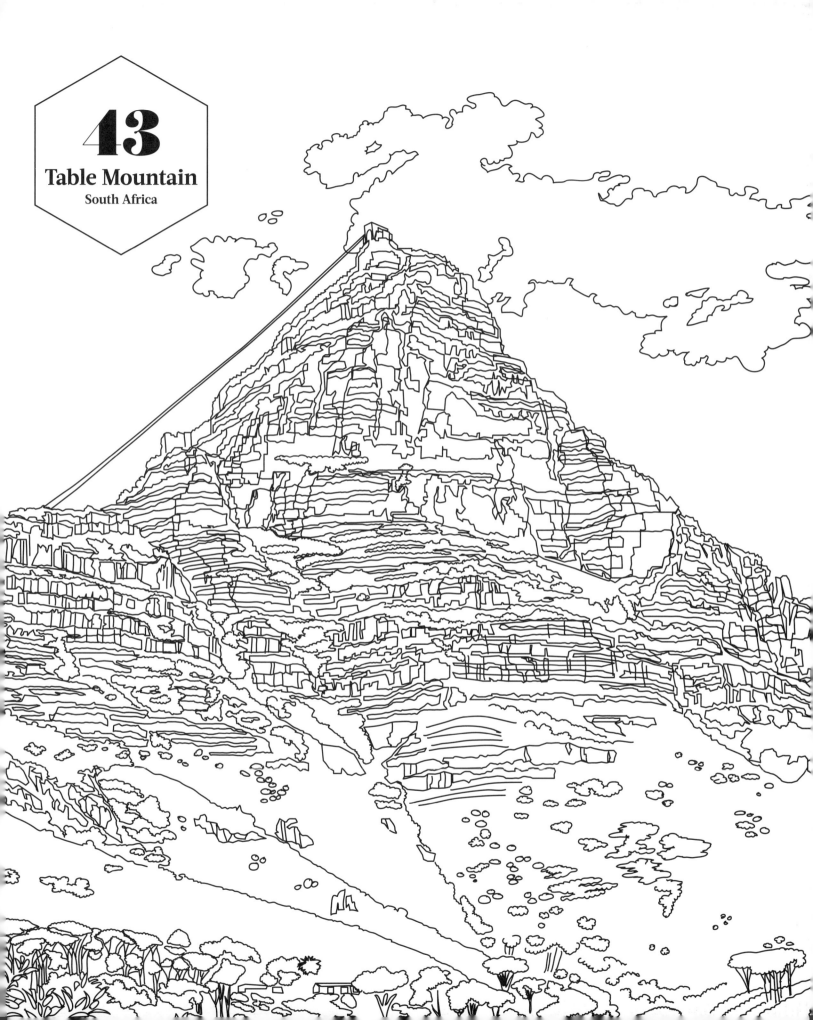

43

Table Mountain

South Africa

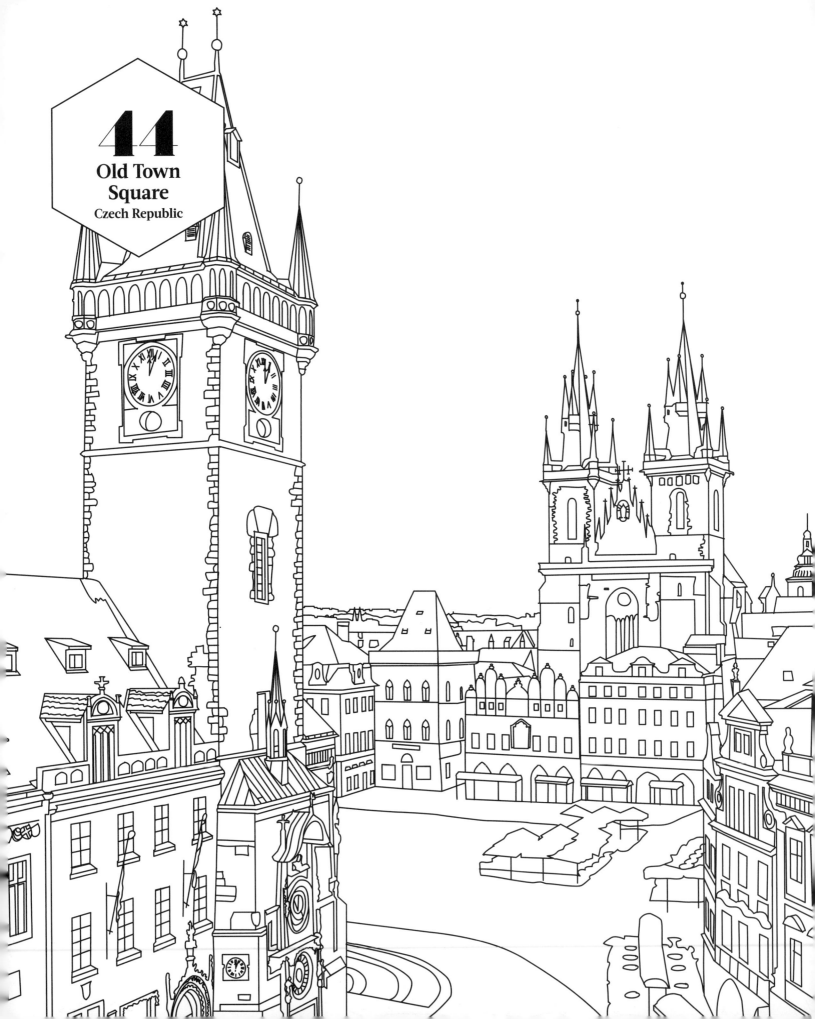

44
Old Town
Square
Czech Republic

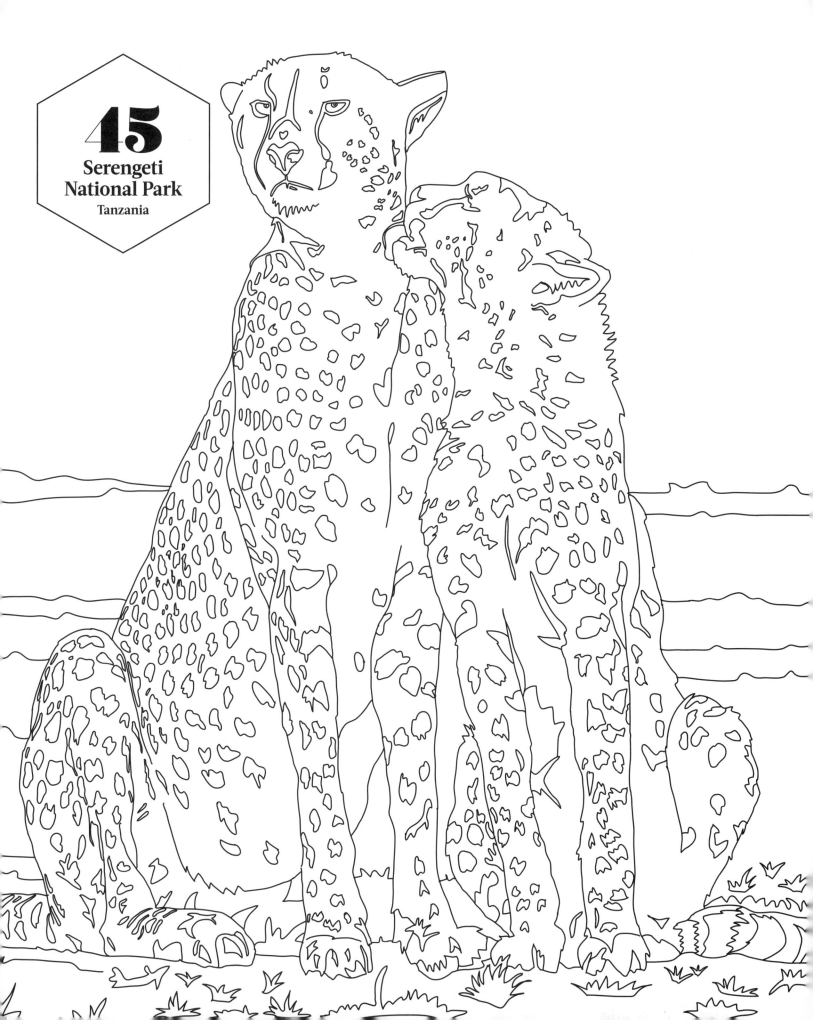

45
Serengeti
National Park
Tanzania

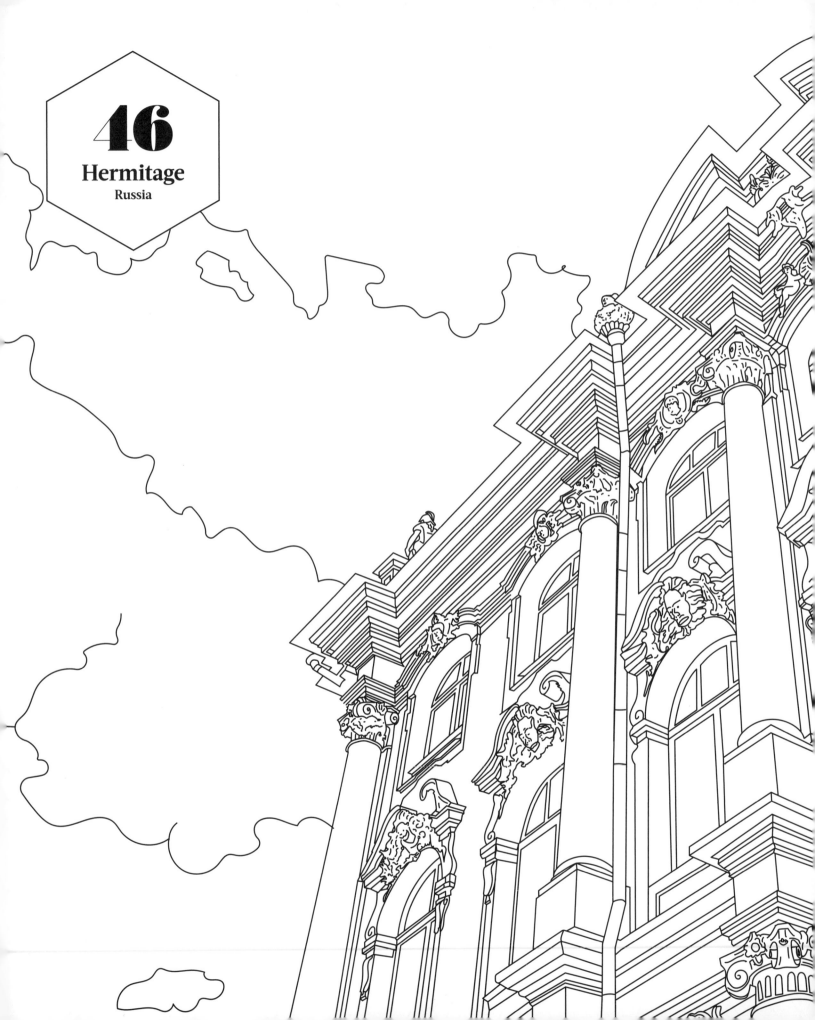

46

Hermitage
Russia

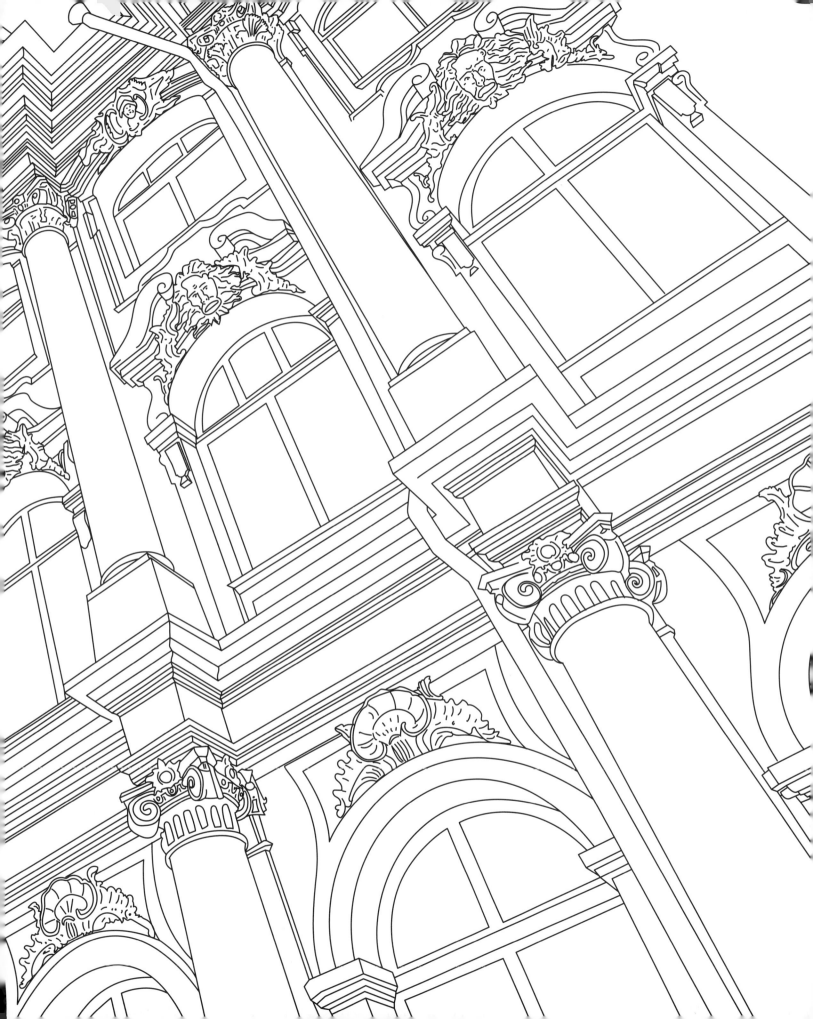

47

Bay of Kotor

Montenegro

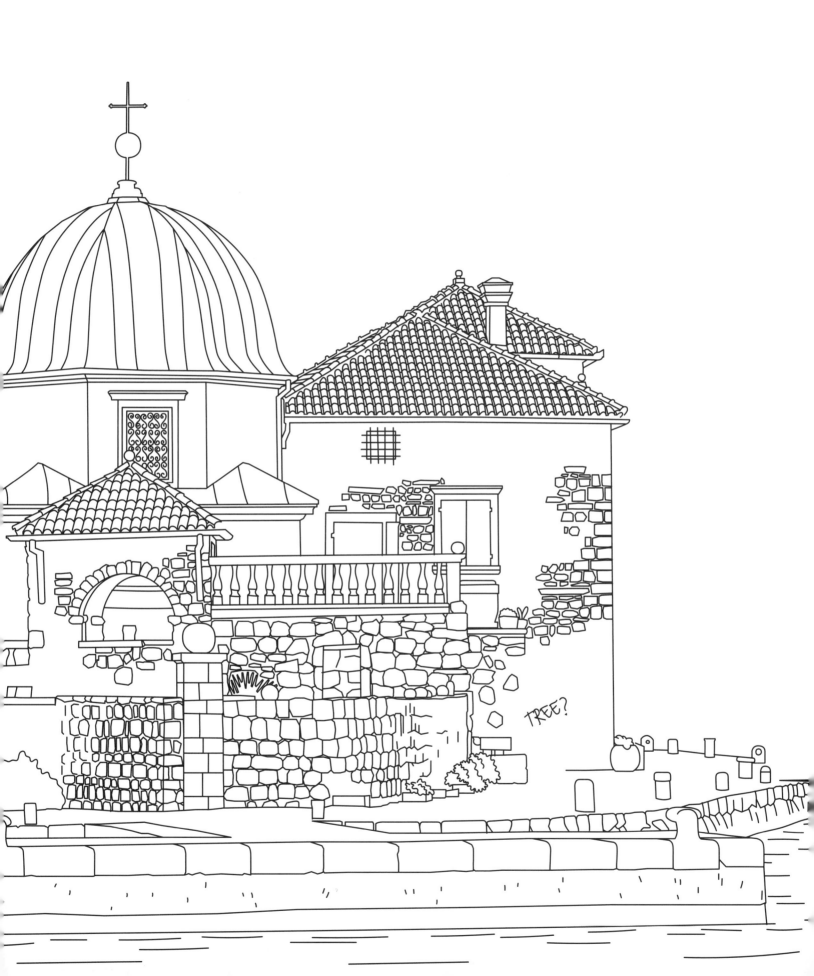

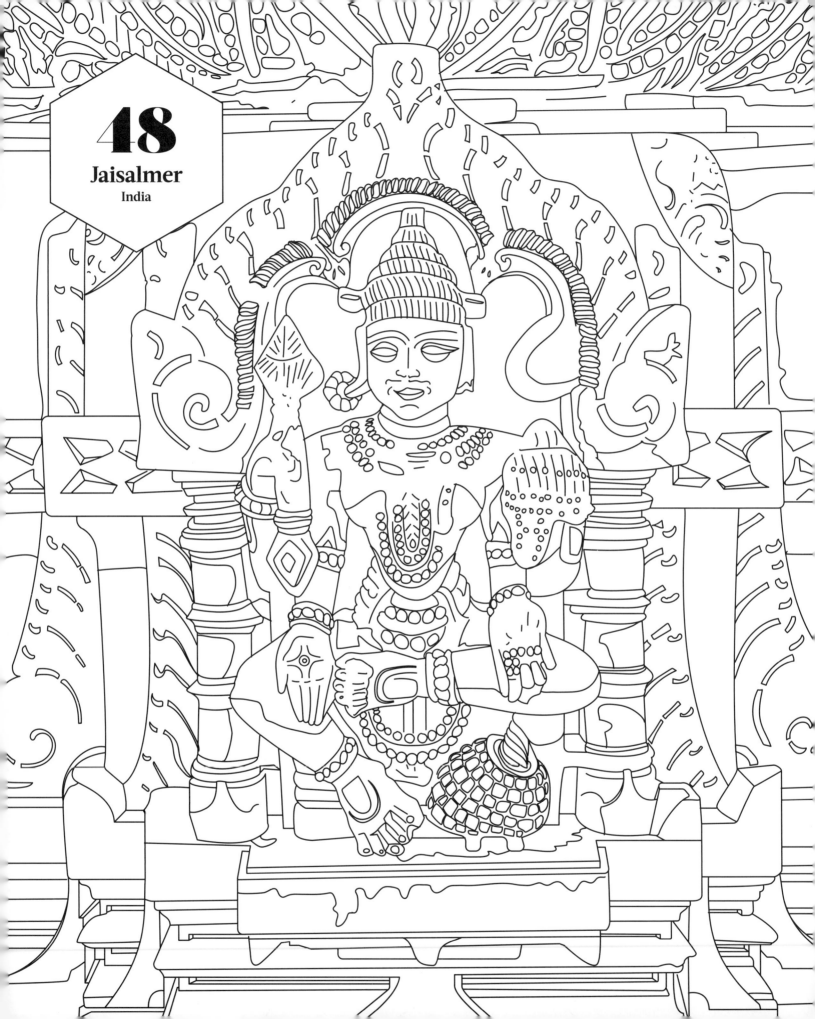

48
Jaisalmer
India

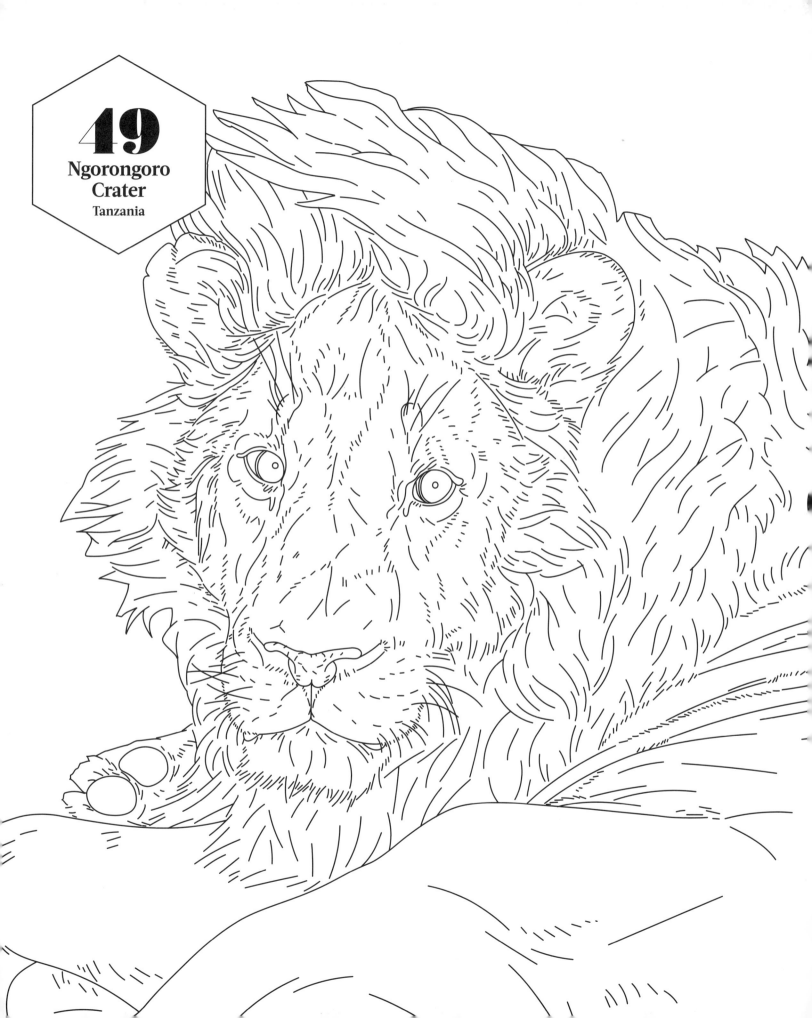

49

Ngorongoro
Crater

Tanzania

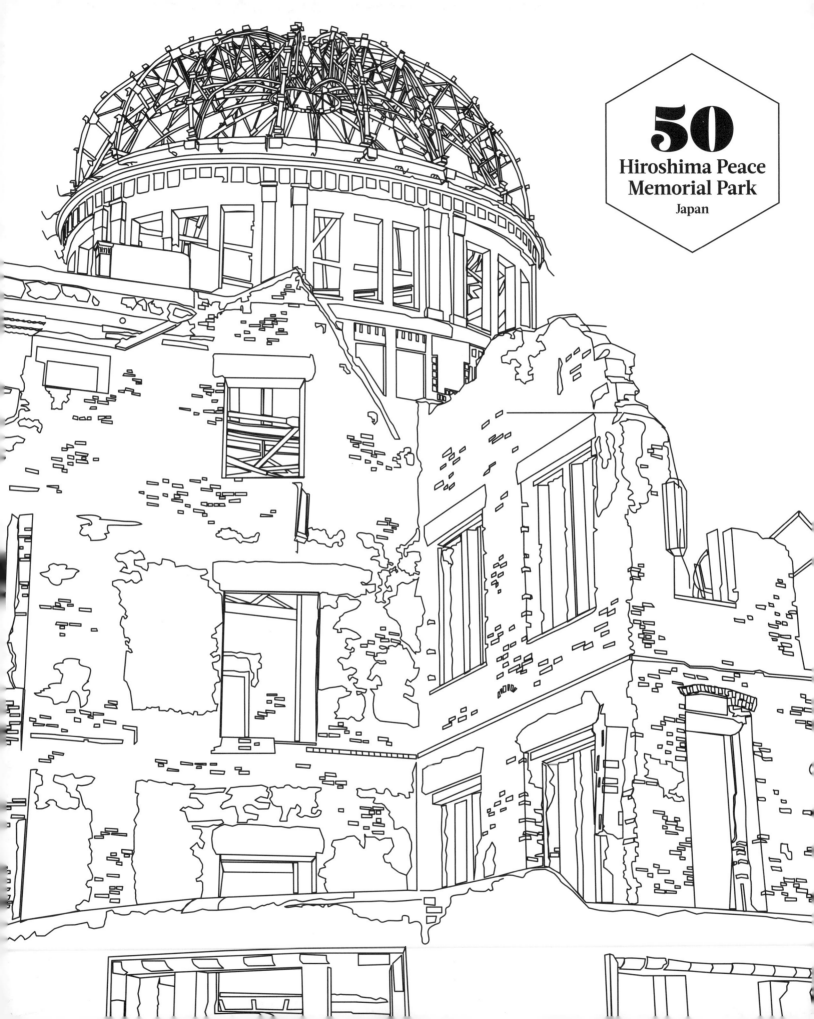

50

Hiroshima Peace
Memorial Park

Japan

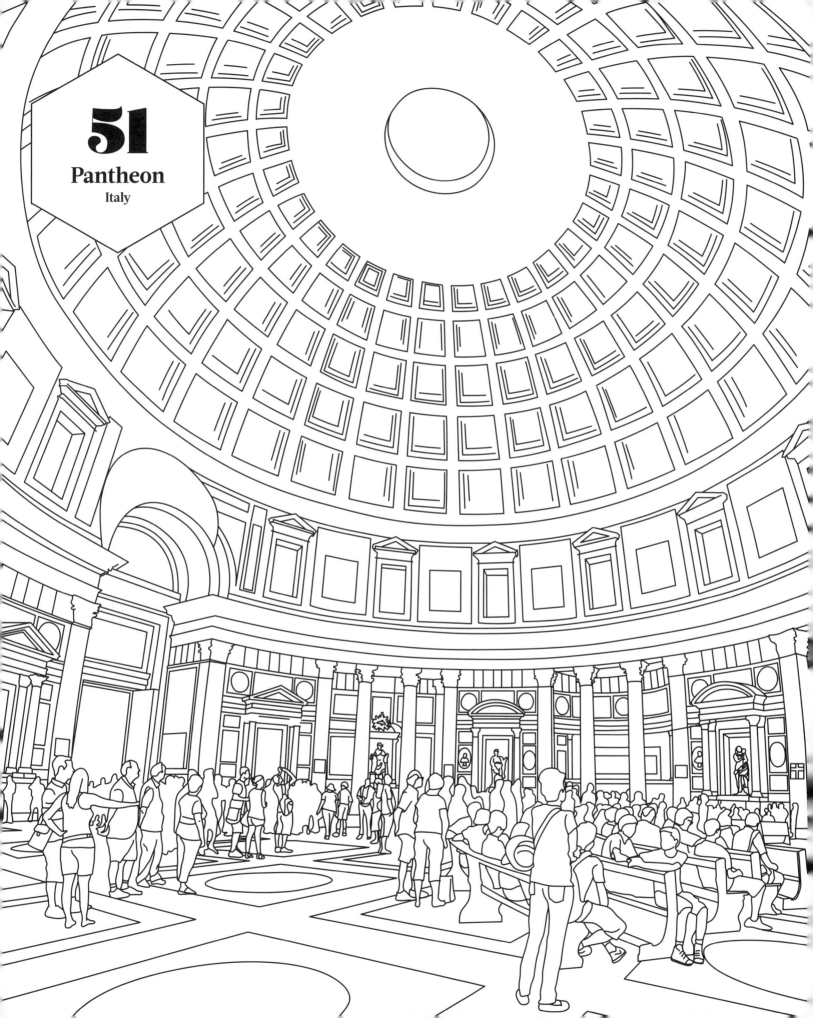

51

Pantheon

Italy

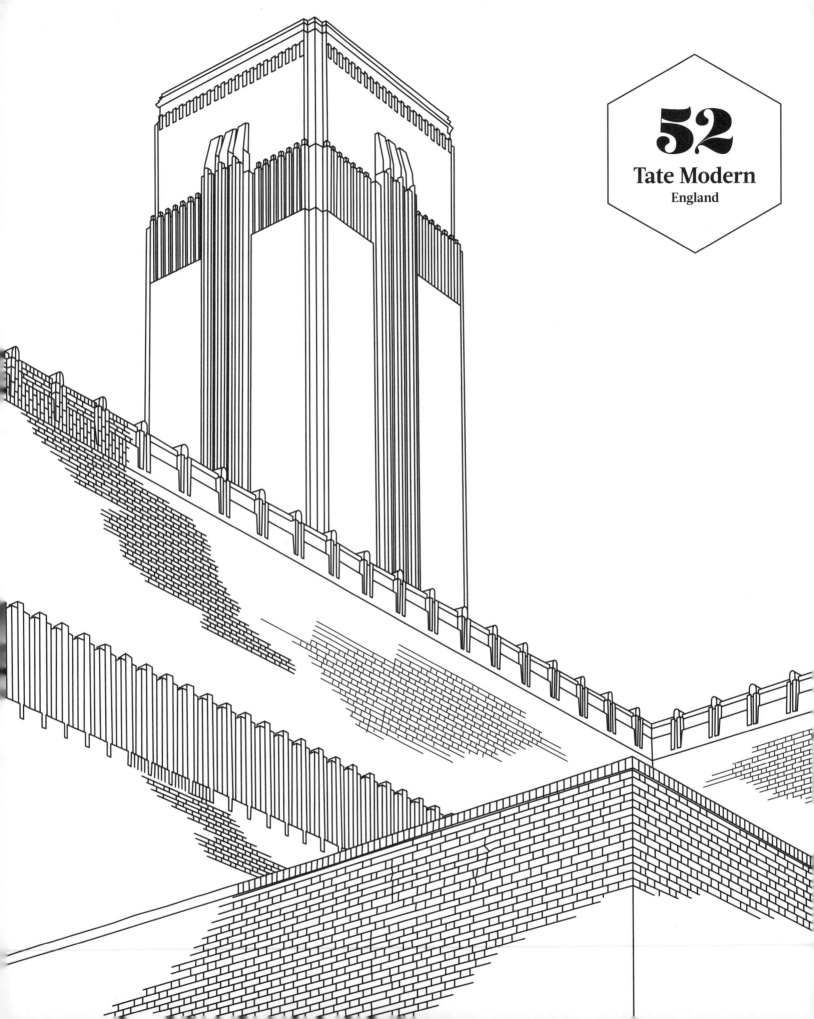

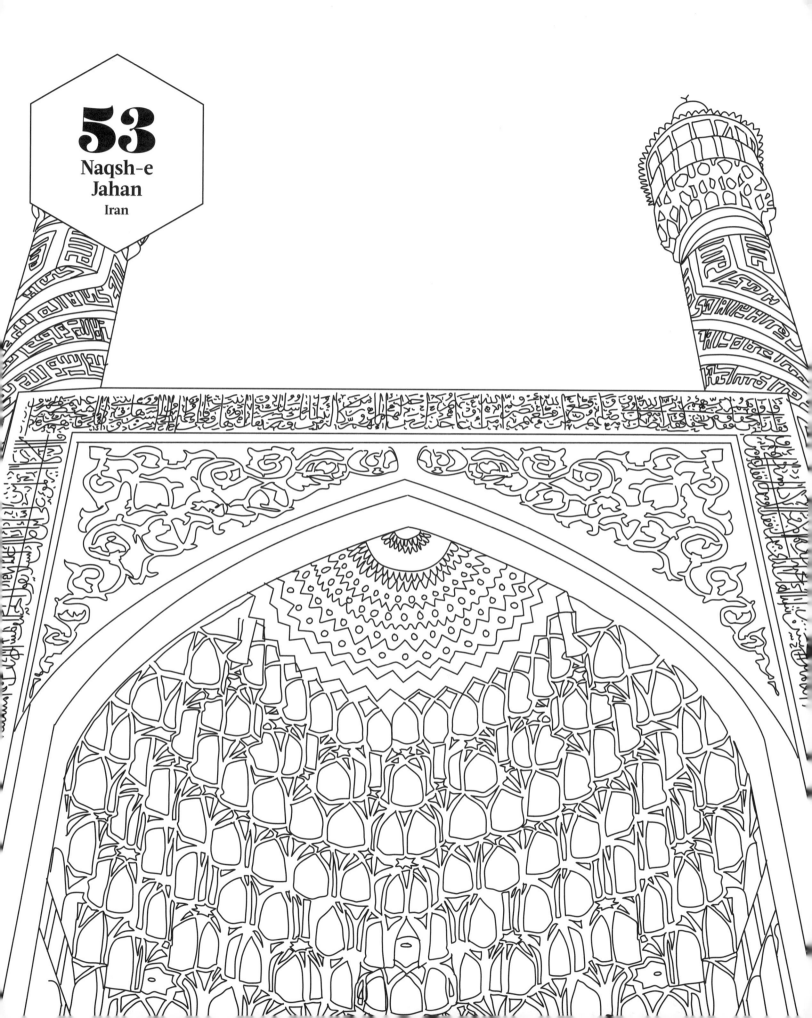

53

Naqsh-e
Jahan

Iran

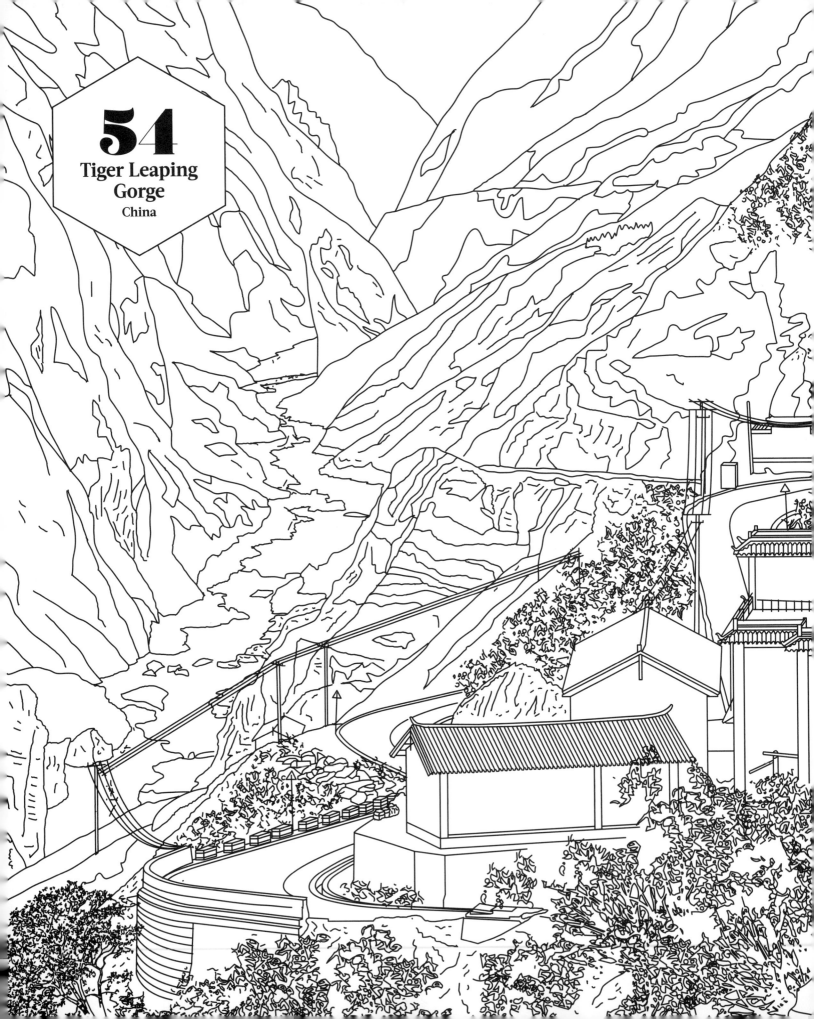

54
Tiger Leaping Gorge
China

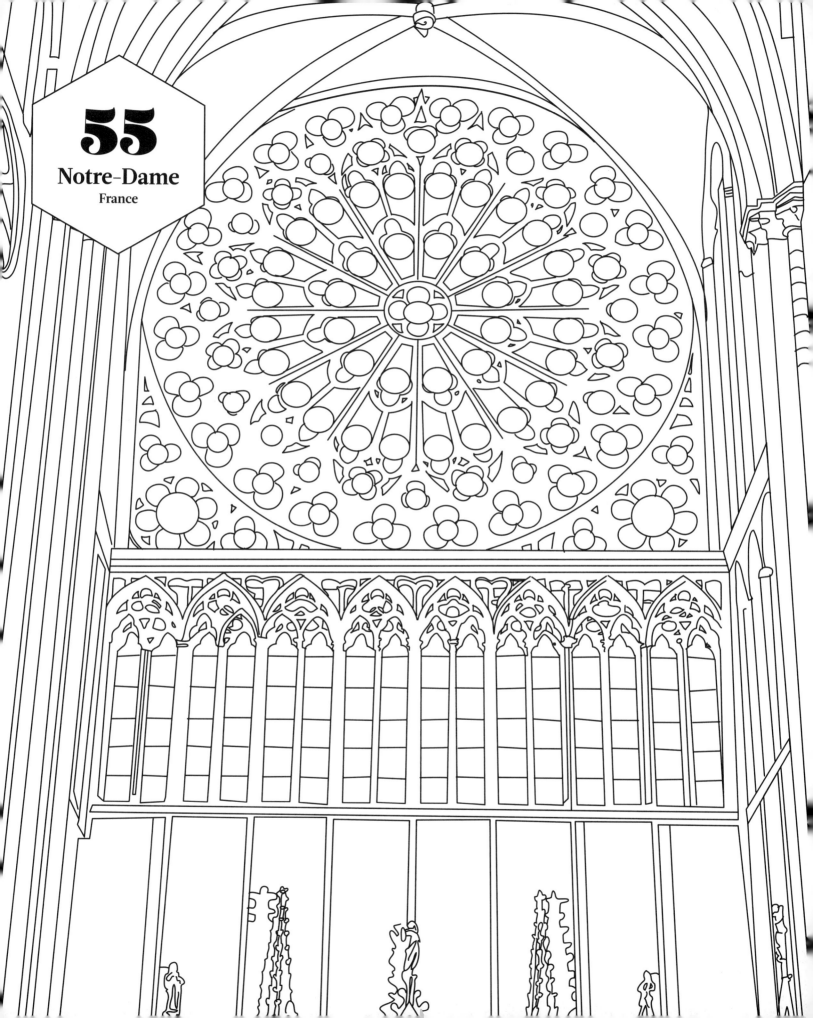

55
Notre-Dame
France

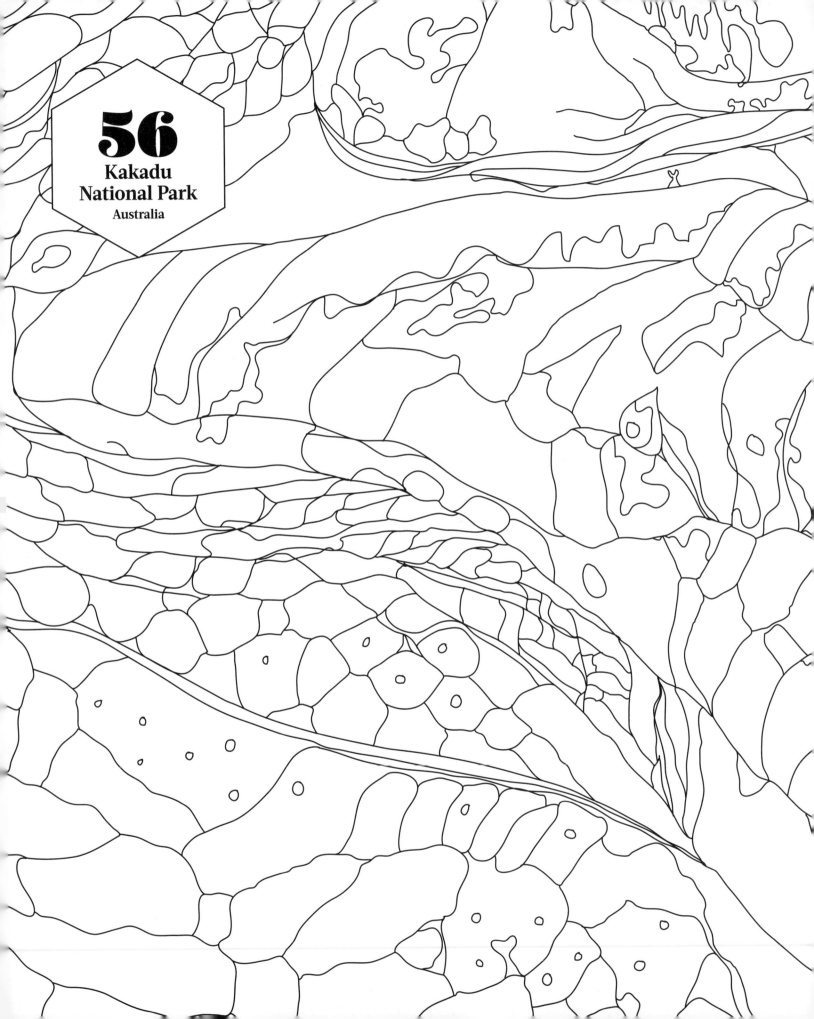

56

Kakadu
National Park

Australia

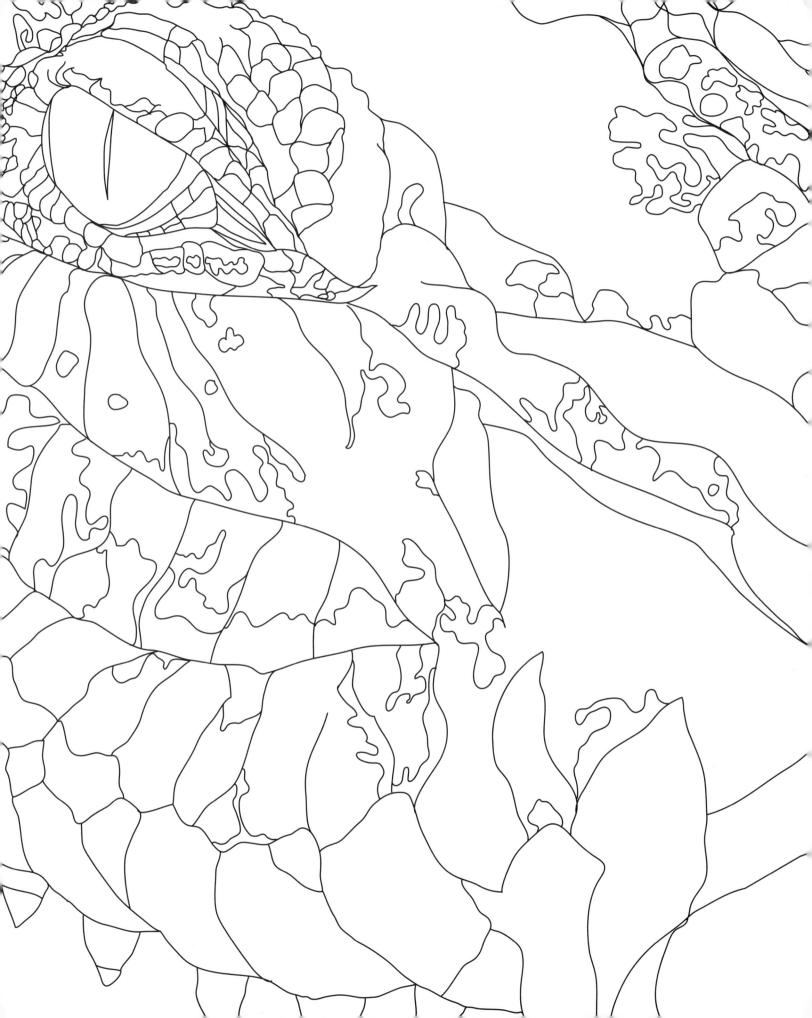

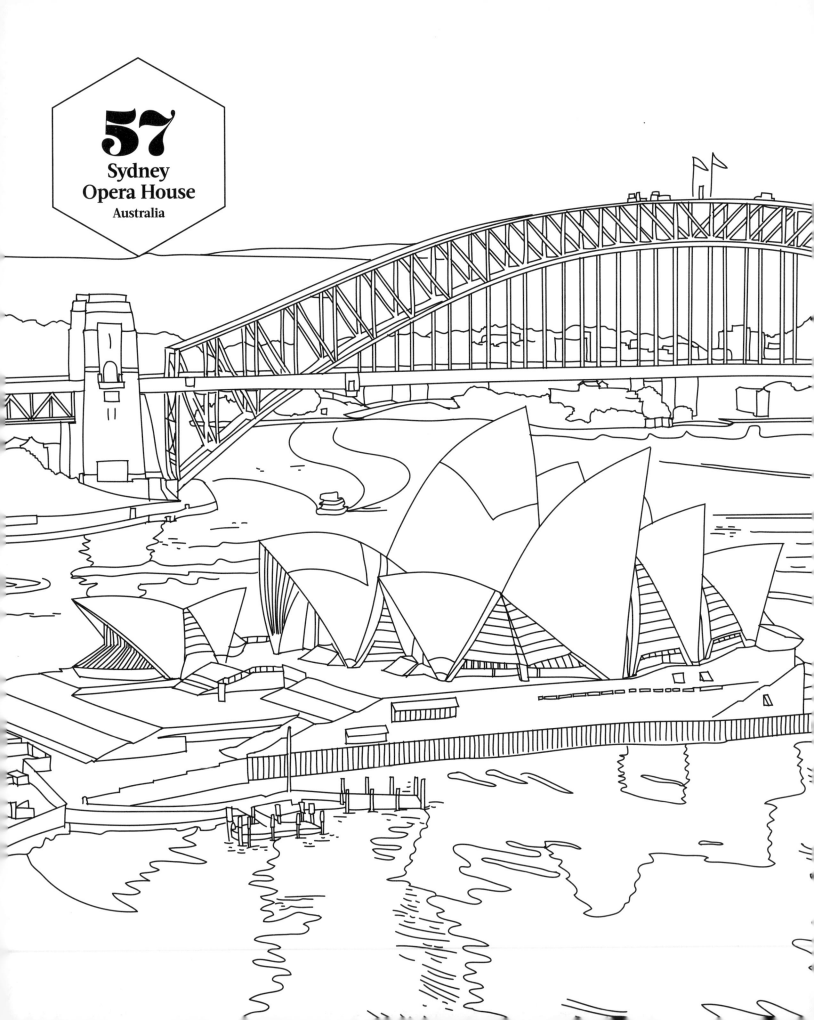

57
Sydney
Opera House
Australia

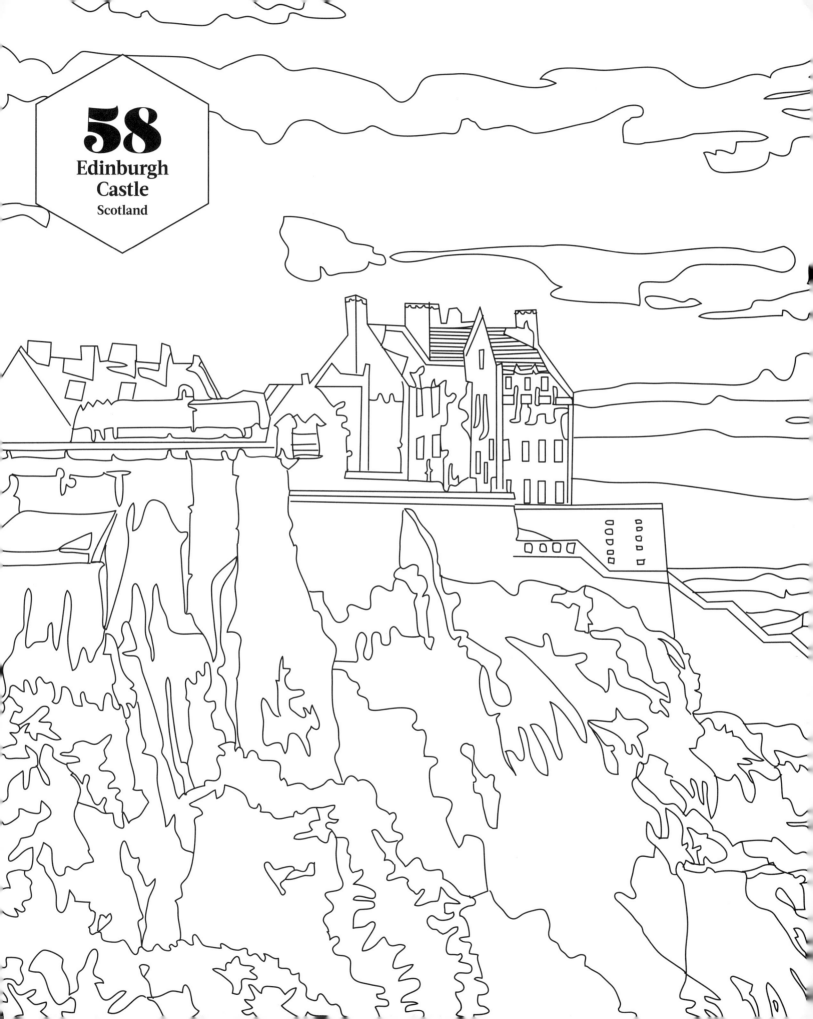

58

Edinburgh
Castle

Scotland

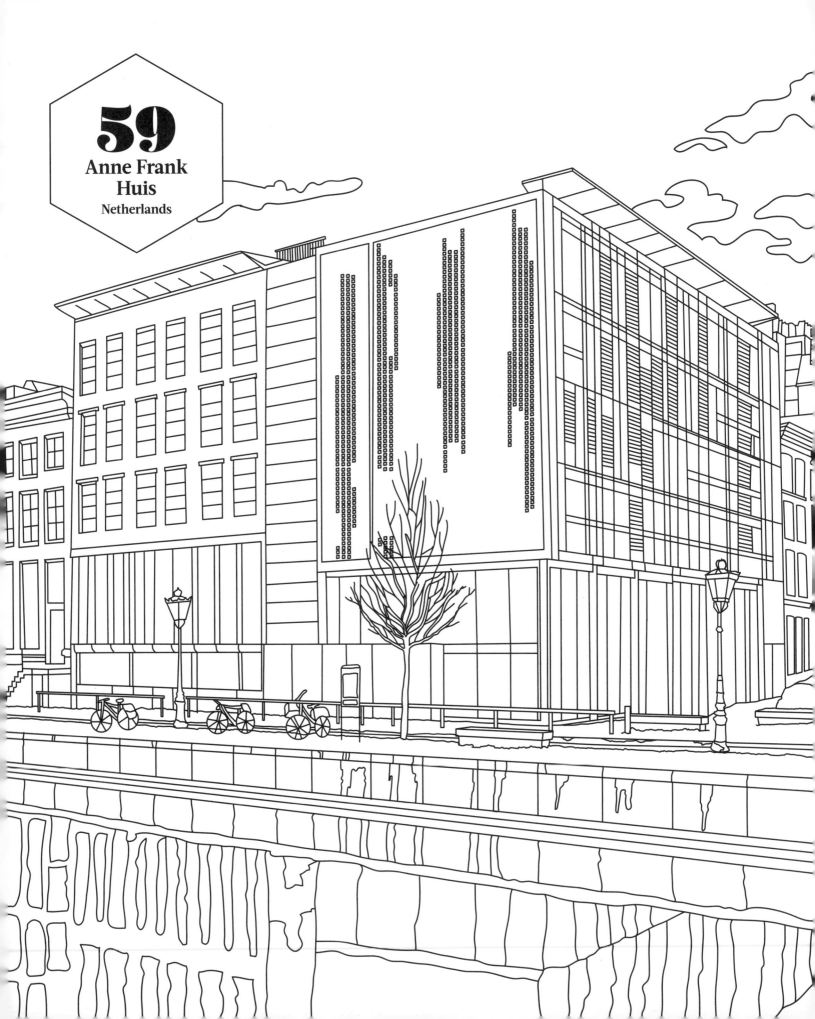

59
Anne Frank Huis
Netherlands

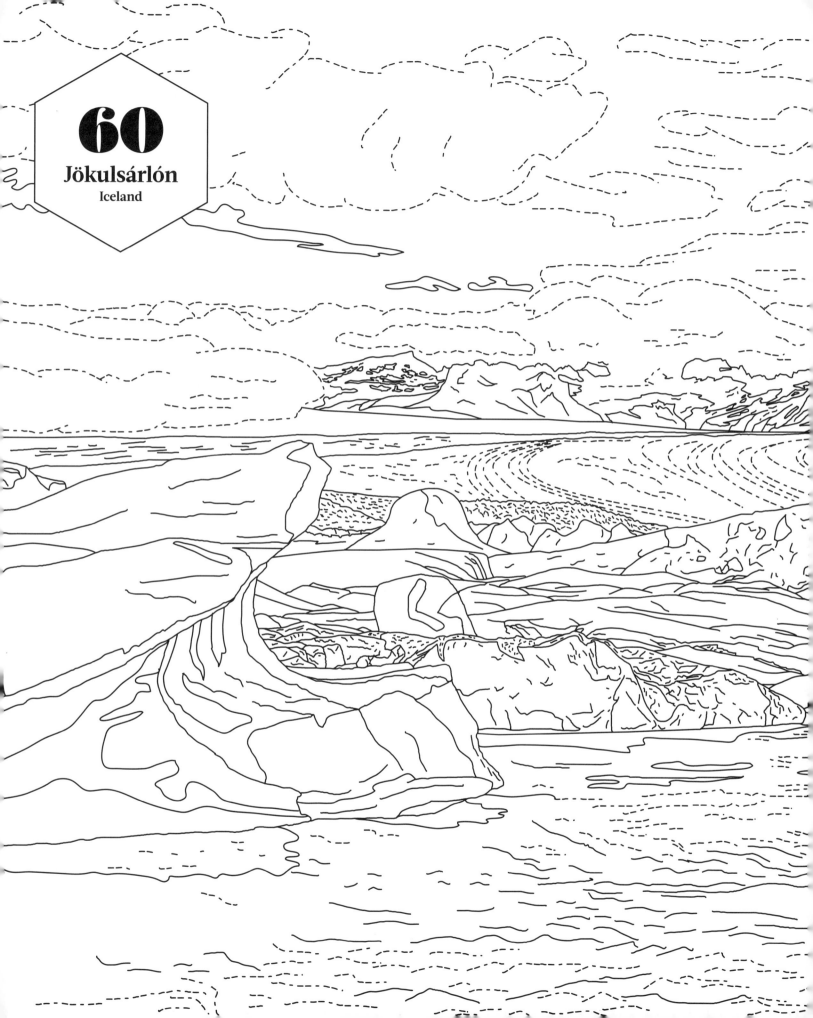

60

Jökulsárlón

Iceland

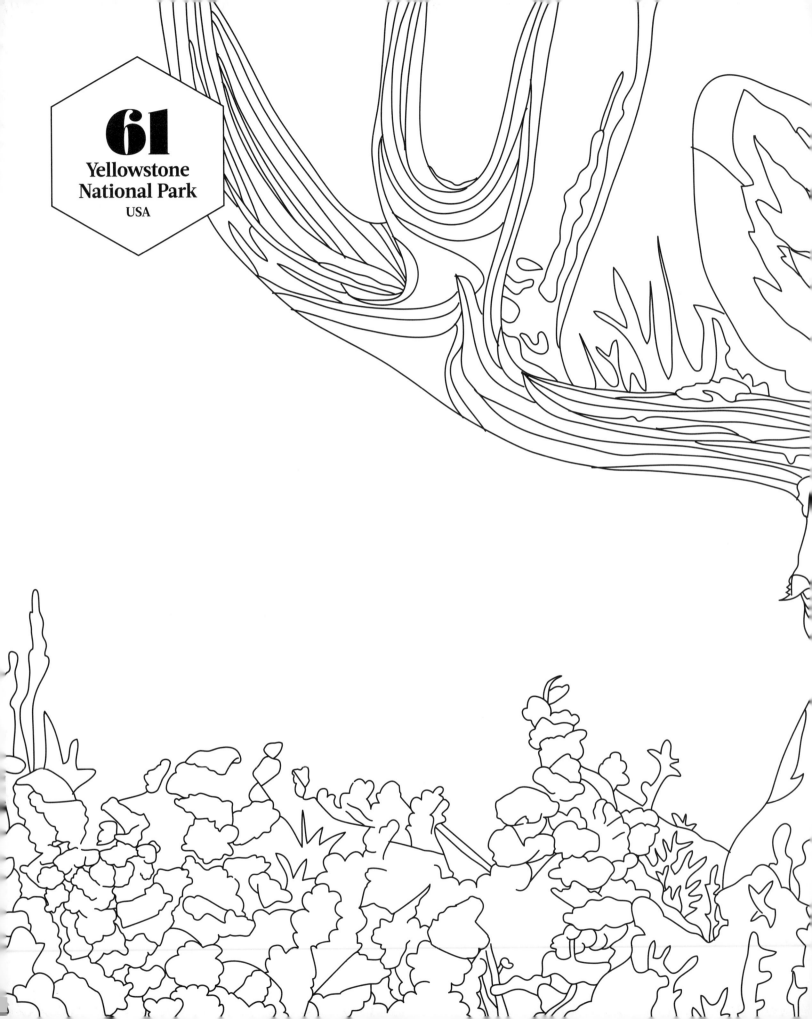

61

Yellowstone
National Park
USA

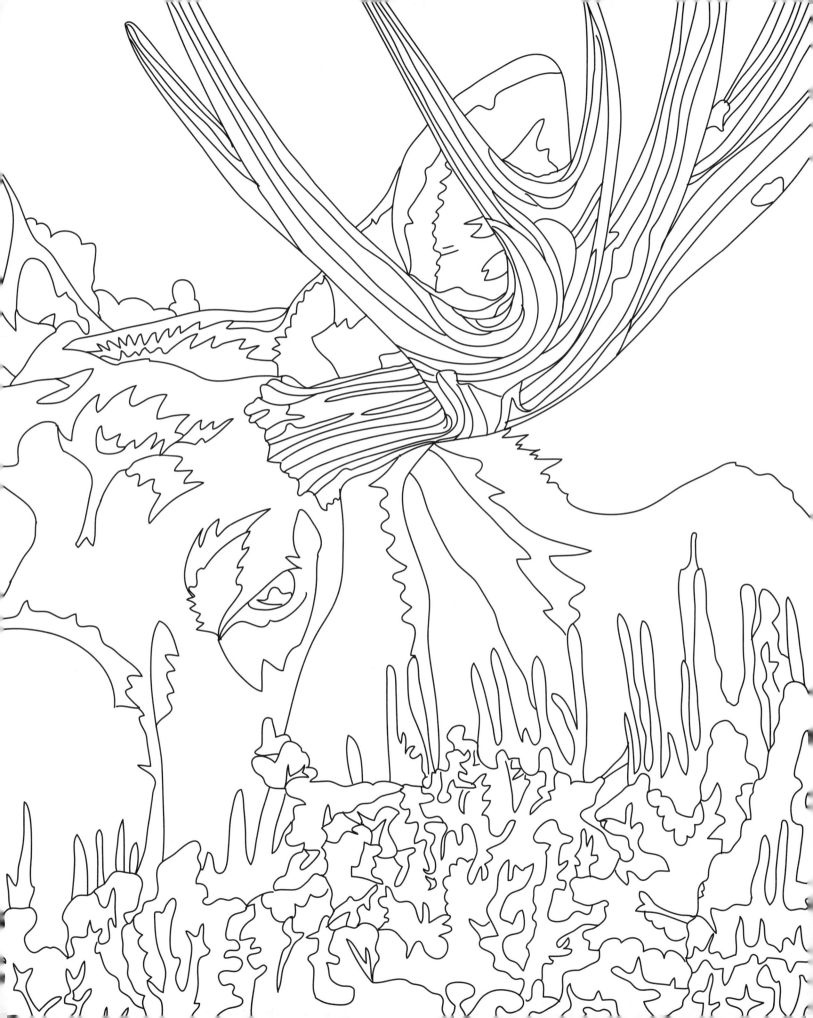

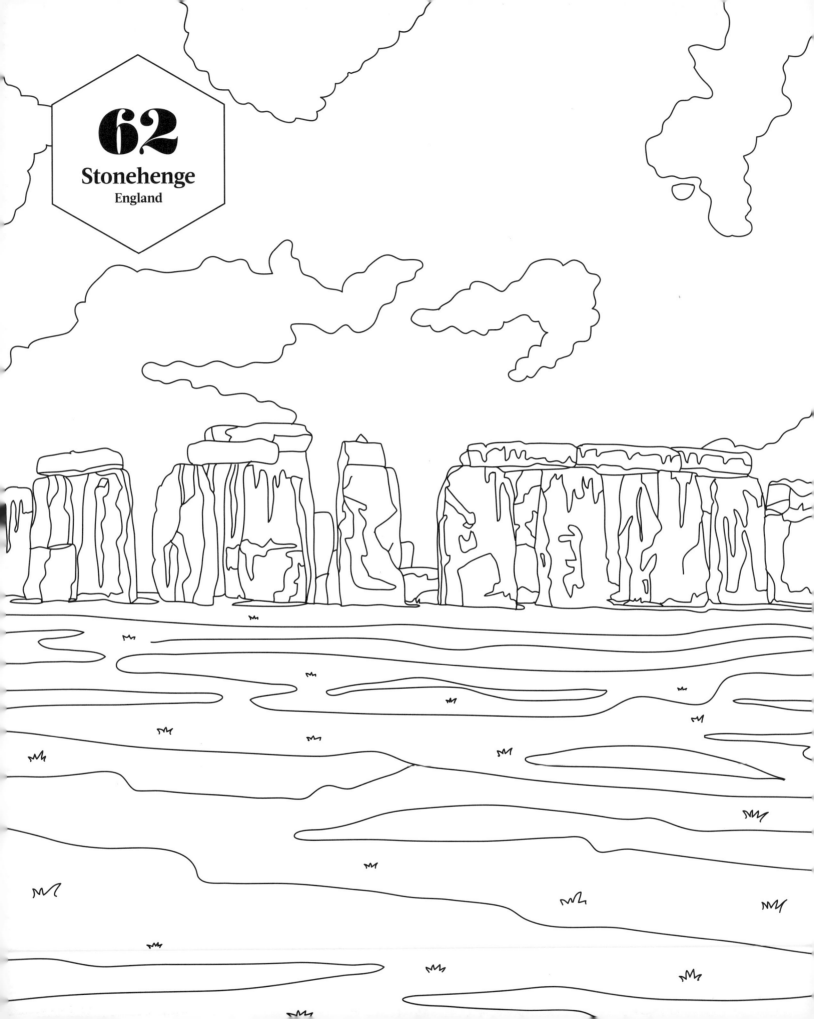

62

Stonehenge

England

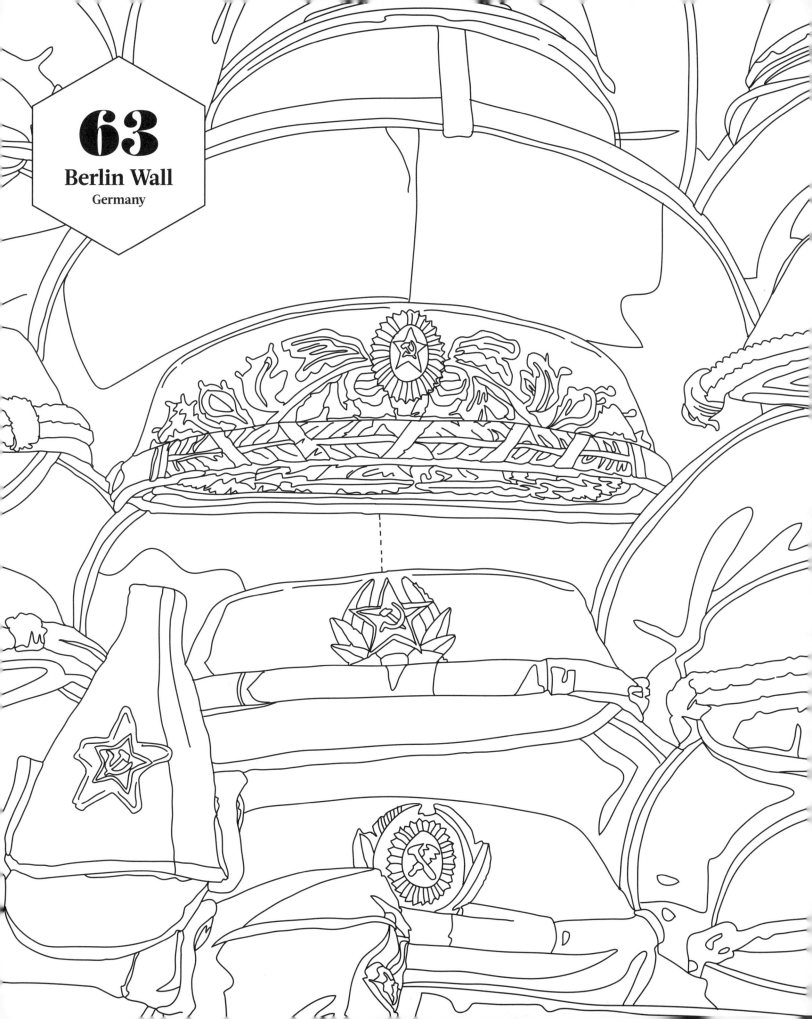

63

Berlin Wall

Germany

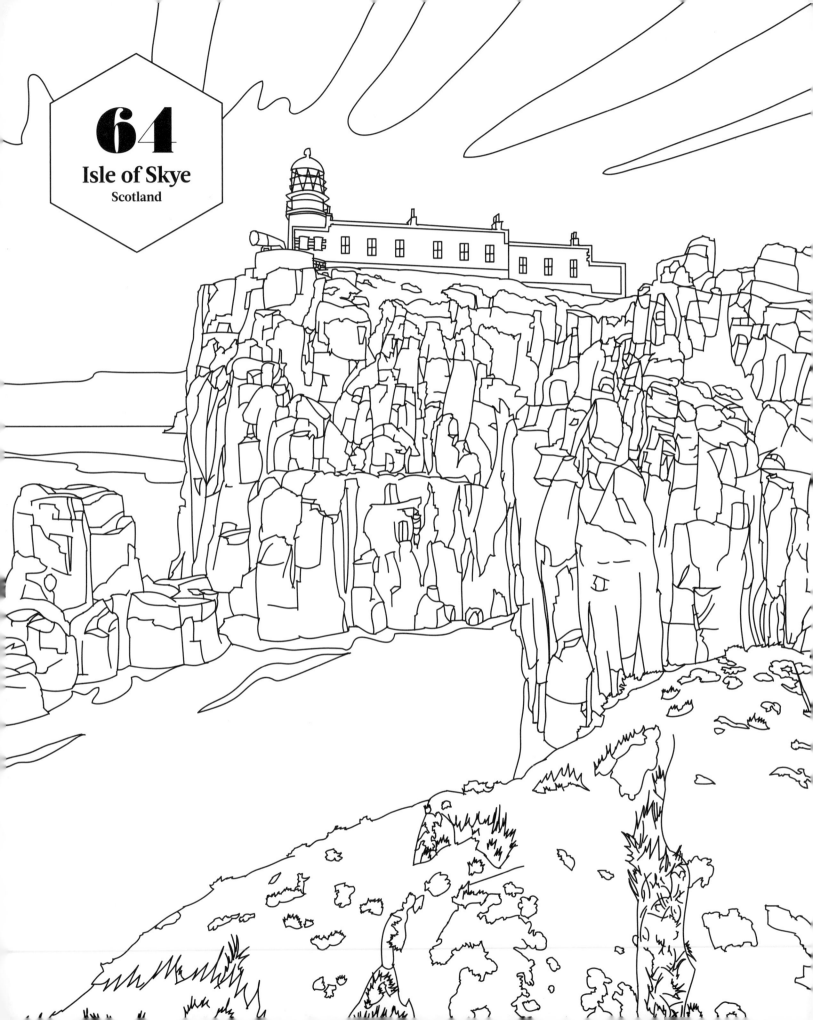

64

Isle of Skye
Scotland

65

Halong Bay

Vietnam

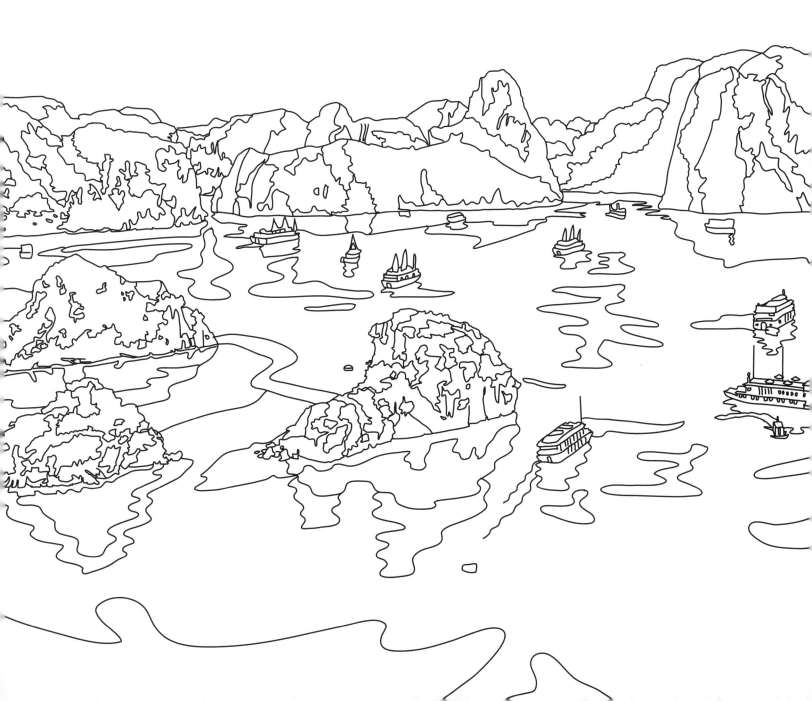

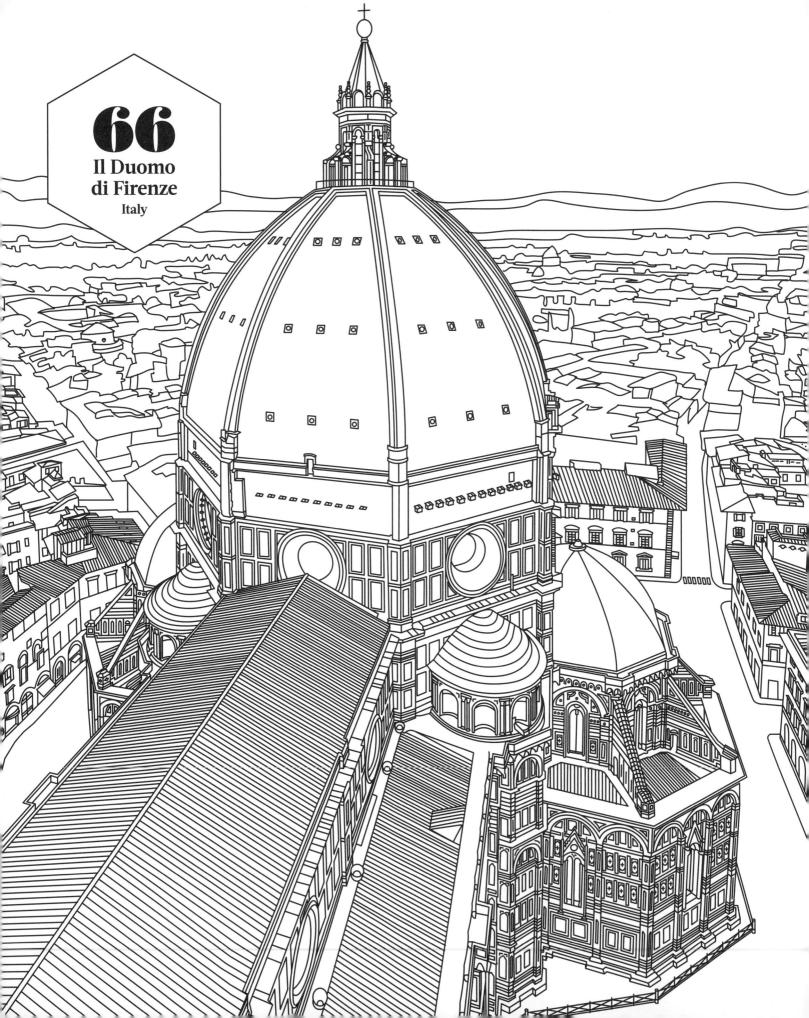

66
Il Duomo
di Firenze
Italy

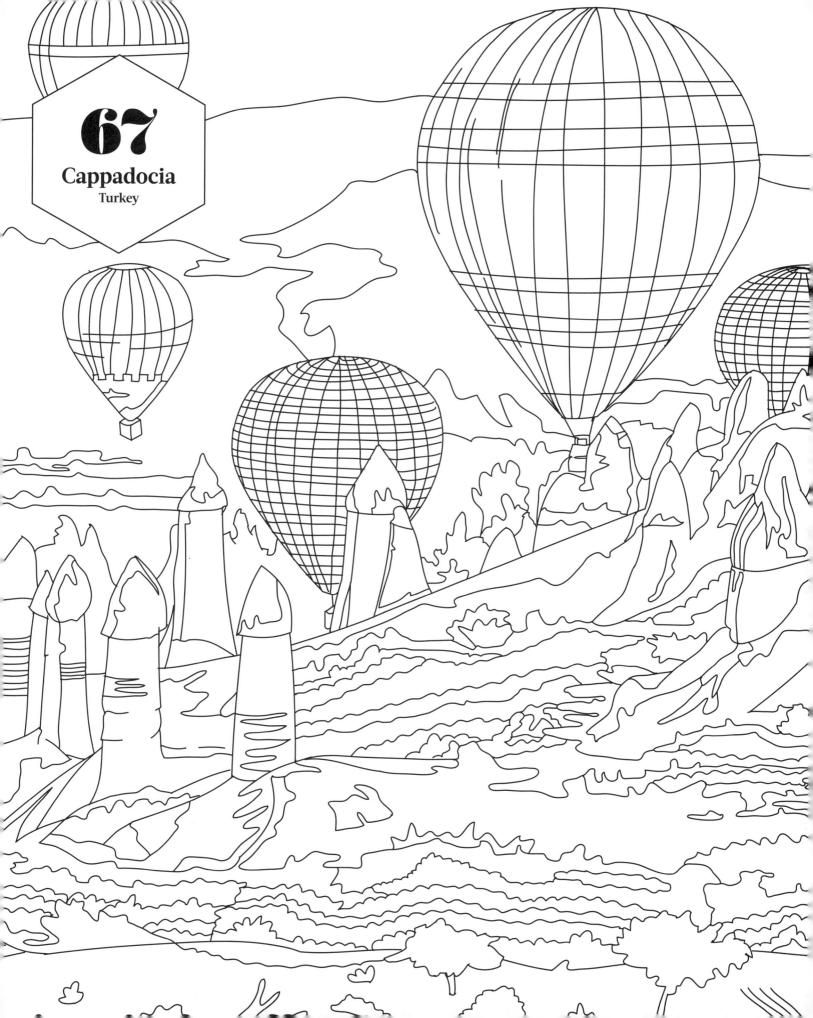

67

Cappadocia

Turkey

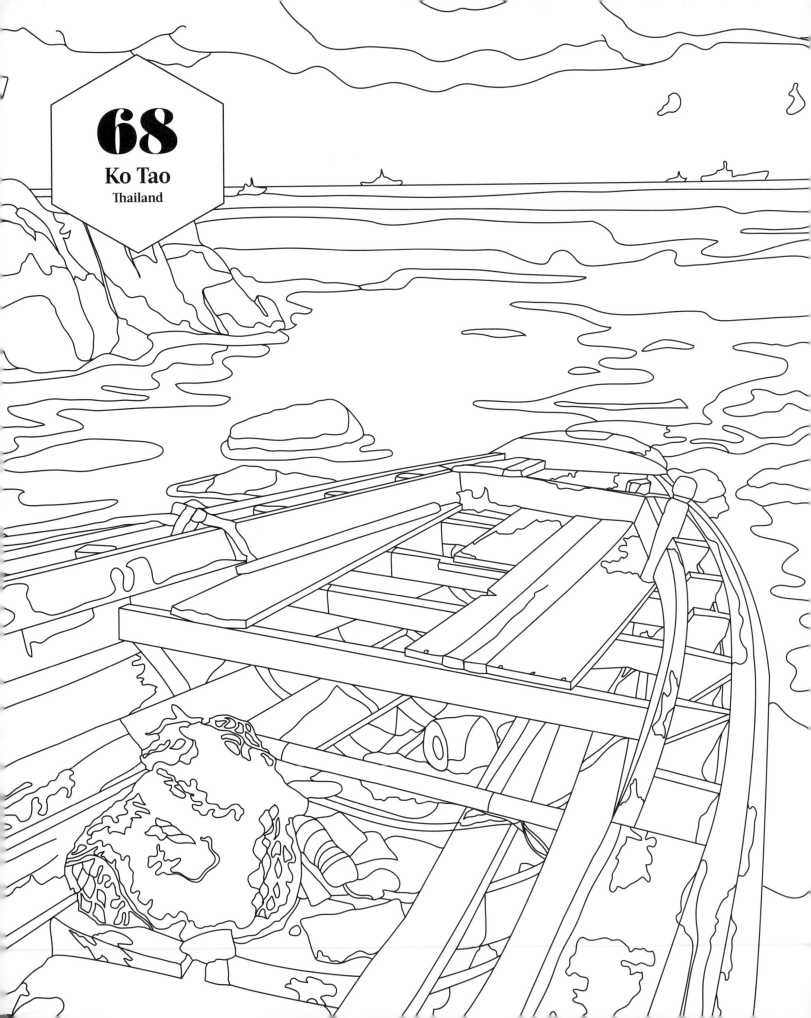

68

Ko Tao

Thailand

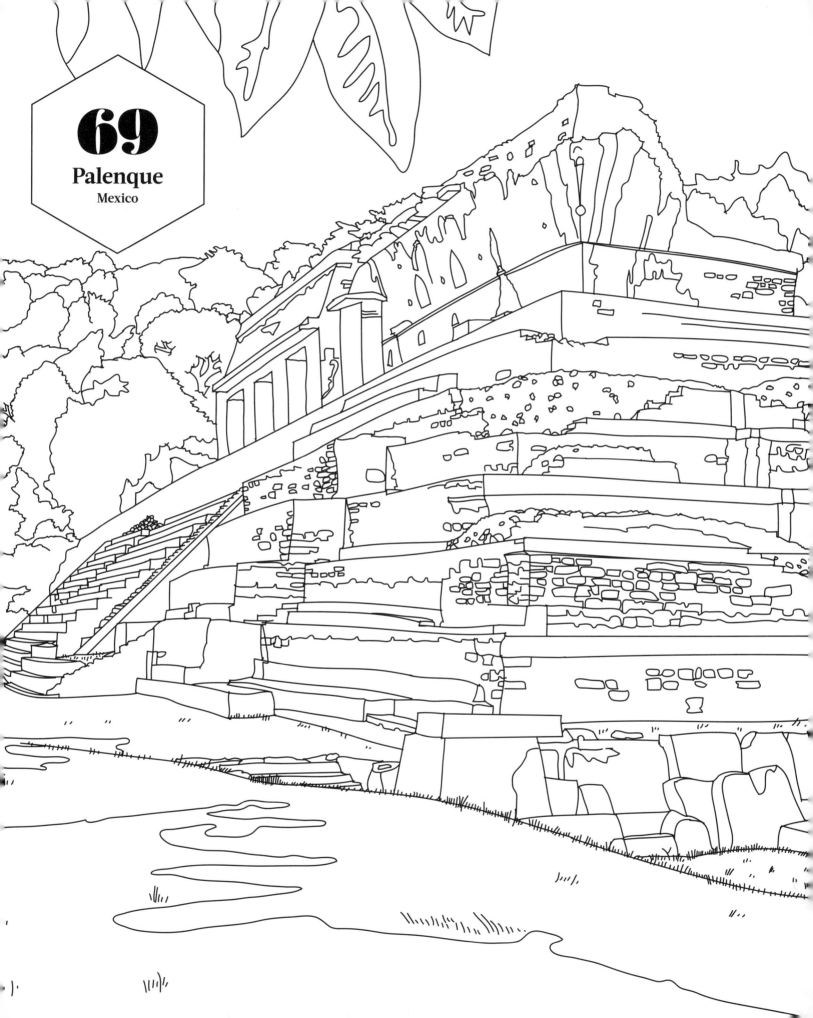

69

Palenque

Mexico

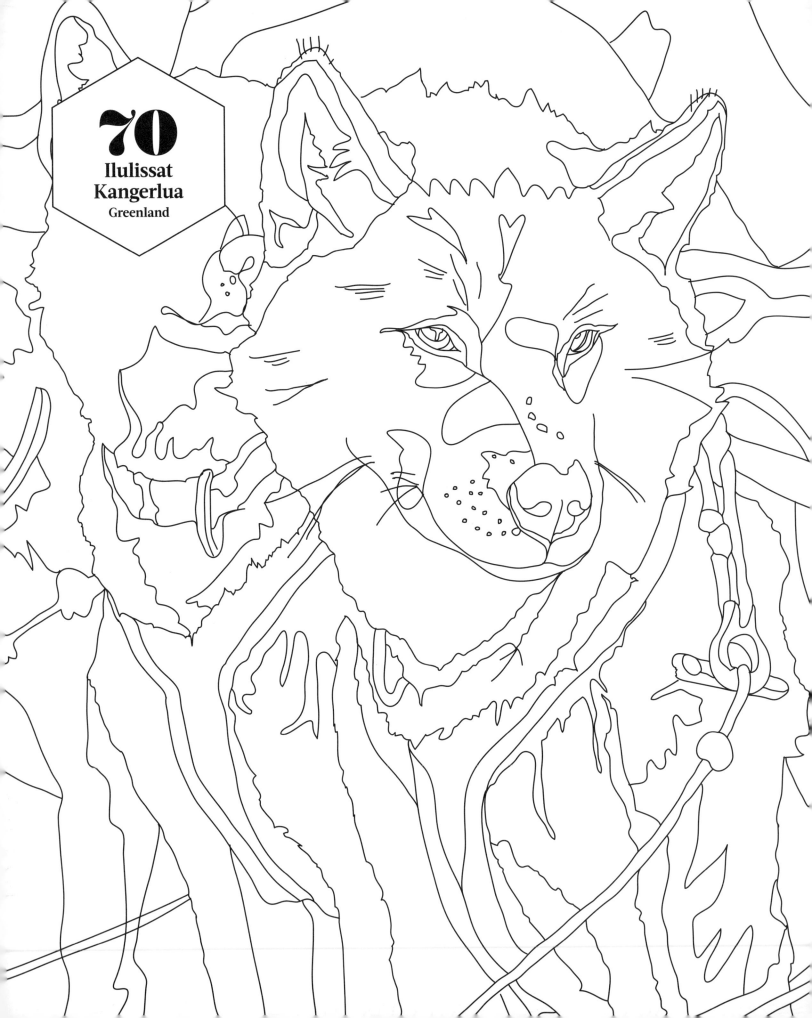

70
Ilulissat
Kangerlua

Greenland

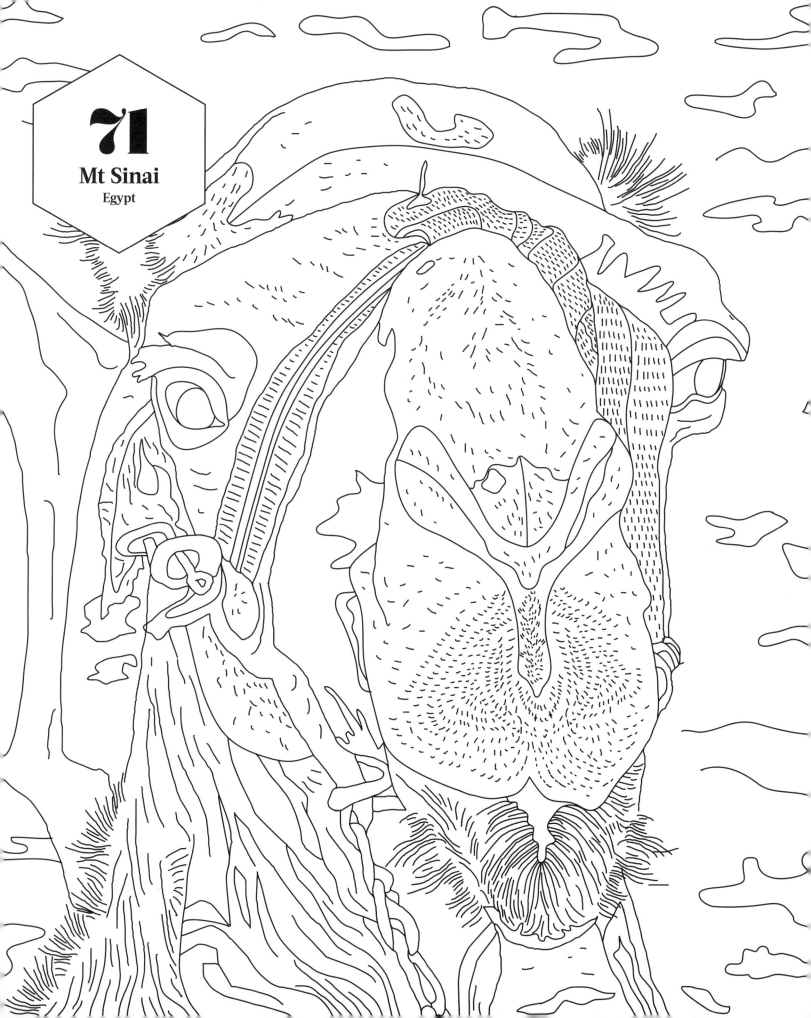

71

Mt Sinai

Egypt

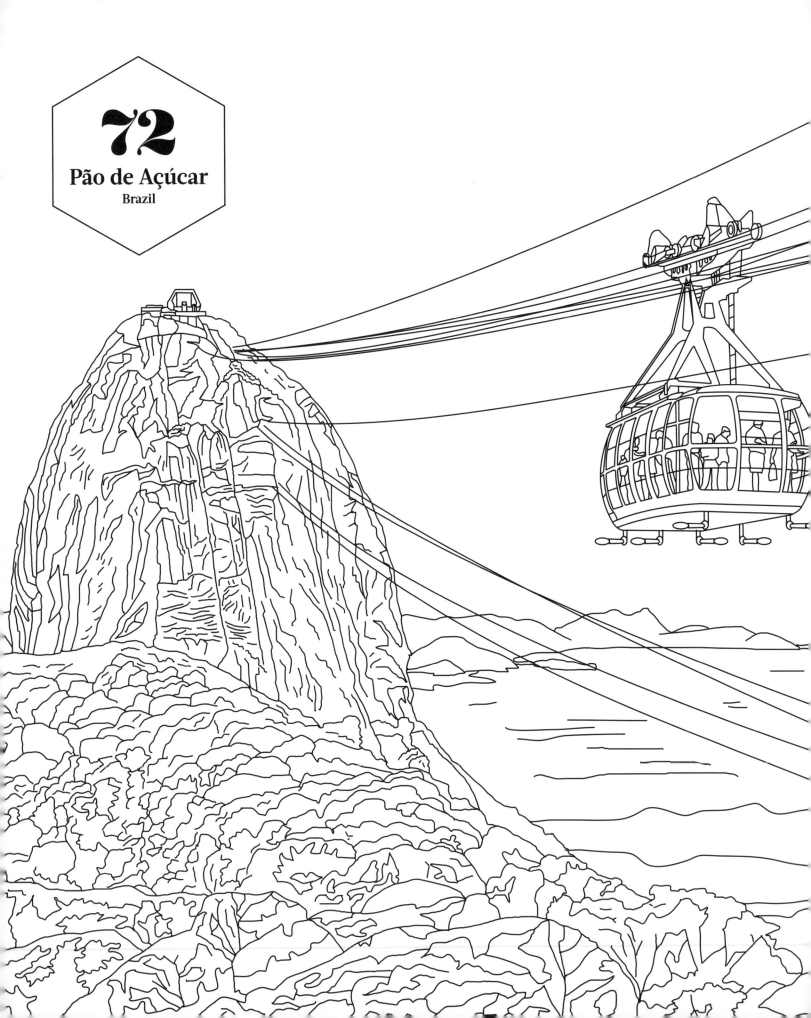

72

Pão de Açúcar

Brazil

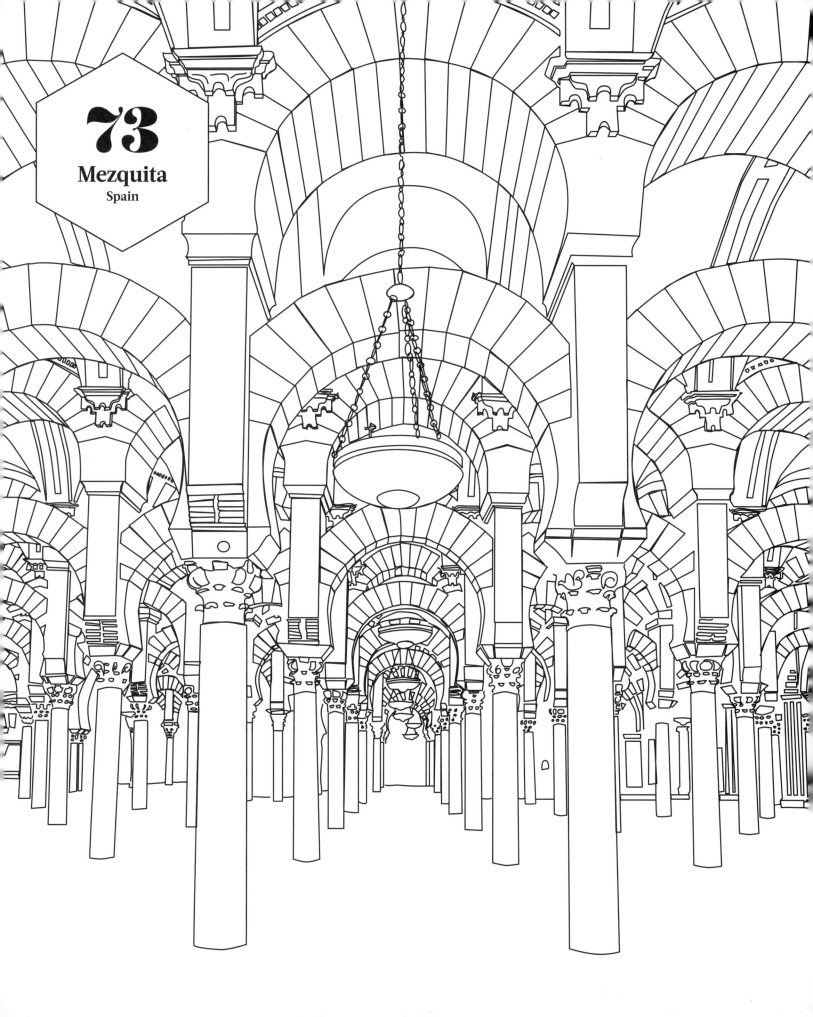

73

Mezquita

Spain

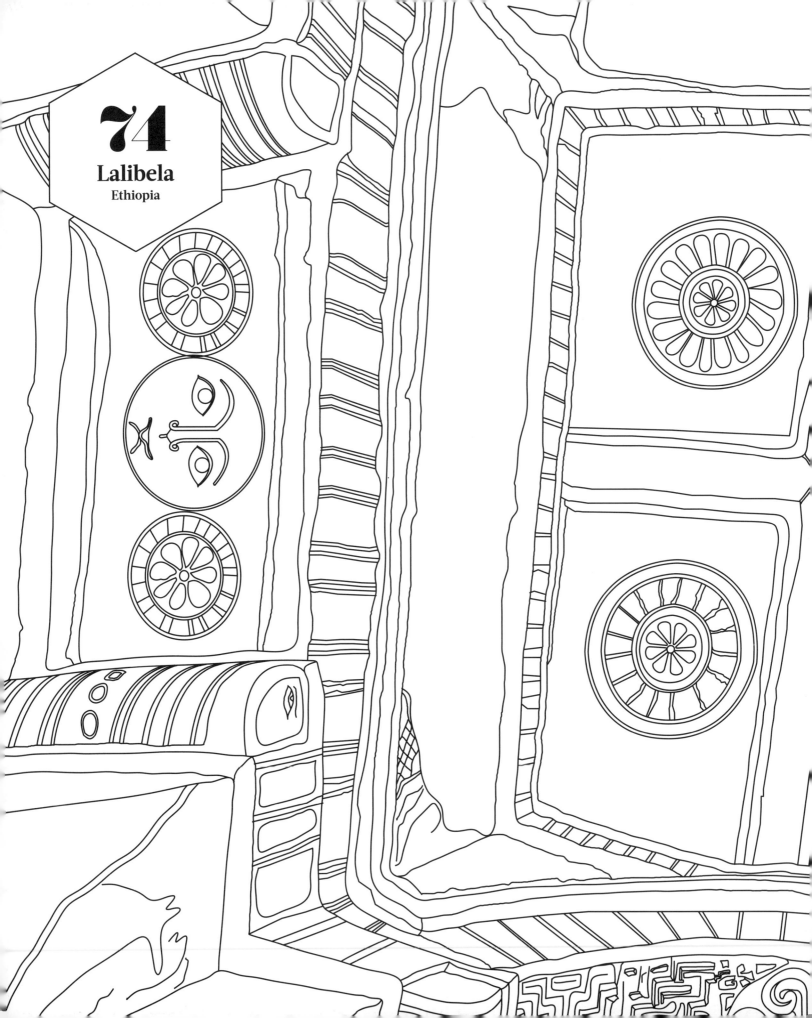

74

Lalibela

Ethiopia

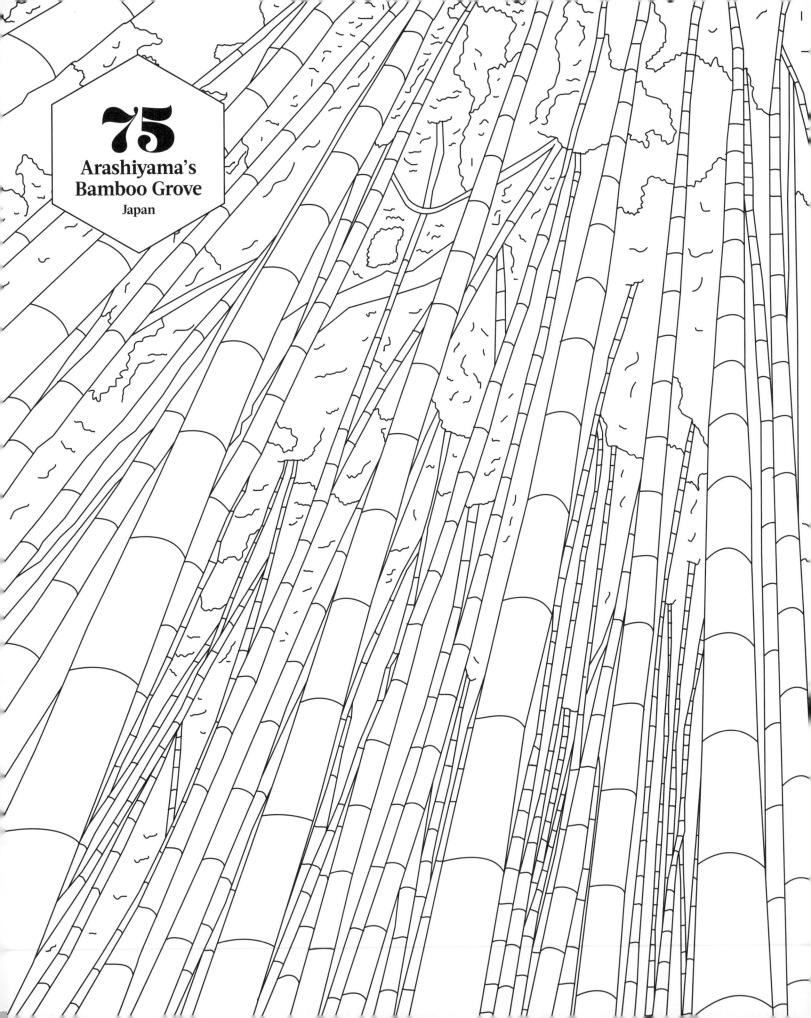

75

Arashiyama's Bamboo Grove

Japan

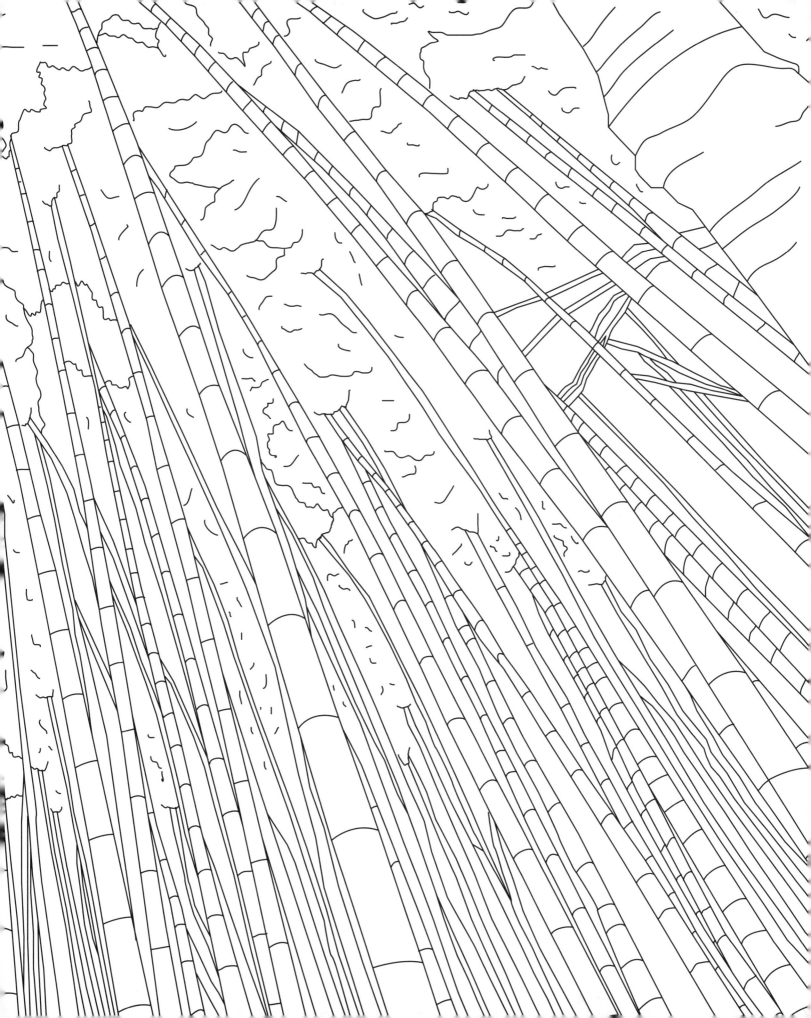

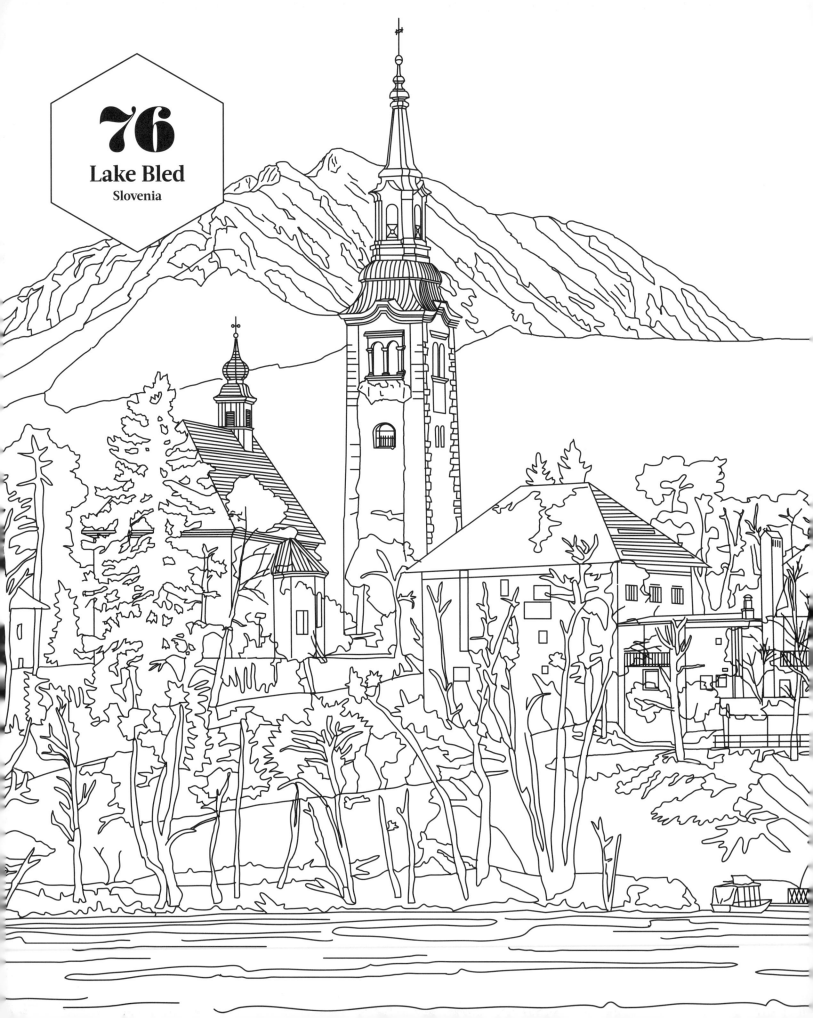

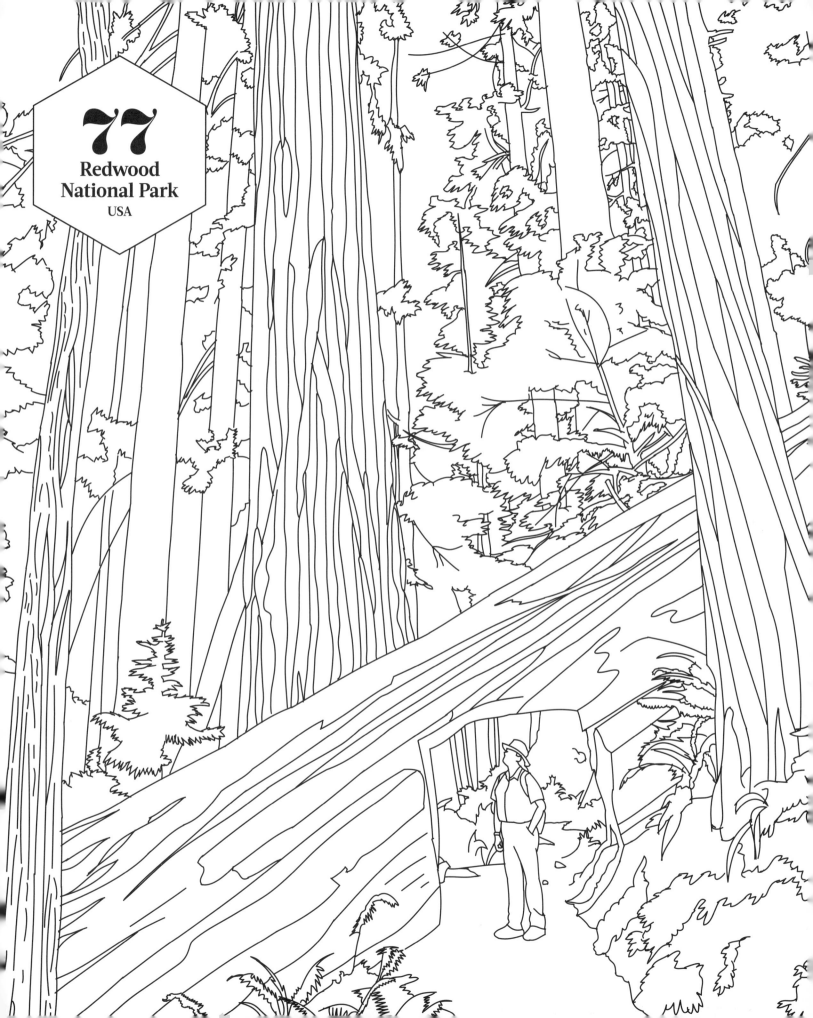

77

Redwood
National Park
USA

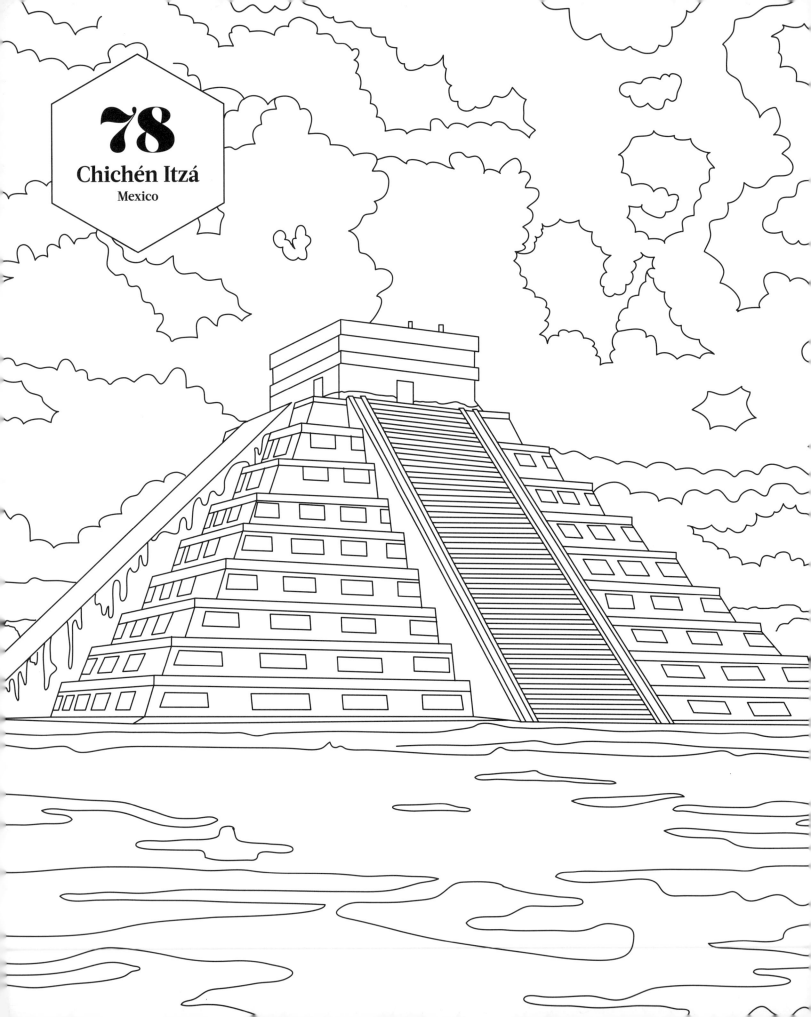

78

Chichén Itzá

Mexico

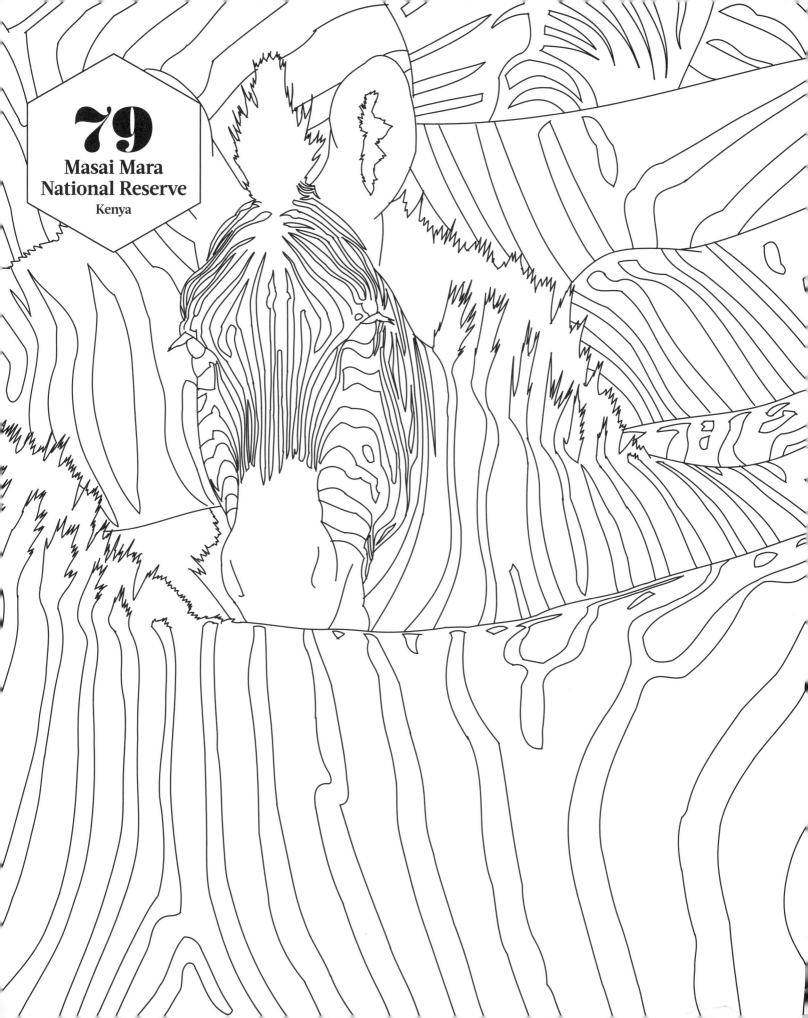

79

Masai Mara
National Reserve

Kenya

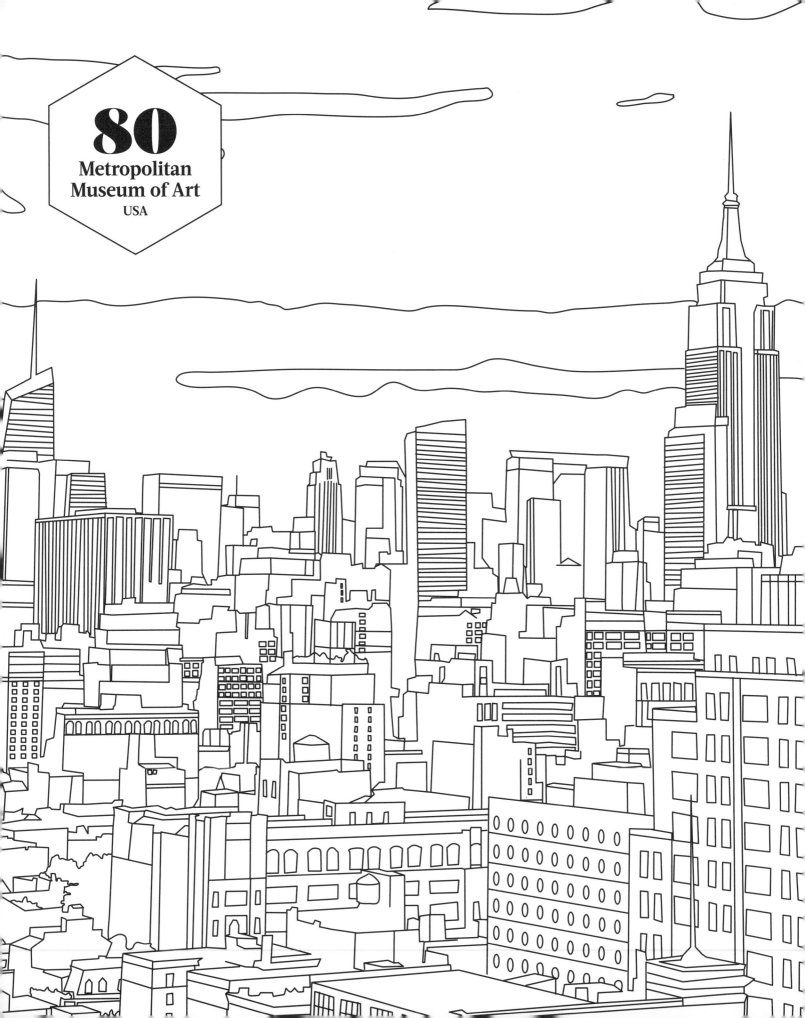

80
**Metropolitan
Museum of Art**
USA

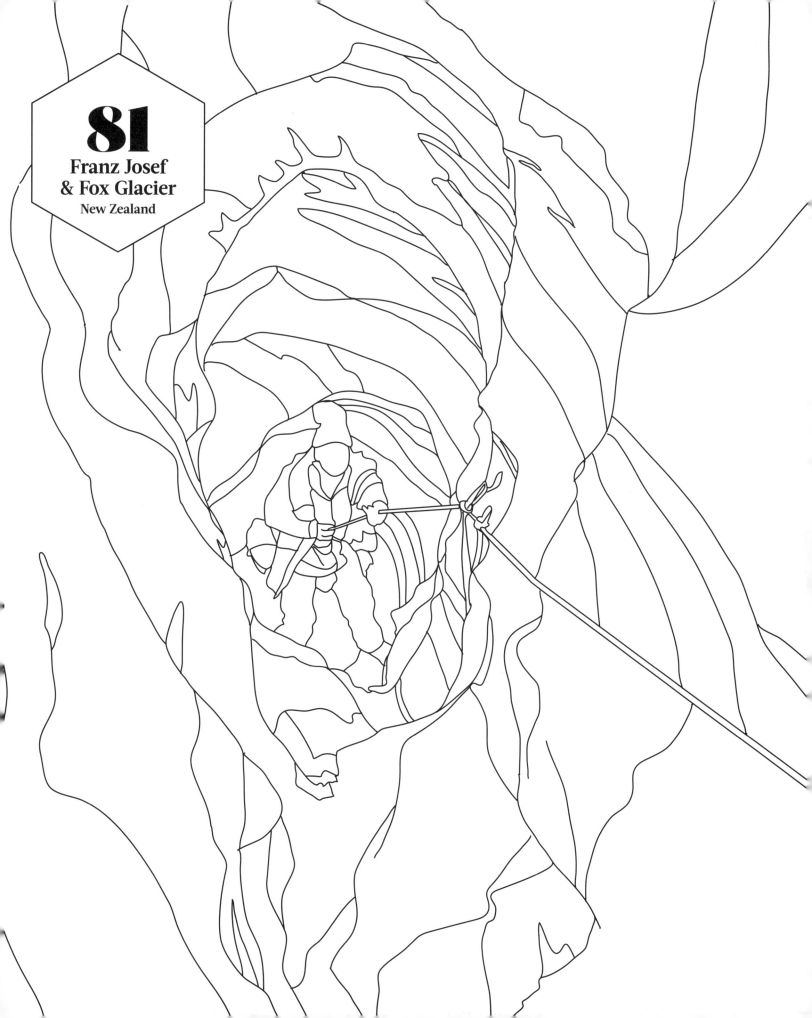

81

Franz Josef
& Fox Glacier

New Zealand

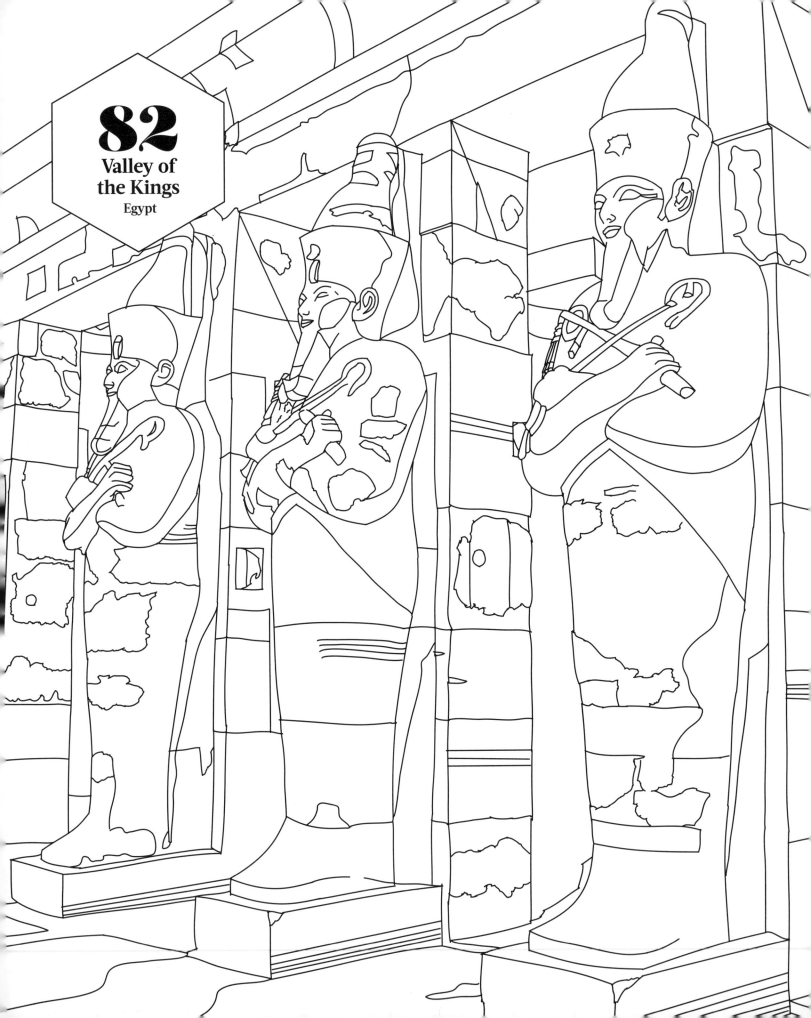

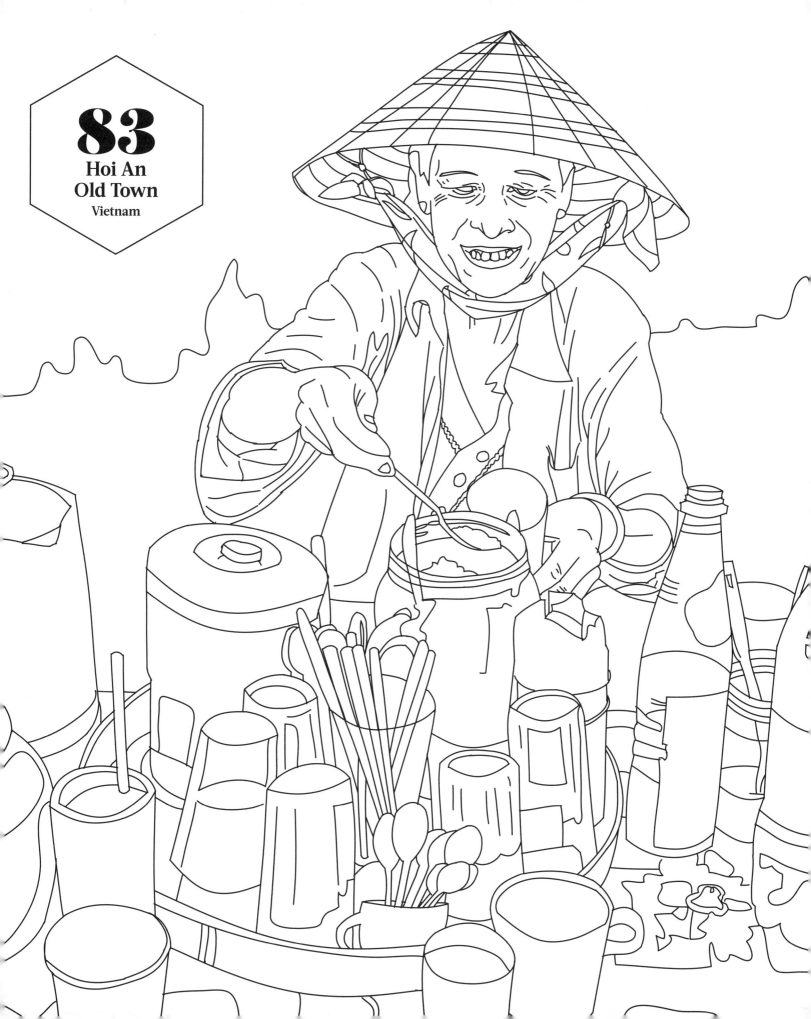

83

Hoi An
Old Town

Vietnam

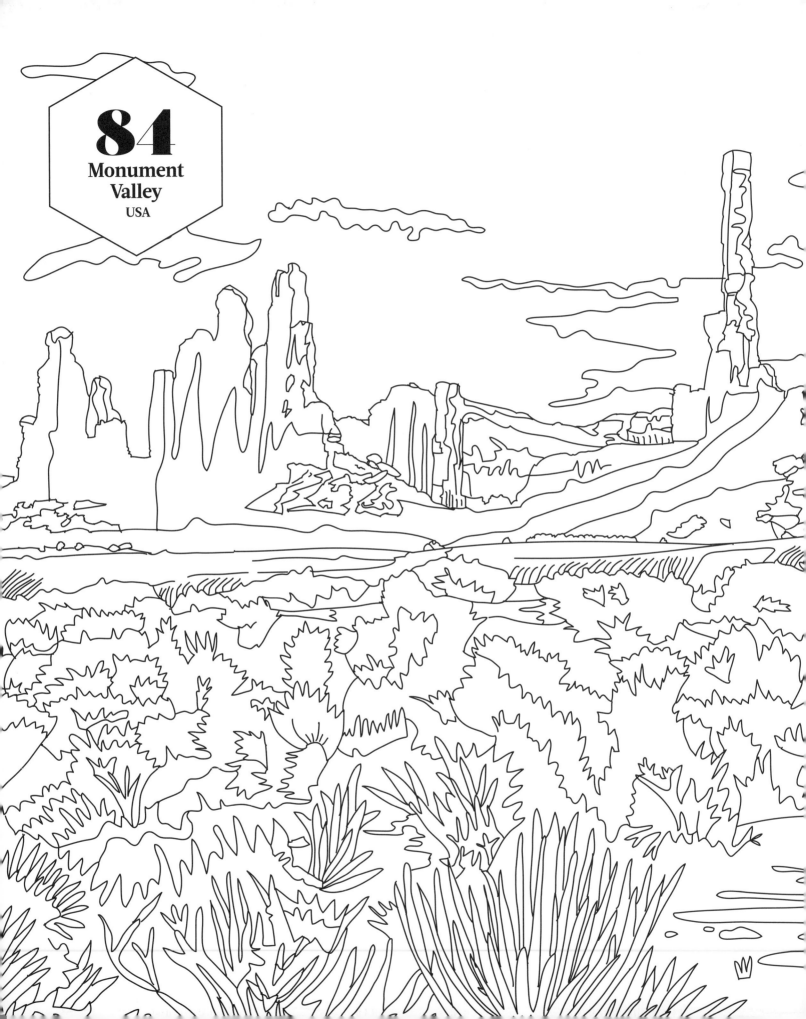

84

Monument
Valley

USA

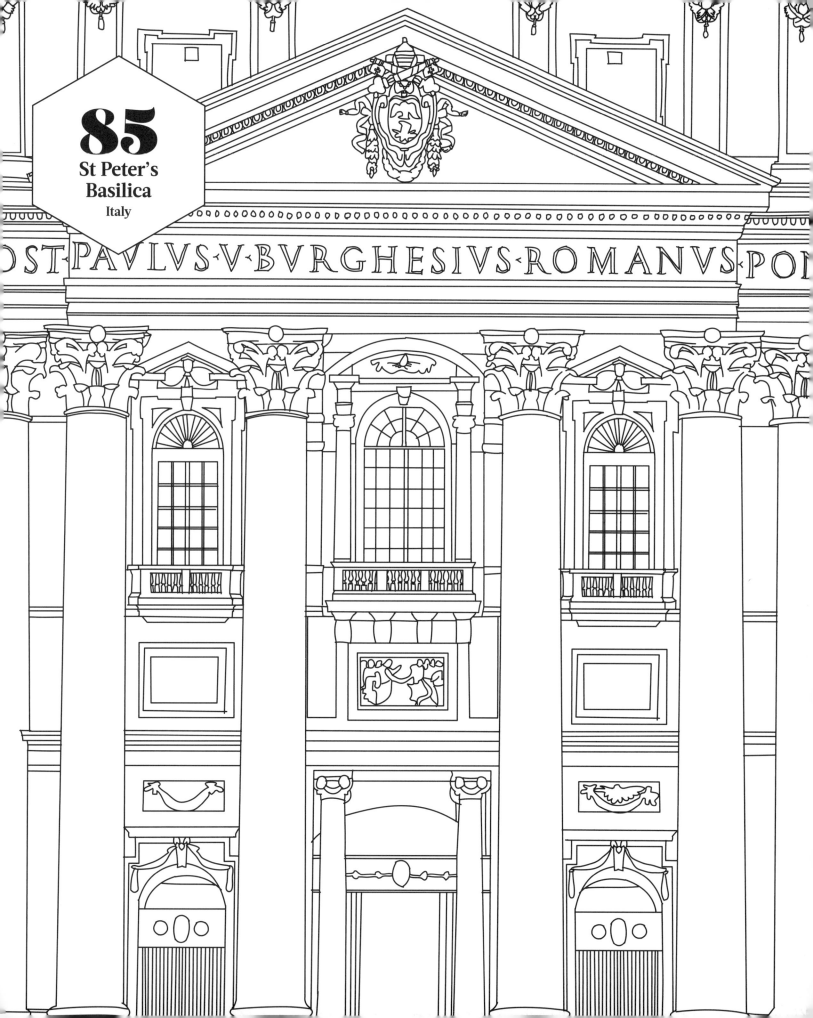

85
St Peter's
Basilica

Italy

PAVLVS·V·BVRGHESIVS·ROMANVS·PON

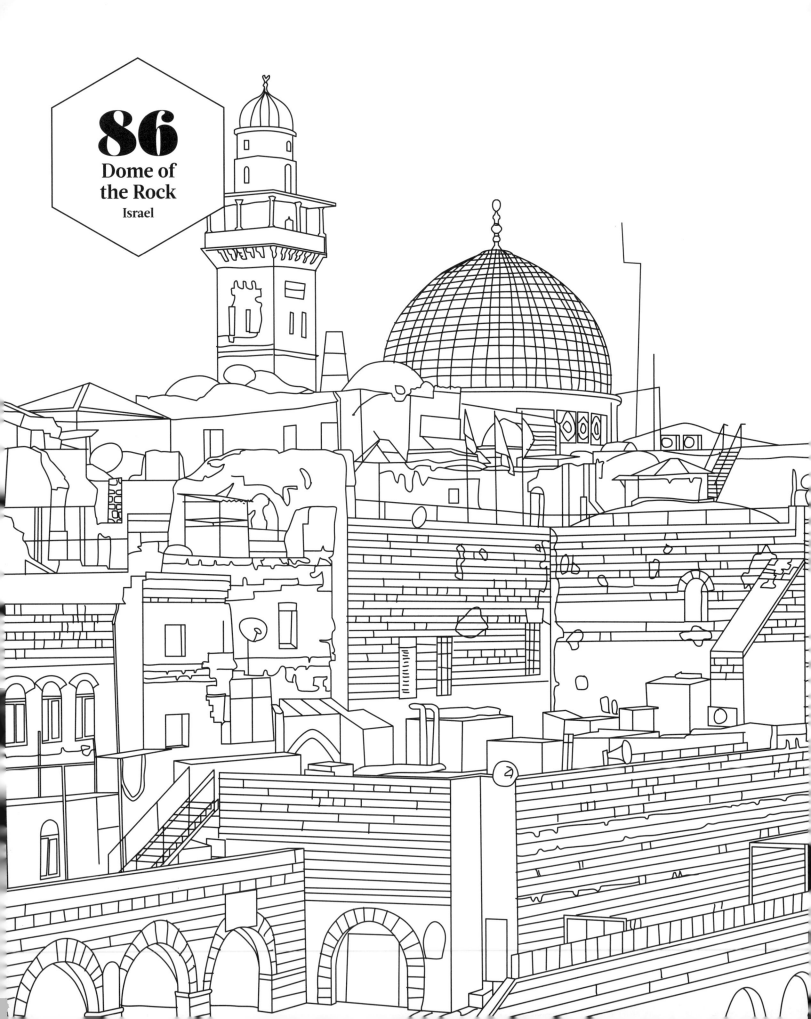

86
Dome of
the Rock
Israel

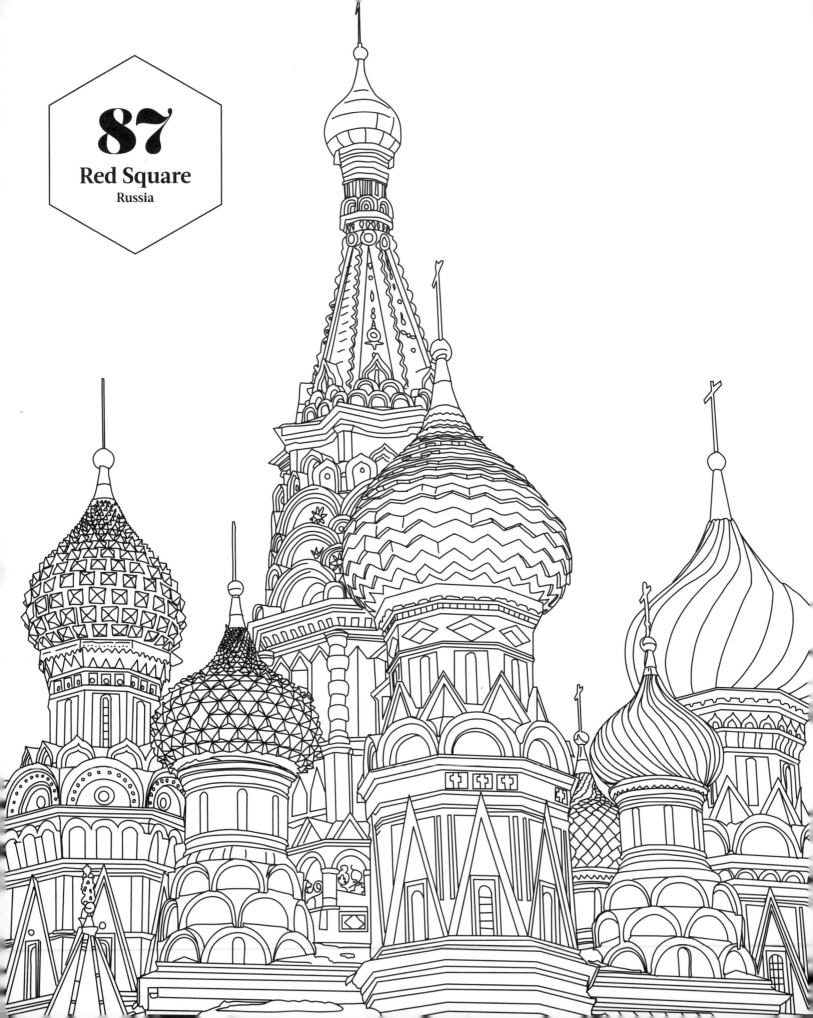

87

Red Square

Russia

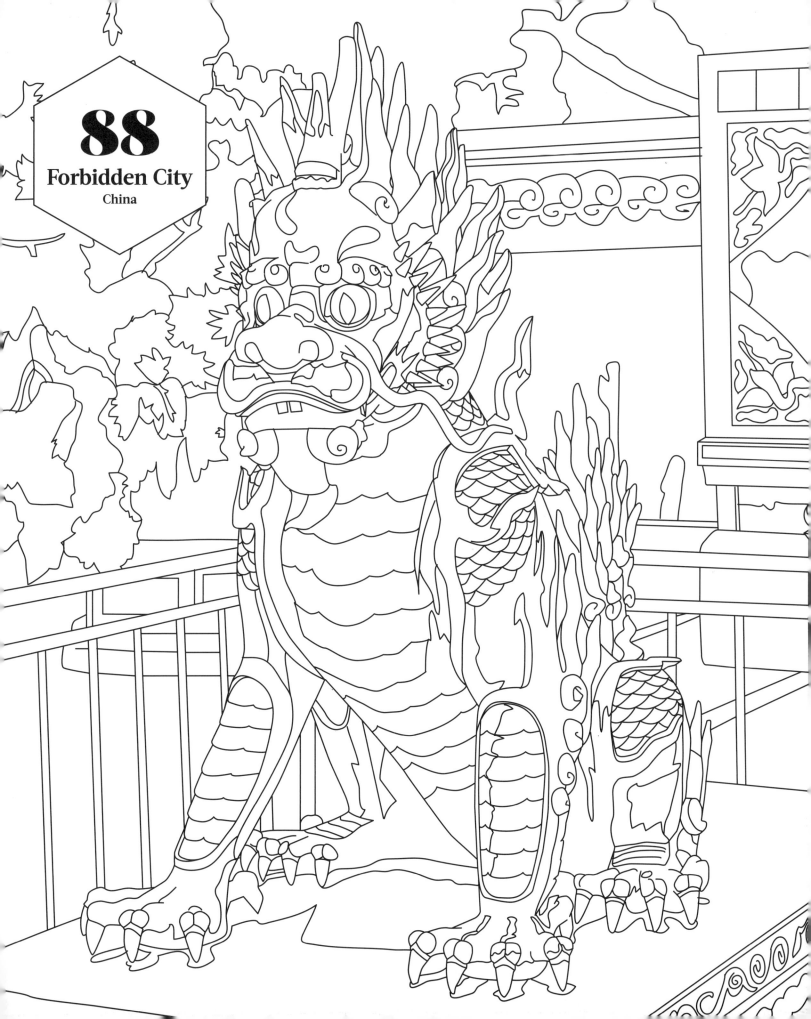

88

Forbidden City

China

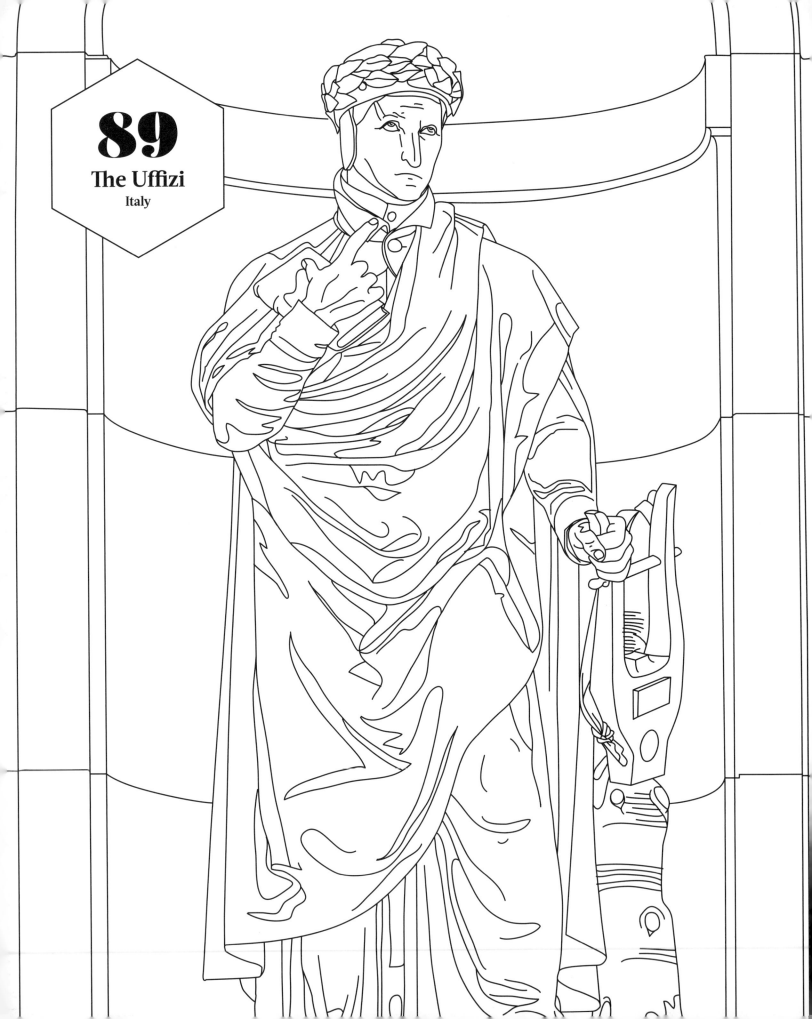

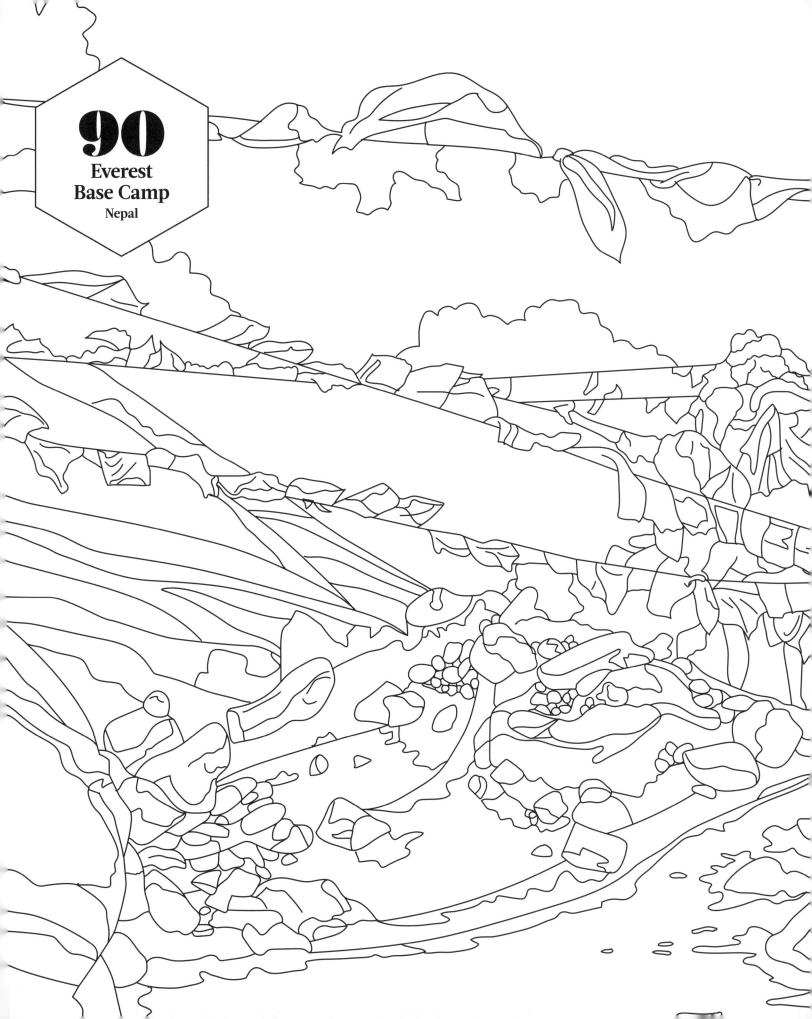

90
Everest
Base Camp
Nepal

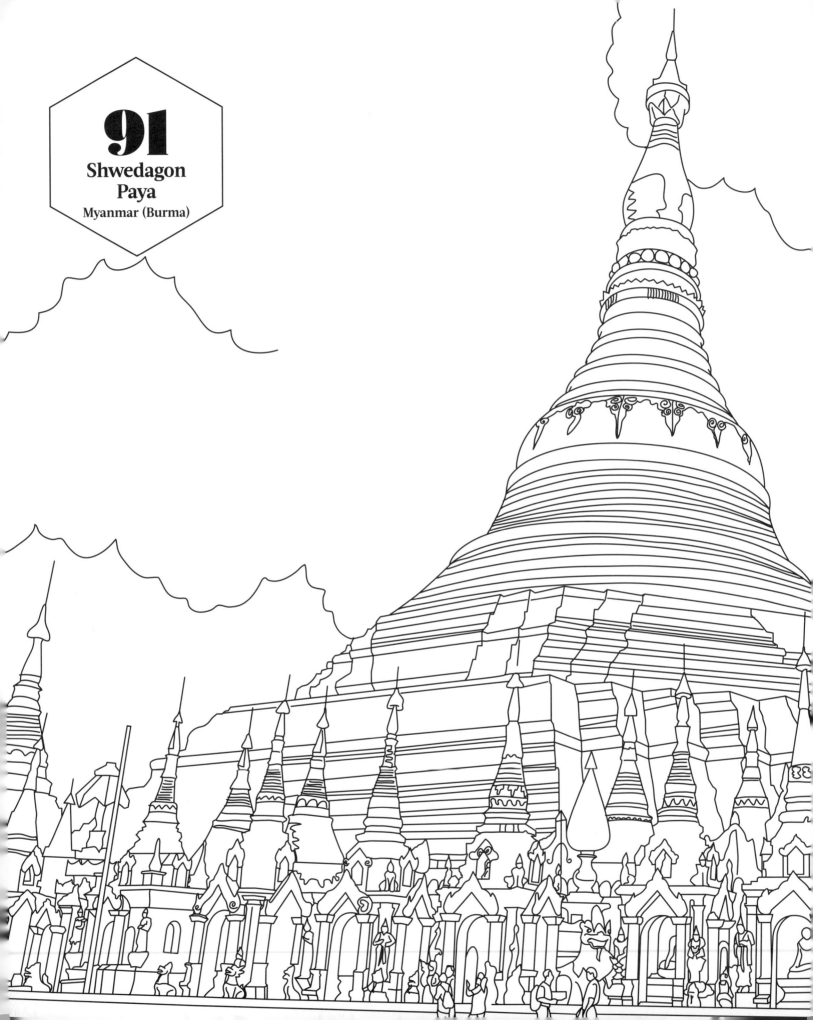

91

**Shwedagon
Paya**

Myanmar (Burma)

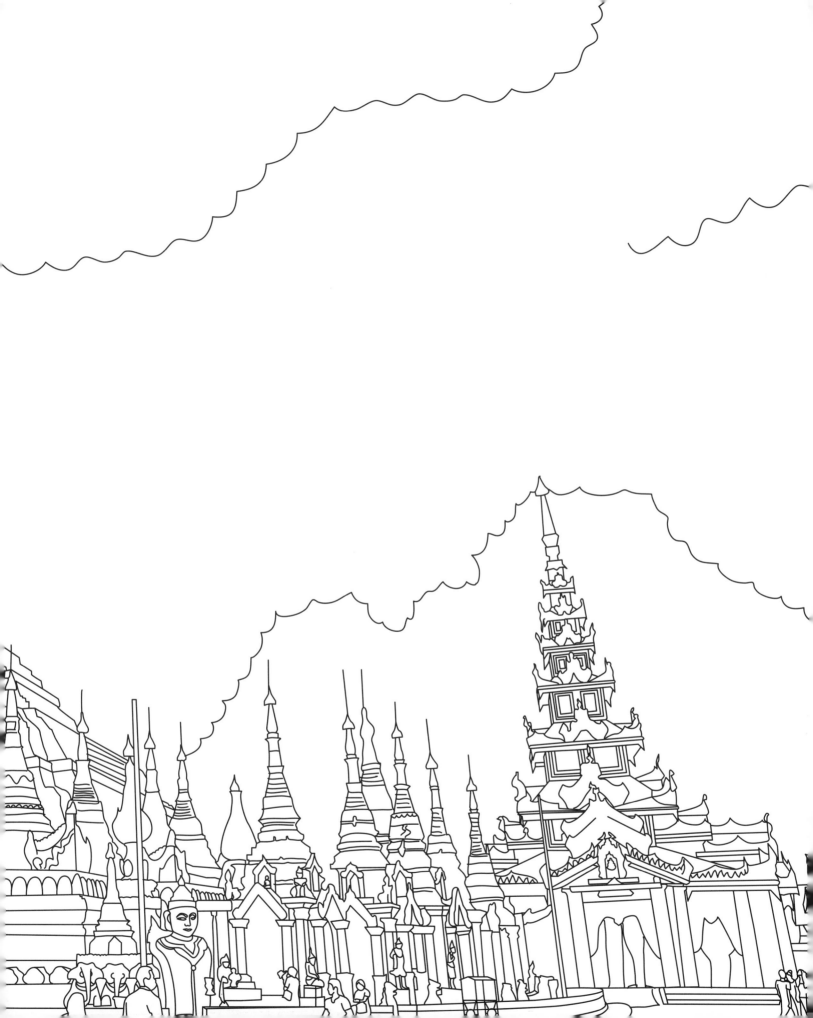

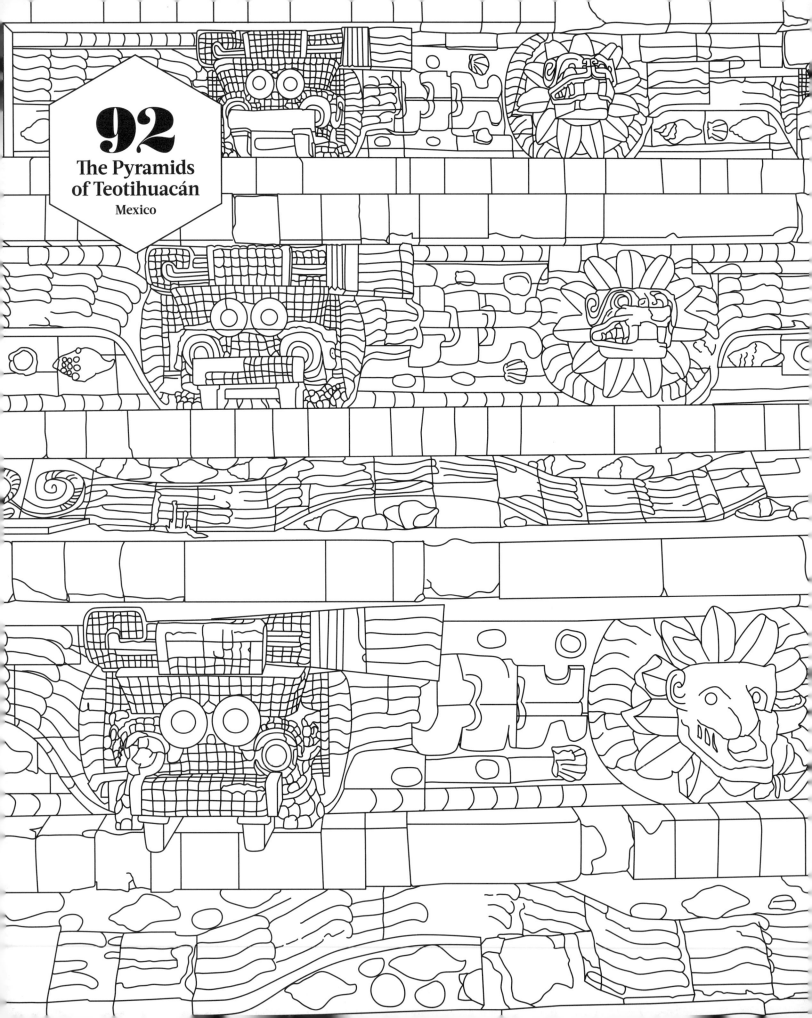

92

The Pyramids
of Teotihuacán

Mexico

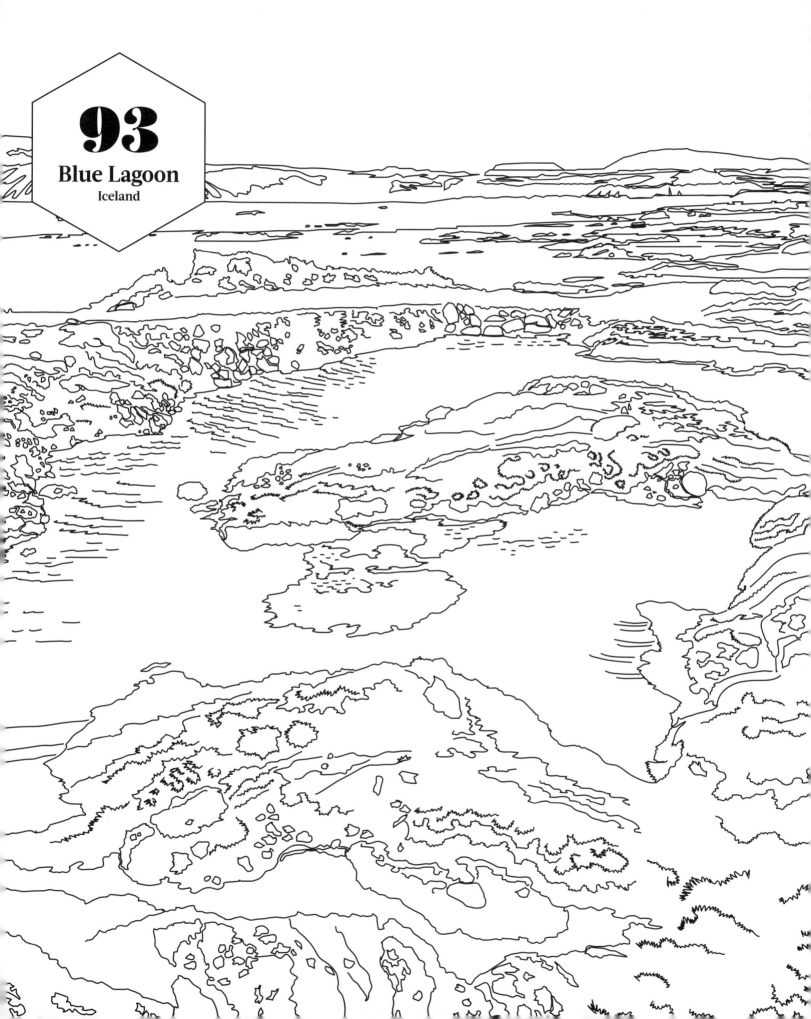

93

Blue Lagoon

Iceland

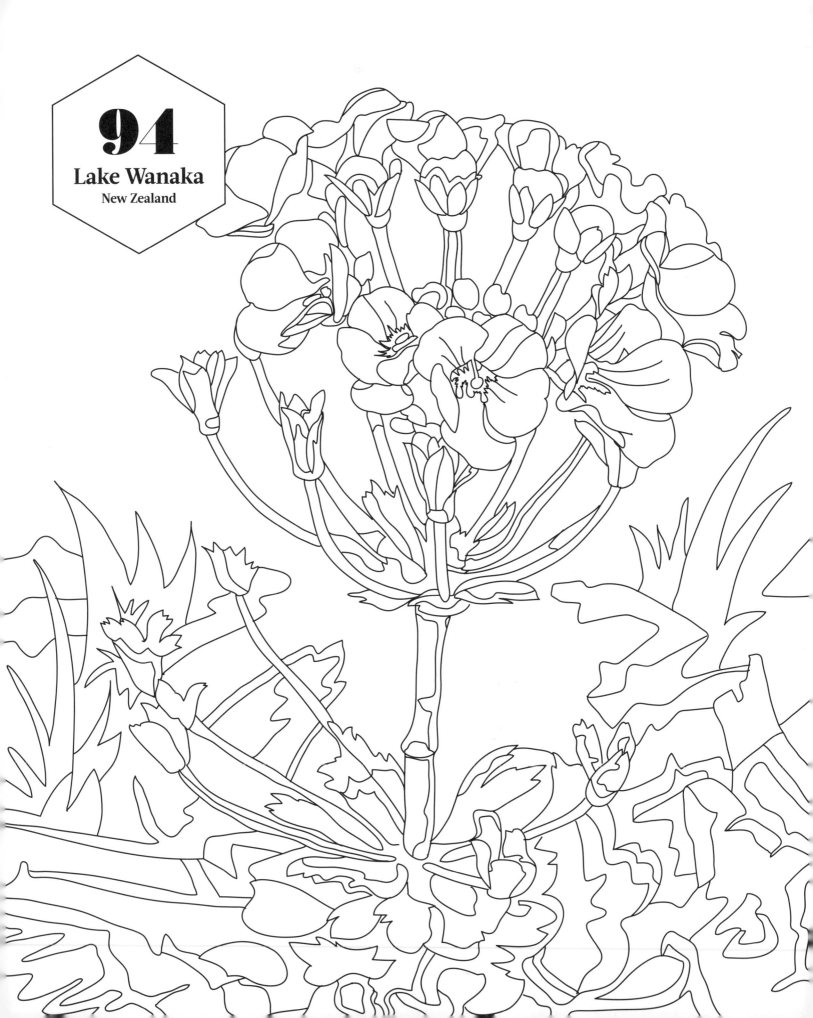

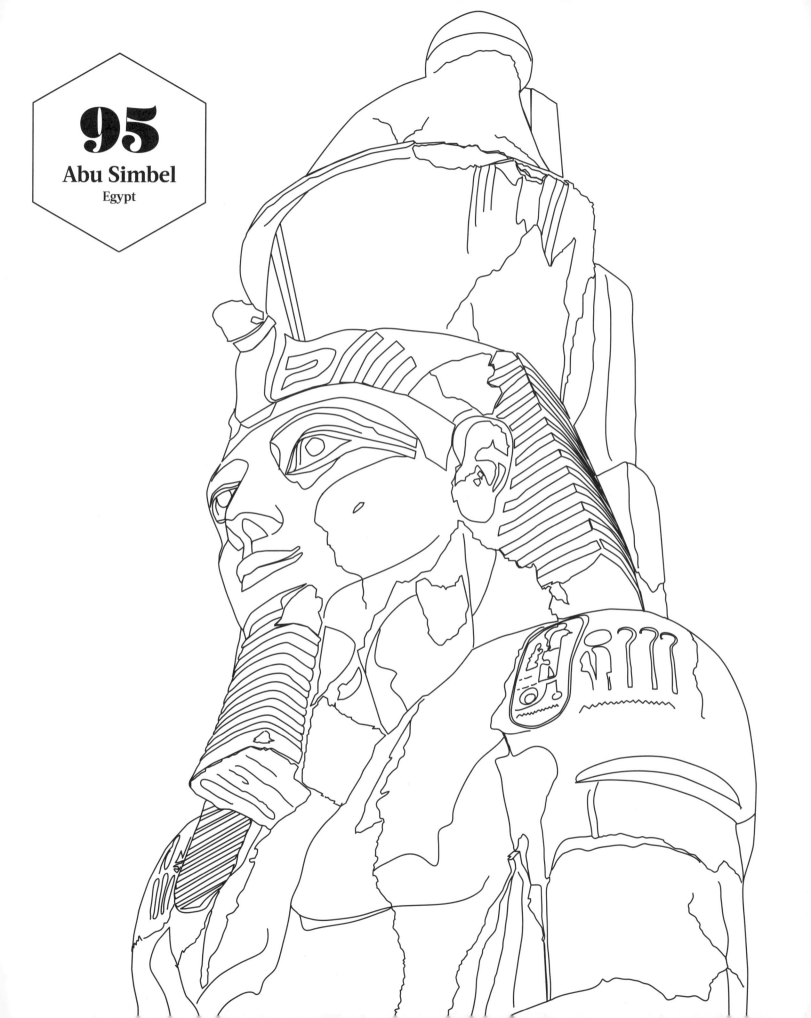

95

Abu Simbel

Egypt

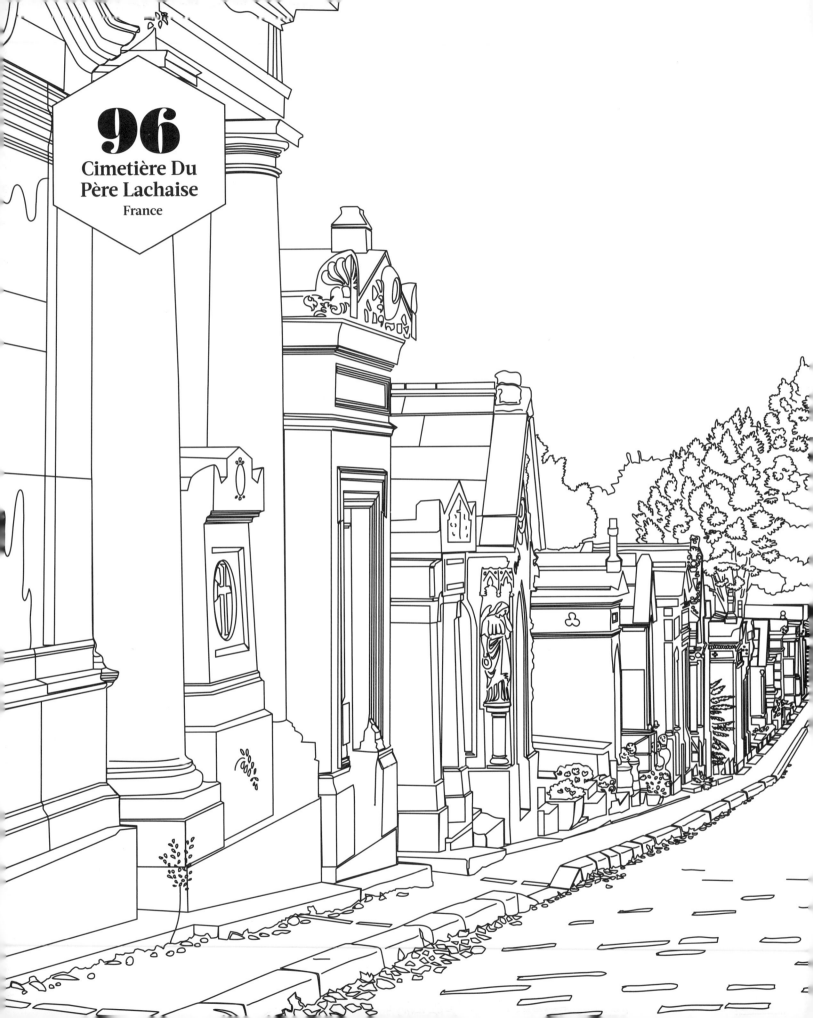

96
Cimetière Du Père Lachaise
France

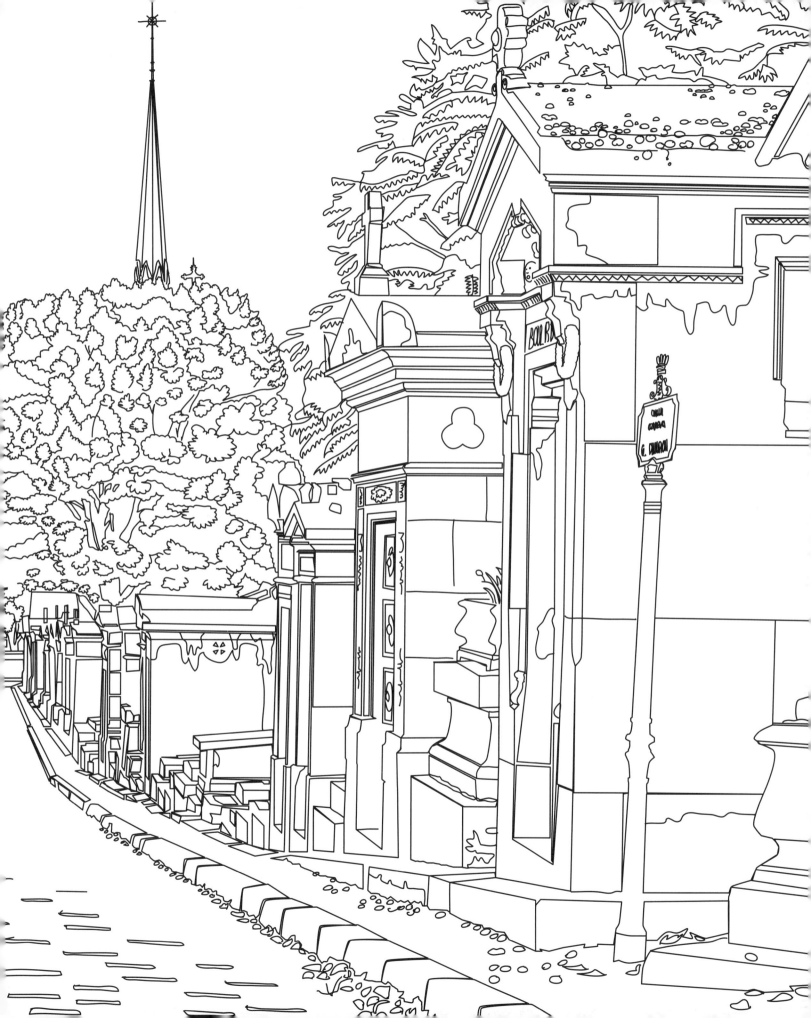

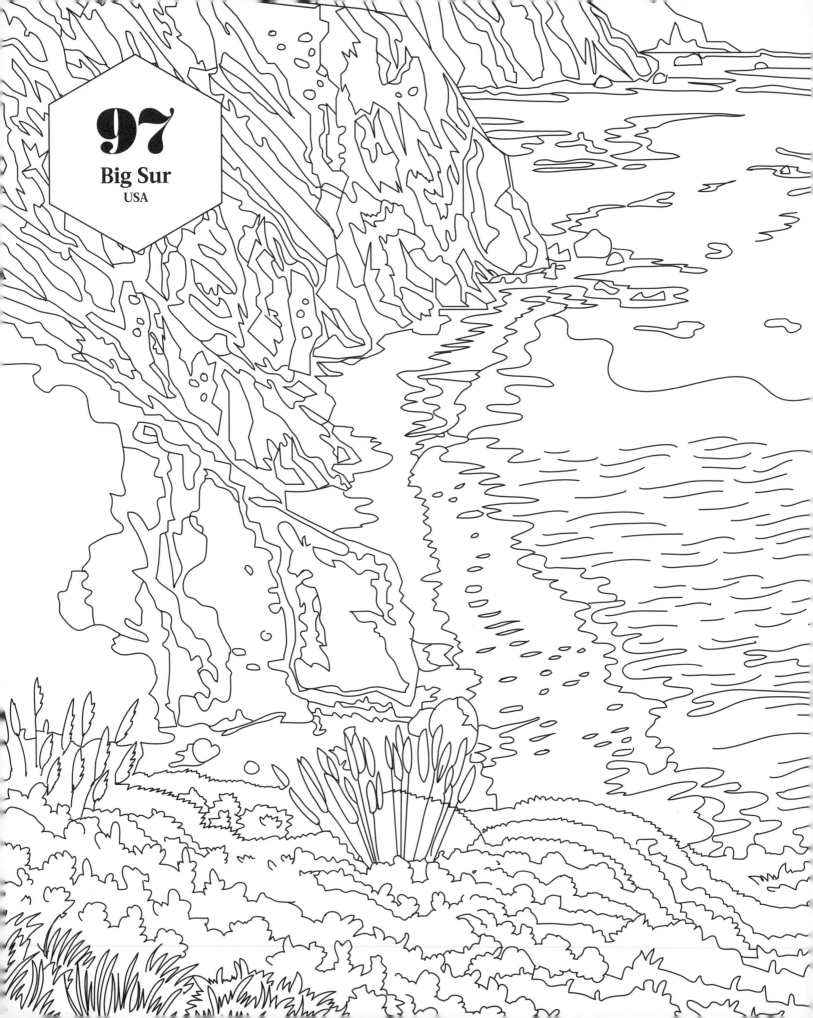

97

Big Sur

USA

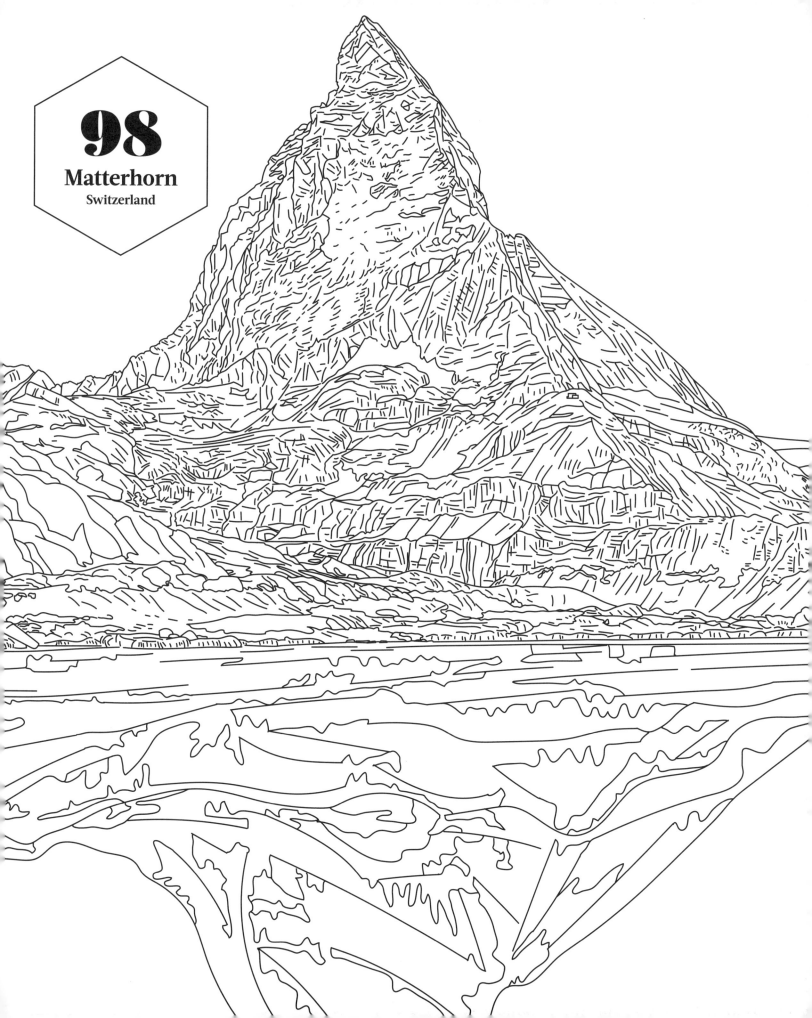

98

Matterhorn

Switzerland

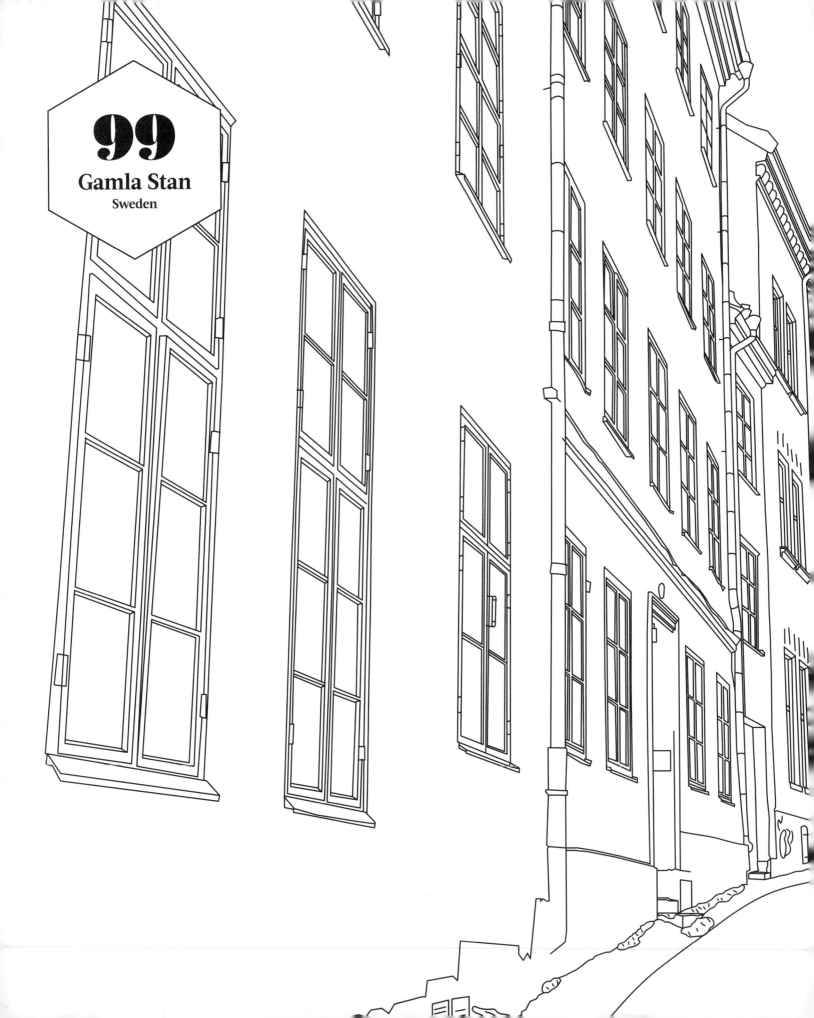

99

Gamla Stan

Sweden

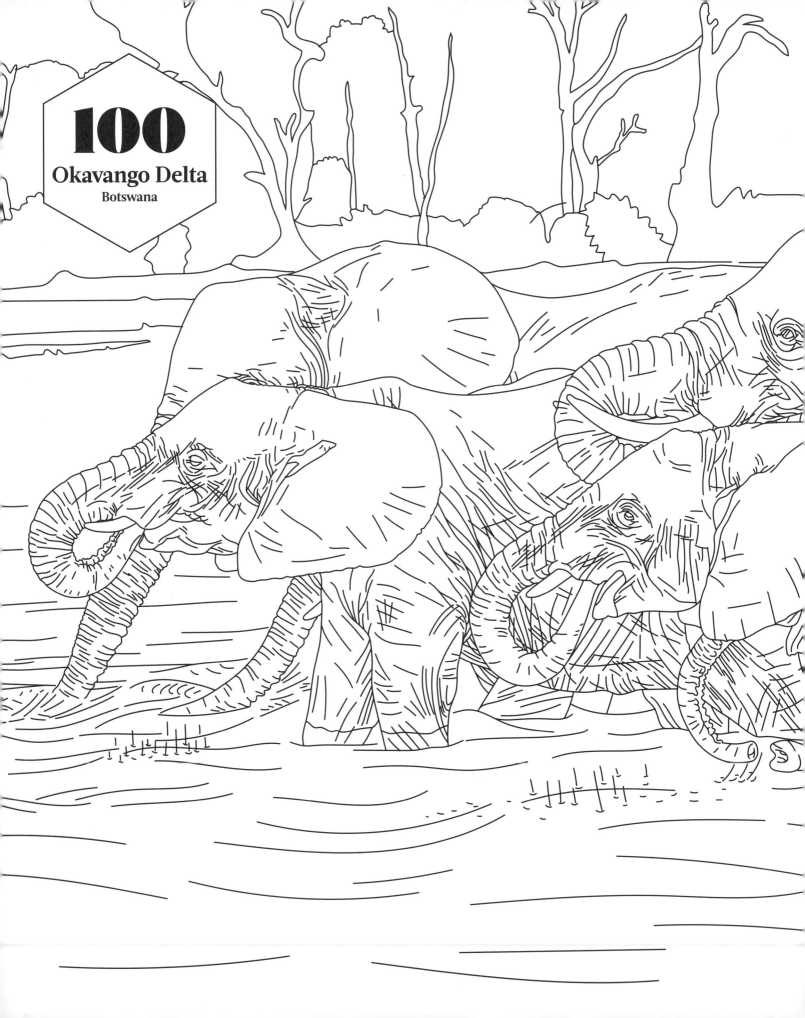

100

Okavango Delta

Botswana

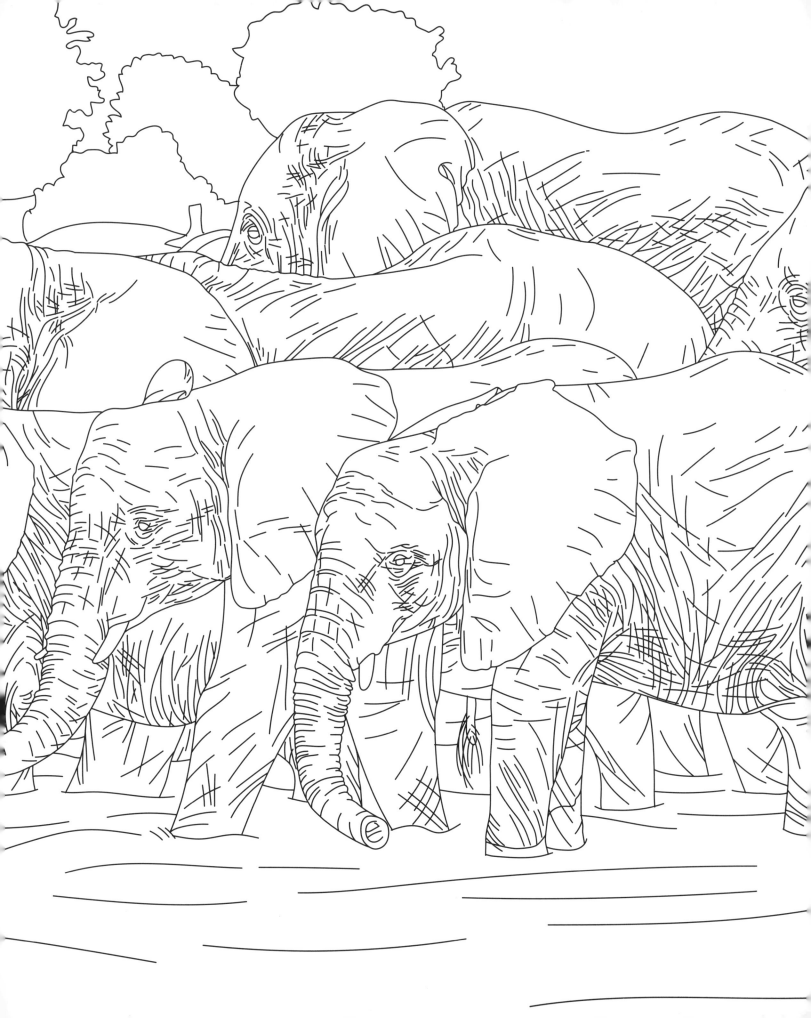

1 Temples of Angkor
Cambodia

Hewn from thousands of sandstone blocks and carved floor-to-ceiling in an expression of extravagant beauty, Angkor was designed to be a literal representation of heaven on earth.

Mark Read © Lonely Planet Images

2 Great Barrier Reef
Australia

Stretching for more than 2000km and home to 400 types of coral and 1500 species of fish, the Great Barrier Reef makes for some of the most spectacular diving imaginable.

Jeff Hunter © Getty Images

3 Macchu Picchu
Peru

This ancient Inca city was virtually forgotten until the early 20th century. To this day, it is an enigma: no one really knows what happened here.

Philip Lee Harvey © Lonely Planet Images

4 Great Wall of China
China

Constructed in waves over more than a thousand years, this maze of fortifications stretching nearly 9000km was built to keep the Mongol hordes out (it failed).

Leo Mason Travel photos © Alamy

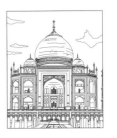

5 Taj Mahal
India

Built by Shah Jahan as a mausoleum for his third wife, Mumtaz Mahal, the shimmering marble Taj Mahal comes as close to architectural perfection as any building on earth.

seogaurav © Budget Travel

6 Grand Canyon National Park
USA

Lit by flaming sunsets, filled with billowing seas of fog and iced with crystal dustings of snow, the mile-deep, 277-mile-long Grand Canyon is nature's cathedral.

Kris Davidson © Lonely Planet Images

7 Colosseum
Italy

A monument to raw, merciless power, this 50,000-seat amphitheatre was once the setting for fights to the death between gladiators, prisoners and wild beasts – for baying, bloodthirsty crowds.

Justin Foulkes © Lonely Planet Images

8 Iguazú Falls
Brazil–Argentina

These falls are mind-bogglingly mighty, and the subtropical rainforest around it forms a 55,000-hectar national park replete with wildlife, including jaguars and lizards.

Rasmus_Christensen © Getty Images

9 Alhambra
Spain

The palace complex of Granada's Alhambra is one of the most extraordinary structures on the planet and a symbol of 800 years of enlightened Moorish rule in medieval Spain.

Pete Seaward © Lonely Planet Images

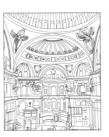

10 Aya Sofya
Turkey

Church, mosque and museum in one, this is a structure unlike any other: Aya Sofya represents a unique crossroads of continents and faiths.

Mark Read © Lonely Planet Images

11 Fez Medina
Morocco

There are in the region of 9400 alleyways in this thousand-year-old tangled labyrinth, which plays host to mosques, medrassas, riads, silversmiths, tanners and more.

Hemis © Alamy

12 Twelve Apostles
Australia

Close to the Great Ocean Road, these lonely rocky stacks were formed some 20 million years ago as the sea eroded the soft limestone cliffs between Port Campbell and Princetown.

DrRave © Getty Images

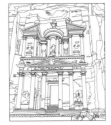

13 Petra
Jordan

The ancient city of Petra lay forgotten for centuries, known only to the Bedouin who made it their home, until Swiss explorer Jean Louis Burckhardt happened upon it in 1812.

Keren Su/China Span © Alamy

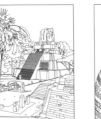

14 Tikal
Guatemala

Twelve hundred years ago, visitors to Tikal would find a bustling Mayan metropolis. Today, they're greeted by haunted jungle ambience: wind through vines and the occasional cacophony of squawks.

imageBROKER © Alamy

15 British Museum
England

The British Museum counts among its treasures such iconic heirlooms as the Rosetta Stone and the Elgin Marbles, alongside an astonishing collection of mummies and sarcophagi.

Greg Balfour Evans © Alamy

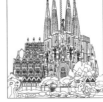

16 Sagrada Familia
Spain

This iconic Modernista masterpiece is jaw-dropping to witness – despite still being a work in progress, close to 100 years after its creator Gaudi's death.

Matt Munro © Lonely Planet Images

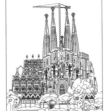

17 Fiordland National Park
New Zealand

Fiordland is a landscape of jagged peaks, glacial valleys, pristine lakes and fjords. Ancient forests drip green and twitch with such birds as kiwi, tahake and kea (pictured here).

Ian Watt © Alamy

18 Santorini
Greece

With multicoloured cliffs soaring over 300m from a sea-drowned caldera, Santorini rests in the indigo Aegean, looking like a giant slab of layered cake.

Justin Foulkes © Lonely Planet Images

19 Galapagos Islands
Ecuador

Arguably Earth's greatest wildlife show, these islands – each the tip of an underwater volcano – play host to myriad weird and wonderful creatures, including the marine iguana (pictured here).

Jürgen Ritterbach © 4Corners

20 Museum of Old & New Art
Australia

In Tasmania's capital, Hobart, MOMA offers a unique package: amazing architecture, provocative art, great food and wine (it's also home to a winery and brewery).

© Robin Barton

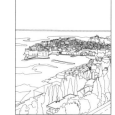

21 Yosemite National Park
USA

The jaw-dropping head-turner of America's national parks, Yosemite plays host to countless waterfalls, giant sequoias and roaming bears – not to mention rocks of epic proportions.

Mark Read © Lonely Planet Images

22 Dubrovnik Old City Walls
Croatia

Europe's most handsome ramparts are elevated by a stunning backdrop: a headland jutting into the blue Adriatic, towers rising over masts of anchored ships and green Dalmatian islands.

Mark Read © Lonely Planet Images

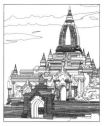

23 Salar de Uyuni
Bolivia

Welcome to the planet's biggest salt lake. There may be virtually nothing to see here, but you've never seen anything half as surreal as this sensation-bending, brain-melting experience.

Westend61 © Getty Images

24 Bagan
Myanmar (Burma)

Huge and dazzling ornate, this complex of Buddhist pagodas – a whopping 2200 of them – is so vast and so varied that it would take many weeks to see everything.

Matt Munro © Lonely Planet Images

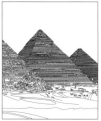

25 Pyramids of Giza
Egypt

Giza's Pyramids are the oldest of the Seven Wonders of the World and the only one to remain largely intact, allowing visitors to marvel at their impeccable 4000-year-old geometry.

WitR © Shutterstock

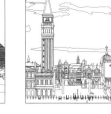

26 Piazza San Marco
Italy

This grand showpiece square – Europe's most famous public space – beautifully encapsulates the splendour of Venice's past and its tourist-fuelled present.

Robert Zehetmayer © Alamy

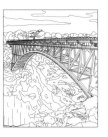

27 Victoria Falls
Zimbabwe–Zambia

Whether viewed from Zimbabwe or Zambia, this relentless wave is an ear-assaulting, drenching flood of one remarkable view after another – and that's just in the dry season…

Steve Humphreys © Getty Images

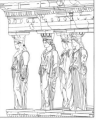

28 Acropolis
Greece

Crowned by the Parthenon, the Acropolis stands sentinel over Athens, visible from almost everywhere within the city. A glimpse of this magnificent sight cannot fail to exalt your spirit.

Bill Heinsohn © Alamy

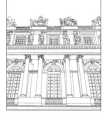

29 Château de Versailles
France

Situated in a leafy, bourgeois suburb of Paris, the Château de Versailles' ostentatious opulence pervades every last brick and baroque, egg-and-dart carved cornice.

ggenova © Getty Images

30 Djemaa el-Fna
Morocco

The vibrant heart of Marrakesh, this main square is a hub of hoopla, *halqa* (street theatre) and *hikayat* (storytelling) that has been thriving since medieval times.

Michael Heffernan © Lonely Planet Images

31 Hanoi Old Quarter
Vietnam

With its French colonial mansions, frenetic Southeast Asian street markets and cool cafes, this is Hanoi's cosmopolitan heart, which beats with exuberance and brash joie de vivre.

Matt Munro © Lonely Planet Images

32 Cradle Mountain
Australia

Tasmania's northwest corner is undoubtedly remote – but those who make it will discover Australia's quirky wildlife, alpine heaths, buttongrass-filled valleys and a varied ecosystem.

Byronsdad © Getty Images

33 Uluru
Australia

Explore this behemoth boulder up close to discover features including pools, waterfalls, sacred sites and an ancient indigenous classroom, complete with old lessons painted on the walls.

Paul Sinclair © Getty Images

34 Charles Bridge
Czech Republic

This handsome Gothic bridge began life in 1357: the foundation stone was laid by Charles IV. Over 600 years – and numerous floods and wars – later, it's still Prague's most popular thoroughfare.

Mark Read © Lonely Planet Images

35 Abel Tasman National Park
New Zealand

This is a pleasuredome – a place where you can swim, sunbathe, kayak and kick back, enjoying all the fun of a beach-bum holiday – in the seductive surroundings of a national park.

Thomas Pickard © Getty Images

36 Lake District National Park
England

Slatecapped fells, craggy peaks, tumbling waterfalls and shimmering lakes are all part of the charm in this, the landscape that inspired such Romantic poets as Wordsworth and Coleridge.

Justin Foulkes © Lonely Planet Images

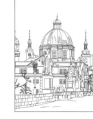

37 Louvre
France
The planet's most visited museum is a finely curated record of human endeavour and expression throughout time, housed in a 12th century building that's as interesting as the exhibits.

38 Torres del Paine
Chile
Patagonia summons every iota of its fabled wilderness into one dramatic thrust of precipitous granite in this, an oasis of forest-cloaked mountains, lakes, plains and glacier.

Matt Munro © Lonely Planet Images

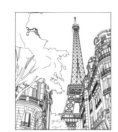

39 Lake Baikal
Russia
The 30-million-year-old Baikal – the world's deepest lake – has an otherworldly air that's stirred and sustained nomadic tribes, Buddhists, Decembrists, artist and adventurers for centuries.

coolbiere photograph © Getty Images

40 Eiffel Tower
France
Gustave Eiffel only constructed this elegant, 320m-tall signature spire as a temporary exhibit for the 1889 World Fair. Luckily, the art nouveau tower's popularity assured its survival.

cbmetz19 © Budget Travel

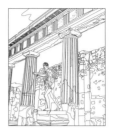

41 Pompeii
Italy
This, surely, is Europe's most compelling archaeological site: the ruins of Pompeii. Sprawling and haunting, the site is a stark reminder of the malign forces that lie deep inside the volcano Vesuvius.

MaRabelo © Getty Images

42 Habana Vieja
Cuba
Cobbled streets, pastel buildings and vintage cars combine to make a visit to old Havana a little like stepping into a sepia-tinted vintage photograph.

Lola L. Falantes © Getty Images

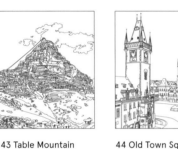

43 Table Mountain
South Africa
Around 600 million years old, and a canvas painted with the rich diversity of the Cape floral kingdom, Table Mountain is a truly iconic symbol of Cape Town.

Dhoxax © Getty Images

44 Old Town Square
Czech Republic
In Prague's Old Town Square, ornate frontages rise up on all sides and heels click on cobbles that have seen nearly a millennium of footfalls.

Jon Cunningham © Getty Images

45 Serengeti National Park
Tanzania
No other park in the world spawns such a magnificent wildlife spectacle as the epic migration of millions of animals, following the ancient rhythm of Africa's seasons.

Steve Bloom Images © Getty Images

46 Hermitage
Russia
The Hermitage is a superlative-defying assemblage of priceless artistic masterpieces and architectural marvels; it now lays claim to a staggering three million items.

Renaud Visage © Getty Images

47 Bay of Kotor
Montenegro
In the many twists and turns of the Bay of Kotor, rugged mountains of lavender-grey scree tumble down to a coastal fringe of olive and pomegranate trees above a limpid opal sea.

Julian Love © Lonely Planet Images

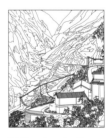

48 Jaisalmer
India
This honey-coloured fortress rises from the sandy plains like a mirage, encircled by 99 mighty bastions. To visit is to step into an *Arabian Nights* fantasy made real: powerful stuff.

aluxum © Getty Images

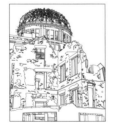

49 Ngorongoro Crater
Tanzania
The concentration of wildlife on the Ngorongoro Crater floor, particularly of lions and other large predators, is unparalleled anywhere else in Africa.

Jonathan Gregson © Lonely Planet Images

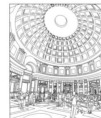

50 Hiroshima Peace Memorial Park
Japan
What was once ground zero for the world's first nuclear attack is now a green expanse, home to numerous memorials – a peaceful place to wander and reflect.

Benoist Sébire © Getty Images

51 Pantheon
Italy
A striking 2000-year-old temple, now a church, the Pantheon is the best preserved of Rome's ancient monuments and one of the most influential buildings in the Western world.

Justin Foulkes © Lonely Planet Images

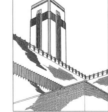

52 Tate Modern
England
Containing works by Rothko, Matisse, Warhol, Pollock and Hirst, the Tate Modern welcomes five million visitors every year to its hallowed halls, built in the shell of a 1940s power station.

Christopher Hope-Fitch © Getty Images

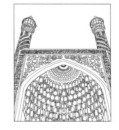

53 Naqsh-e Jahan
Iran
Begun in 1602 as the centrepiece of Abbas' new capital, this vast and captivating square was designed as home to the finest jewels of the Safavid empire.

Ravi Tahilramani © Getty Images

54 Tiger Leaping Gorge
China
With snowcapped mountains rising on either side, and winding trails that pass through tiny villages, this gorge is China's unmissable trek.

Blake Kent / Design Pics © Getty Images

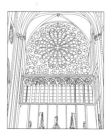

55 Notre-Dame
France

A masterpiece of French Gothic architecture, Notre-Dame was the focus of Catholic Paris for seven centuries, its vast interior accommodating 6000-plus worshippers.

Pete Seaward © Lonely Planet Images

56 Kakadu National Park
Australia

Australia's Kakadu holds in its boundaries a spectacular ecosystem and a mind-blowing concentration of ancient Aboriginal rock art.

Mint Images/ Art Wolfe © Getty Images

57 Sydney Opera House
Australia

Designed by Danish architect Jørn Utzon, this World Heritage-listed building is Australia's most recognisable landmark, situated on Sydney's Circular Quay.

Pete Seaward © Lonely Planet Images

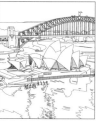

58 Edinburgh Castle
Scotland

Lording over the Scottish capital, this stronghold seems to segue organically out of the volcanic plug below; it's hard to tell where nature ends and masonry begins.

Ashley Tenbarge © Lonely Planet Images

59 Anne Frank Huis
Netherlands

In the dark and airless Secret Annex of this house the Franks hid from the Nazis for several years. Now a museum, this is a moving and powerful experience.

dennisvdw © Getty Images

60 Jökulsárlón
Iceland

A host of spectacular, luminous-blue icebergs drift through Jökulsárlón glacier lagoon. Its ice sculptures are sometimes striped with ash layers from volcanic eruptions.

Gary Latham © Lonely Planet Images

61 Yellowstone National Park
USA

With an enigmatic concentration of wildlife, half the world's geysers and rivers and a giant supervolcano, this is one of Mother Nature's most fabulous creations.

Chase Dekker Wild-Life Images © Getty Images

62 Stonehenge
England

This compelling ring of monolithic stones has been attracting a steady stream of pilgrims, poets and philosophers for the last 5000 years.

JSO © Budget Travel

63 Berlin Wall
Germany

Twenty-five years after its fall, little remains of the barrier between East and West Berlin, but the wall's absence is as affecting as the fragments that still stand.

Marco Cristofori © Getty Images

64 Isle of Skye
Scotland

The largest island in the Inner Hebrides, Skye has castles and crofts, granite-grey seas and crystalline fairy pools, heather moors and emerald glens.

WR Mekwi © Getty Images

65 Halong Bay
Vietnam

This verdant bay's immense number of islands are dotted with wind- and wave-eroded grottoes, and their sparsely forested slopes ring with birdsong.

Matt Munro © Lonely Planet Images

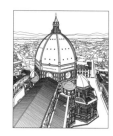

66 Il Duomo di Firenze
Italy

Dominating the Florence skyline is the russet-domed Cattedrale di Santa Maria del Fiore, with its furiously pretty façade in pink, white and green marble.

Justin Foulkes © Lonely Planet Images

67 Cappadocia
Turkey

Turkey's Cappadocia is a geological oddity of honeycombed hills and towering boulders of otherworldly beauty.

Eugene Reshetov © Lonely Planet Images

68 Ko Tao
Thailand

This jungle-topped island has the busy vibe of Samui mixed with the laid-back nature of Pha-Ngan. But its wildcard is accessible, diverse diving right off its shores.

Juan Ignacio Marin / EyeEm © Getty Images

69 Palenque
Mexico

The soaring jungle-swathed temples of Palenque are a national treasure and one of the best examples of Maya architecture in Mexico.

Justin Foulkes © Lonely Planet Images

70 Ilulissat Kangerlua
Greenland

This bay's mouth is filled with bergs the size of buildings or whole towns. It's mesmerising to hear the almighty thunderclaps when they fissure or explode.

RubyRascal © Getty Images

71 Mt Sinai
Egypt

Revered by Christians, Muslims and Jews, all of whom believe that God delivered his Ten Commandments to Moses at its summit, Mt Sinai is an easy and beautiful climb.

Nadja Rueckert © Lonely Planet Images

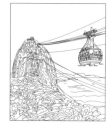

72 Pão de Açúcar
Brazil

From the peak of Pão de Açúcar, the city of Rio unfolds beneath you to reveal green hills and golden beaches, with skyscrapers sprouting along the shore.

Steve Allen © Getty Images

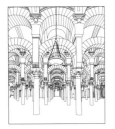

73 Mezquita
Spain

It's impossible to overemphasise the beauty of Córdoba's great mosque, with its remarkably serene and spacious interior. This is one of the world's greatest works of Islamic architecture.

Matteo Colombo © Getty Images

74 Lalibela
Ethiopia

The breathtaking rock-hewn churches of Lalibela represent history and mystery frozen in stone. This is not only a World Heritage Site, but truly a world wonder.

Philip Lee Harvey © Lonely Planet Images

75 Arashiyama's Bamboo Grove
Japan

Arashiyama's ethereal bamboo grove could be the most magical place in Japan. The visual effect of walking among the seemingly infinite stalks of bamboo is like entering another world.

Dawn Biggs © Lonely Planet Images

76 Lake Bled
Slovenia

With crystal-clear blue water, a tiny island topped with a pretty church and a dramatic Cliffside castle, Lake Bled is lovely to behold from almost any vantage point.

Paul Biris © Getty Images

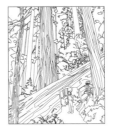

77 Redwood National Park
USA

This national park is home to the largest trees on earth: coast redwoods, which often grow more than 100m in height and live for hundreds, occasionally more than a thousand years.

Matt Munro © Lonely Planet Images

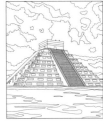

78 Chichén Itzá
Mexico

The most famous and best restored of the Yucatán Maya sites, Chichén Itzá will impress even the most jaded visitor: it is simply spectacular.

Sergio Germano © Lonely Planet Images

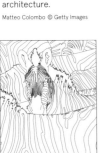

79 Masai Mara National Reserve
Kenya

A vast tract of savannah, dotted with shady umbrella acacias and divided by meandering rivers, the Mara is where nature is at her most ferocious, extrovert and heroic.

chantal © Getty Images

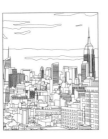

80 Metropolitan Museum of Art
USA

This sprawling encyclopedic museum houses one of the biggest art collections in the world, with more than two million objects, from Egyptian temples to American paintings.

Matt Munro © Lonely Planet Images

81 Franz Josef & Fox Glacier
New Zealand

Franz Josef and Fox are twin glaciers, remarkable for many reasons, including that visitors can venture on to their frozen flanks to explore an incredible ice-scape.

Marco Simoni © Getty Images

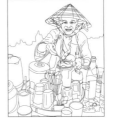

82 Valley of the Kings
Egypt

It was in this isolated hollow that the pharaohs constructed their princely tombs for hundreds of years. What remains is a succession of 63 magnificent royal tombs.

Michelle McMahon © Getty Images

83 Hoi An Old Town
Vietnam

Vietnam's most civilised town is both cosmopolitan and provincial but, above all, beautiful. Once an ancient port, it's now bursting with gourmet restaurants, hip bars, boutiques and tailors.

Matt Munro © Lonely Planet Images

84 Monument Valley
USA

A fantasyland of crimson sandstone towers soaring up to 1200ft skyward, this valley was once home to Ancestral Puebloans, who abruptly abandoned the site some 700 years ago.

Mark Read © Lonely Planet Images

85 St Peter's Basilica
Italy

Rising on the west bank of the Tiber like a gargantuan wedding cake, St Peter's is vast. Its great double dome, an architectural tour de force, was designed by Michelangelo.

Justin Foulkes © Lonely Planet Images

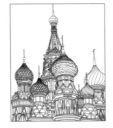

86 Dome of the Rock
Israel

Jerusalem's Dome of the Rock is perhaps the city's most enduring symbol. Its gold top shimmers above a turquoise octagonal base. The site is sacred to both the Muslim and Jewish faiths.

Daniel Zelazo © Getty Images

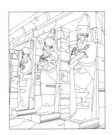

87 Red Square
Russia

The historical, geographic and spiritual heart of Moscow, Red Square is crowded on all sides by architectural marvels; individually they are impressive, but the ensemble is electrifying.

Daniel Korzeniewski © Getty Images

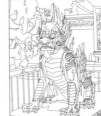
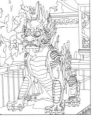

88 Forbidden City
China

Beijing's enormous palace complex, the largest in the world and home to 24 emperors over 500 years, exudes dynastic grandeur with its vast halls and splendid gates.

Mark Read © Lonely Planet Images

89 The Uffizi
Italy

As extraordinary as the Michelangelo, da Vinci, Raphael, Titian and Caravaggio paintings in the Uffizi is its setting – a gargantuan riverside palace built by the Medici family in the 1500s.

Liz Leyden © Getty Images

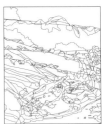

90 Everest Base Camp
Nepal

In 2015 an avalanche devastated Mt Everest's base camp. But it has proven its resilience over the years; people will return to trek through villages where people live among the biggest mountains on earth.

Nikita Lack © Lonely Planet Images

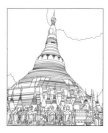

91 Shwedagon Paya
Myanmar (Burma)

Myanmar's signature monument, a 99m-high *zedi* (stupa), is coated with 27 tons of gold and topped with an eye-popping 2000 carats of diamonds.

Matt Munro © Lonely Planet Images

92 The Pyramids of Teotihuacán
Mexico

With its sprawling complex of pyramids, this was Mexico's biggest ancient city and the heart of the country's largest pre-Hispanic empire.

Marc Volk © Getty Images

93 Blue Lagoon
Iceland

This milky, teal-coloured spa lounges in a magnificent black lava field, fed by waters marinating at a perfect 38°C from a futuristic geothermal plant.

RobertHoetink © Getty Images

94 Lake Wanaka
New Zealand

New Zealand's alternative adventure hub, the Lake Wanaka region offers more than just watersports; it's the gateway to the South Island's mighty Mt Aspiring and nearby snowsport centres.

Philip Lee Harvey © Lonely Planet Images

95 Abu Simbel
Egypt

Carved out of the mountain on the Nile's west bank more than 3000 years ago, the colossal Great Temple of Ramses II was lost in the shifting desert-sands of time before its rediscovery in 1813.

Michelle McMahon © Getty Images

96 Cimetière Du Père Lachaise
France

Everyone who was once anyone is buried here, from Balzac to Chopin to Édith Piaf to Oscar Wilde. The tree-lined, cobblestoned cemetery is today rich in folklore and superstition.

Pere-lachaise cemetery © Budget Travel

97 Big Sur
USA

Nestled up against mossy redwood forest, the Big Sur coast is a secretive place in which hot springs, waterfalls and beaches lay hidden. It has long been a muse for creative types.

Myriam Denis © Lonely Planet Images

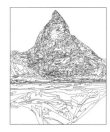

98 Matterhorn
Switzerland

No other mountain inspires as much obsession as the charismatic Matterhorn. Some 3000 worshipful Alpinists summit its 4478m-high peak each year.

Samuel Gachet © Getty Images

99 Gamla Stan
Sweden

In Stockholm's old town, founded in 1250, cobblestone streets wriggle past Renaissance churches, baroque palaces and medieval squares, while spice-coloured buildings frame cosy cafes.

annhfhung © Getty Images

100 Okavango Delta
Botswana

This huge inland delta's annual flood attracts a wonderful concentration of the continent's big-ticket animals and seeing them here feels intimate and personal.

Mint Images/ Art Wolfe © Getty Images

First edition
Published in March 2016
by Lonely Planet Global Limited
ABN 36 005 607 983
www.lonelyplanet.com
ISBN 978 1 7603 4421 4
© Lonely Planet 2016
Printed in China
10 9 8 7 6 5 4 3

Managing Director, Publishing Piers Pickard
Associate Publisher Robin Barton
Commissioning Editor Jessica Cole
Art Direction Daniel Di Paolo
Designer Hayley Warnham
Illustrators Iris Abol, Carolina Celas, Luisa Cosio, Leni Kauffman, Ourania Kondyli, Jonathan Long, Zoe Payne, Mariana Sameiro, Murray Somerville, Franek Wardynski, Hayley Warnham
Print Production Larissa Frost, Nigel Longuet

Lonely Planet offices

AUSTRALIA
The Malt Store, Level 3, 551 Swanston St, Carlton, Victoria 3053 T: 03 8379 8000

IRELAND
Unit E, Digital Court, The Digital Hub, Rainsford St, Dublin 8

USA
150 Linden St, Oakland, CA 94607 T: 510 250 6400

UK
240 Blackfriars Rd, London SE1 8NW T: 020 3771 5100

STAY IN TOUCH
lonelyplanet.com/contact

Although the authors and Lonely Planet have taken all reasonable care in preparing this book, we make no warranty about the accuracy or completeness of its content and, to the maximum extent permitted, disclaim all liability from its use.

Paper in this book is certified against the Forest Stewardship Council™ standards. FSC™ promotes environmentally responsible, socially beneficial and economically viable management of the world's forests.